SPECTACULAR HOMES
of Tennessee

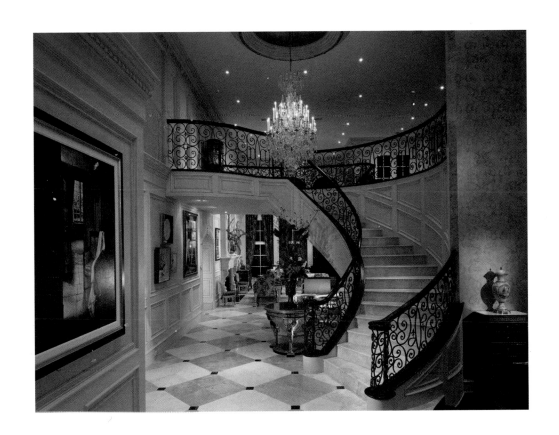

AN EXCLUSIVE SHOWCASE OF TENNESSEE'S FINEST DESIGNERS

Published by

13747 Montfort Drive, Suite 100
Dallas, Texas 75240
972-661-9884
972-661-2743
www.panache.com

Publishers: Brian G. Carabet and John A. Shand

Printed in Malaysia

Distributed by Gibbs Smith, Publisher
800-748-5439

PUBLISHER'S DATA

Spectacular Homes of Tennessee

Library of Congress Control Number: 2005909008

ISBN Number: 978-1-933415-11-6

First Printing 2006

10 9 8 7 6 5 4 3 2 1

On the Cover: William R. Eubanks, William R. Eubanks Interior Design
See page 57 Photo by Woodliff Photography

Previous Page: Marjorie Feltus Hawkins, Feltus|Hawkins Design
See page 73 Photo by Bill LaFavor

This Page: Rozanne Jackson, The Iron Gate
See page 97 Photo by Chris Little

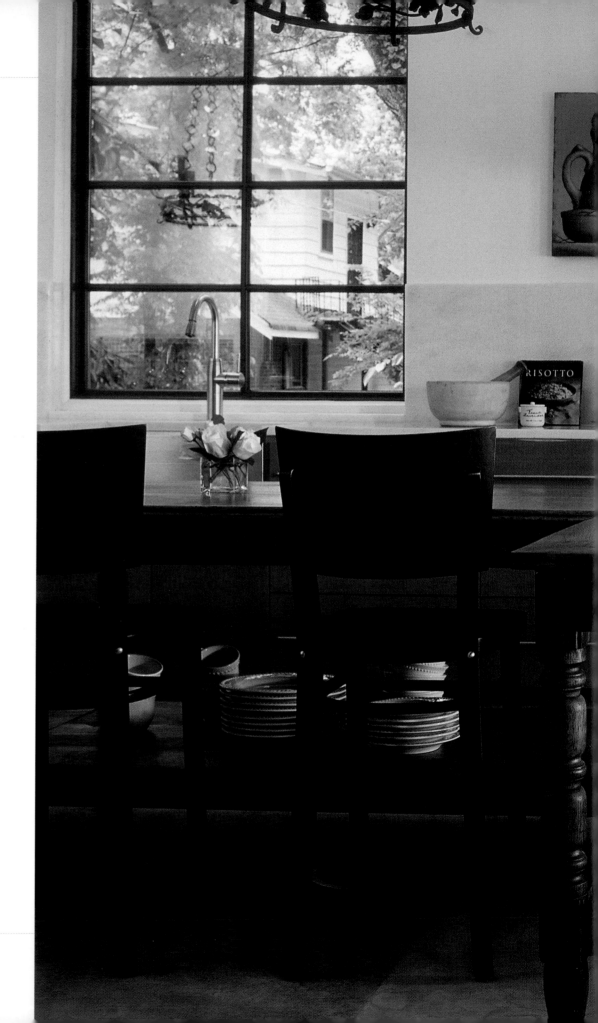

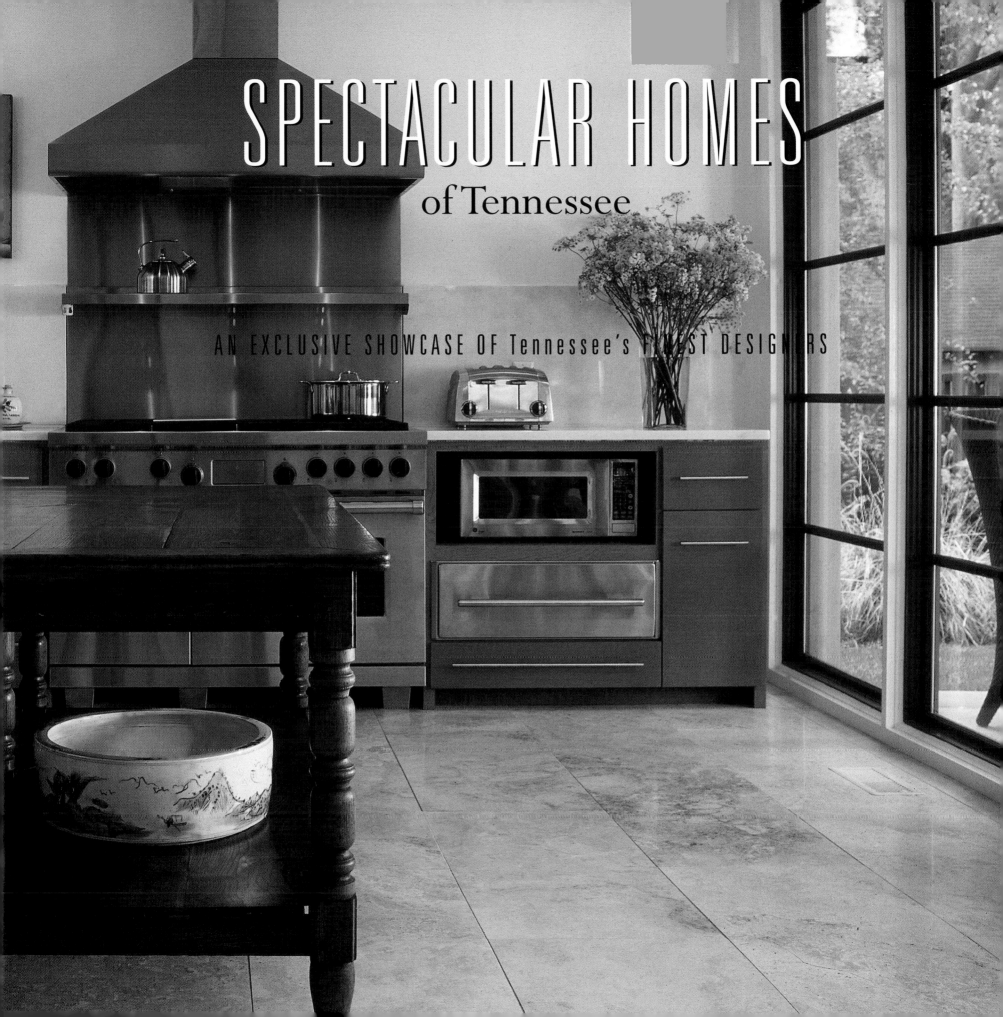

SPECTACULAR HOMES
of Tennessee

AN EXCLUSIVE SHOWCASE OF Tennessee's FINEST DESIGNERS

INTRODUCTION

From the mountains of East Tennessee to the blues on Beale Street in Memphis, the homes across this state are filled with creative style, comfort, and elegance created by the many brilliant designers featured within the pages of *Spectacular Homes of Tennessee*. These talented professionals possess the ability to turn a home into a retreat that serves as a refuge, and for so many of their busy clients, a true haven. Since every client is unique, designers must show a chameleon's finesse when it comes to changing styles, ideas and images with each job. Design is a challenging profession, and this remarkable collection of men and women shows how some of the best in the business rise to the occasion with grace and precision.

On the following pages you will visit homes that have been lovingly decorated by many well-known designers. Many of these professionals have spent their lives working within the design industry. One in particular has been working in the business for over 40 years, and while he promises he is partially retired, he is still creating beautiful spaces for his clients. He's certainly not alone. Within the pages of *Spectacular Homes of Tennessee* you will discover a fresh mix between beautiful, traditional interiors that transcend time and sophisticated contemporary residences that showcase the region's urban areas.

Lose yourself within these pages as designers from West, Middle and East Tennessee take the desires of their clients and transform homes into environments that exude classic sophistication, metropolitan chic or simple elegance. Visualize your home's potential with the help of our featured designers, and let their advice, inspiration and creative ideas guide you.

Someone once said, "It takes hands to build a house, but only hearts can build a home." These designers have the heart to help build the homes we share with you in *Spectacular Homes of Tennessee*. The professionals featured within the pages of this book come from diverse backgrounds. Many hail from prestigious design schools and while many work with executives or celebrities, the one thing they all bring to their work—no matter the size or scope of the project—is a huge desire to make their clients happy. Their designs showcase the hard work and heart they put into each project. As one designer told me, "'Each home is like a child, you want the very best for it." Heart is also something shared by the many people behind the scenes who have helped make the designers' ideas a reality. Without complaint, families have tolerated demanding schedules, mornings without mom or dad and hours spent away from home. This is what is truly spectacular.

Allow *Spectacular Homes of Tennessee* to inspire and motivate you as the pages reveal beauty, style, elegance and heart from across this scenic state. After all, home is where the heart is.

Warmest regards,

Julia Hoover

Julia Hoover, Associate Publisher

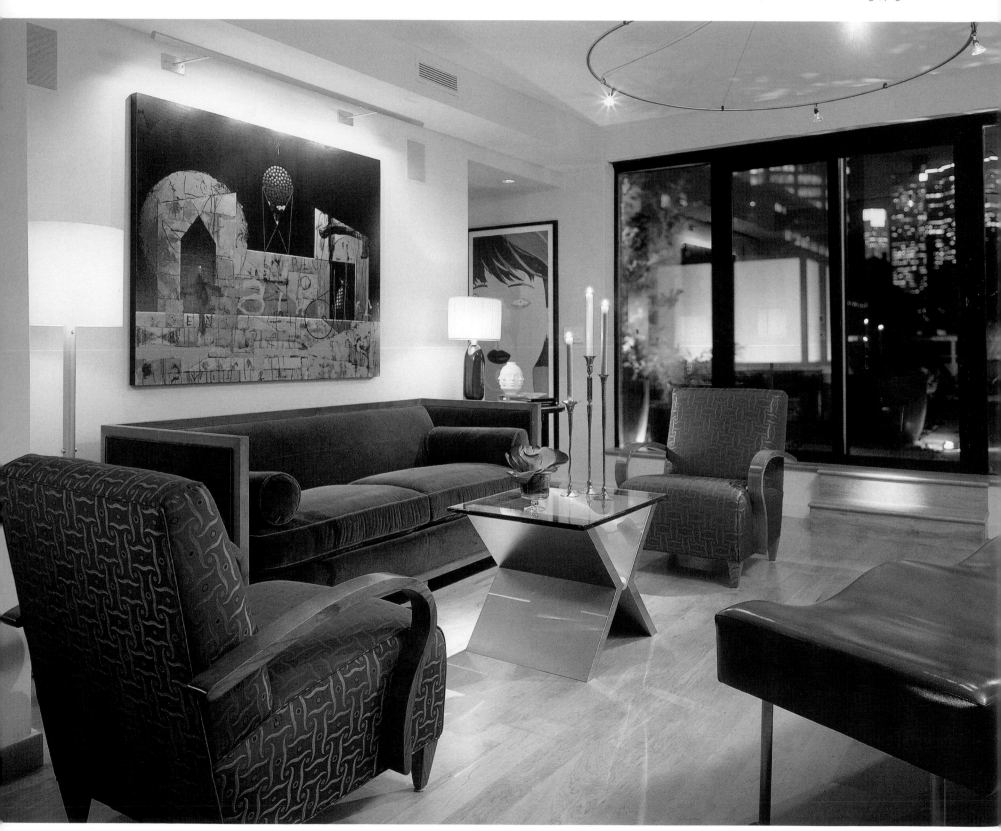

TABLE OF CONTENTS

JEFFREY ADKISSON .. 11
Adkisson Design

KATHY ANDERSON .. 19
Anderson Design Studio

LISA BIGGERS & KELLY HARWOOD 21
J.J. Ashley Fine Interiors

SHANDRA BLACKWELL ... 25
Shea-Noel Interiors

BAYLOR ANNE BONE AND GAIL C. COOK 29
Baylor Bone Interiors

KATHRYN BROADWATER .. 33
New Directions

BRADFORD COLLIER .. 39
B W Collier Inc.

KENNETH W. CUMMINS .. 45
Kenneth Cummins Interior Design

GWEN DRISCOLL ... 49
Gwen Driscoll Designs

JOE ERWIN, MARY FOLLIN & DAVID WHITE 51
Erwin, Follin & White

WILLIAM R. EUBANKS .. 57
William R. Eubanks Interior Design, Inc.

LANDY GARDNER ... 65
Landy Gardner Interiors

SARA GILLUM ... 69
Sara Gillum Interiors

MARJORIE FELTUS HAWKINS 73
Feltus|Hawkins Design, LLC

KEITH HEADLEY ... 77
Headley Menzies Interior Design

KAREN W. HEALY & MEG M. THOMAS 83
Healy & Associates

JILL E. HERTZ .. 87
Jill Hertz Interior Design

SHIRLEY HOROWITZ, NATALIE HART & JASON ARNOLD 91
Davishire Interiors

ROZANNE JACKSON .. 97
The Iron Gate

ALLYSON JUSTIS ... 105
Allyson Interiors

CINDY MCCORD .. 111
Cindy McCord Design, Inc.

LANNIE NEAL ... 113
L. Neal Interiors

BIGGS POWELL ... 119
Biggs Powell Interior Design & Antiques

LEE PRUITT .. 123
Lee Pruitt Interior Design

ROBIN RAINS .. 129
Robin Rains Interior Design

GRANT RAY & GREG BAUDOIN 137
Ray & Baudoin Interior Design

BARBARA G. RUSHTON .. 141
Bradford's Interiors

LESLIE SHANKMAN-COHN 145
Eclectic Interiors

LYNDA MEAD SHEA .. 147
Shea Design & French Country Imports

LESLIE NEWPHER TACHEK 153
Leslie Newpher Tachek Interior Designer L.L.C.

CONNIE BELL TAYLOR & ANN LIVINGSTON HUIE 157
Taylor & Huie Fine Interiors & Appointments

JOE TICE .. 159
Joe Tice Interiors

BARRY WILKER ... 161
B. Wilker & Company Interior Design Studio

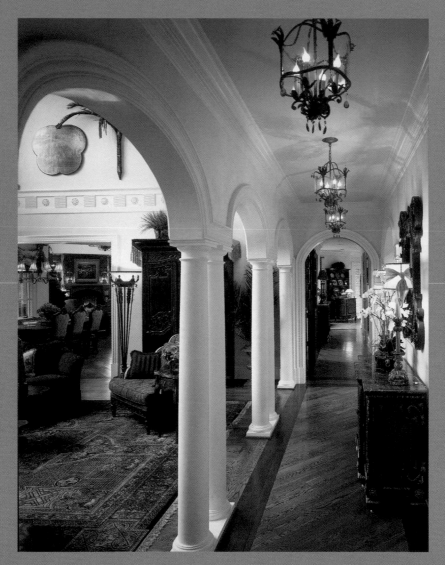

DESIGNER Kathryn Broadwater, New Directions, page 33

Tennessee

AN EXCLUSIVE SHOWCASE OF TENNESSEE'S FINEST DESIGNERS

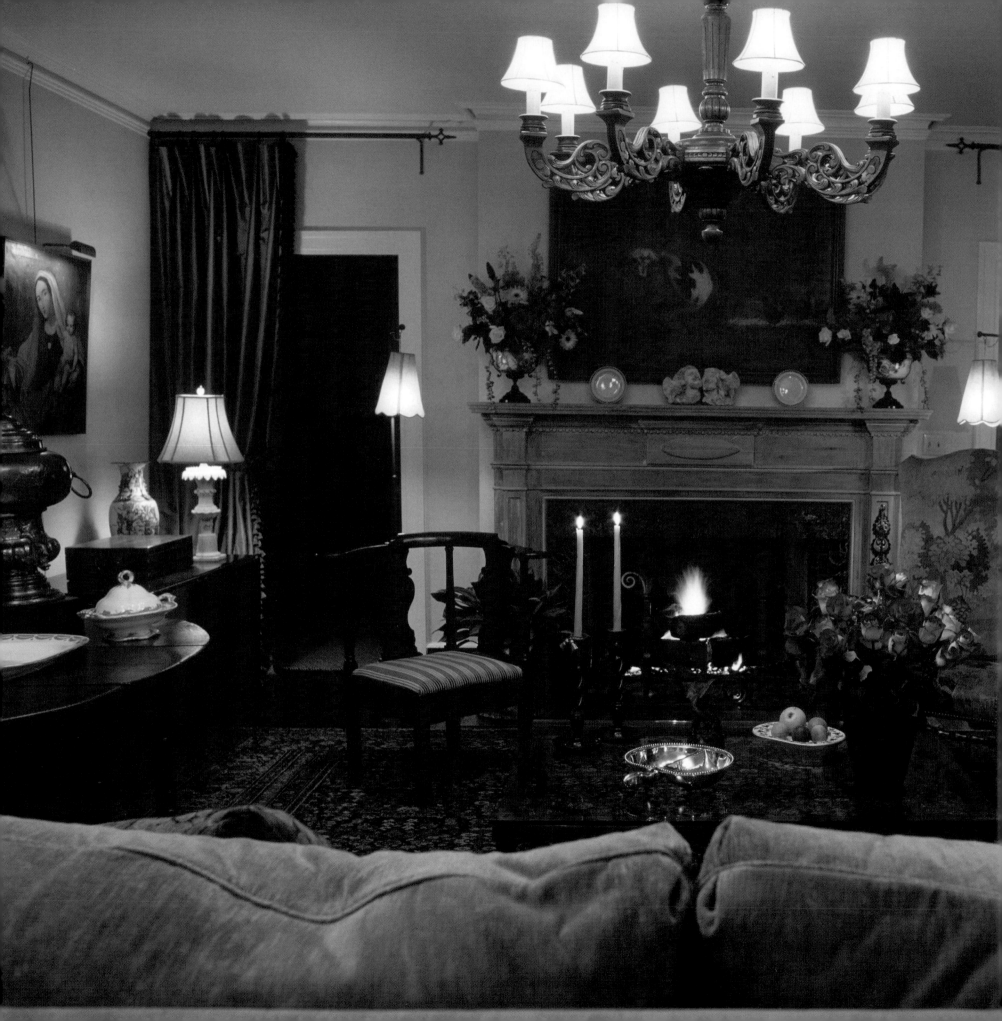

JEFFREY ADKISSON

ADKISSON DESIGN

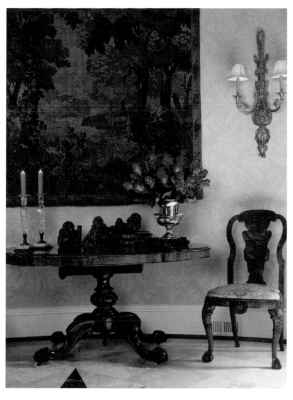

ABOVE An elliptical-shaped entrance hall with hand-painted damask pattern walls. The burled walnut antique table, tapestry and Queen Anne chairs offer a sense of grandeur contrasted against the light stone flooring.

LEFT Warm, soothing earth tones provide a relaxing backdrop to a collection of Antiques and paintings in the Adkisson's living room. Silk portiere's and linen velvet covered sofas marry perfectly with the Malayer Oriental rug.

There is a new attitude prevalent in interior design today that reflects both individual taste and international influences. In this age of global communication, an overwhelming amount of information must be absorbed before reaching an understanding of our material culture and how to best express it. Jeff Adkisson's designs reflect a youthful spirit and an extreme respect for the past in a fresh way. He strives to create within his clients the same enthusiasm he feels for the charm and magic of each project. He derives great satisfaction in imparting classic fine art, architecture and interior design to clients seeking broader knowledge of how art and design can influence and improve daily life. He takes pleasure in projects ranging from the very simple to rich and sumptuous, and his work has inspired and brought gratitude to people from all walks of life.

A love of decoration for its own sake is innate to Jeff and has been so since childhood. His father was one of Nashville's first real estate appraisers, and through assisting his dad he was exposed to all types of homes and lifestyles. After graduating from Vanderbilt University, he did postgraduate study in France and Italy and apprenticed for four years with the late Bill Hamilton, a renowned Nashville designer. During his association with Bill, Jeff was fortunate to meet Nina Wakefield, the legendary antiquarian from Atlanta. She exposed him to great and honest antiques from France, Germany, the UK, Russia and the Orient and honed his talent for connoisseurship. Jeff's extensive travels nourish his design abilities and enable him to collect antiques and decorations for his projects throughout the Southern states and as far afield as England and the West Indies.

Jeff established his company, Adkisson Design, twenty-five years ago and has since forged a solid reputation for creating fine residences of excep-

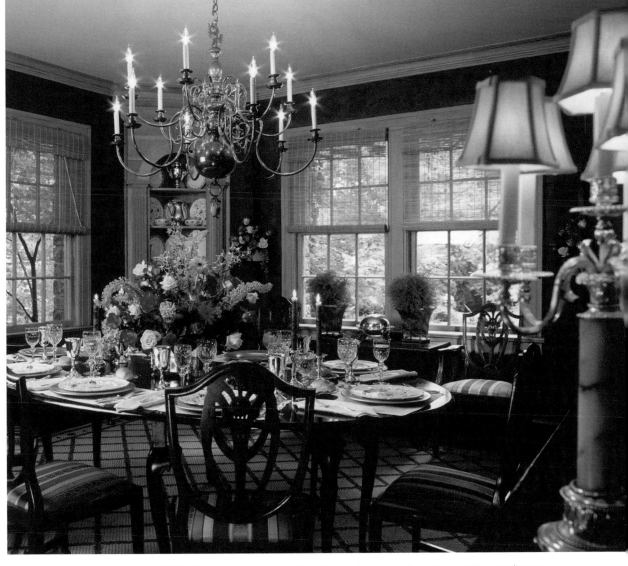

ABOVE Cinnamon red glazed walls and faux grained wood decorative painting compliment a pair of popular corner cabinets and the woodwork. Prince of Wales Sheraton chairs surround an oval mahogany Irish wake table.

LEFT In the Adkisson's den is an exquisite English Chesterfield sofa which backs up to an outdoor courtyard with obelisk fountain. Red Italian damask uphostered walls with dark mahogany trim offer a rich ambiance for relaxing.

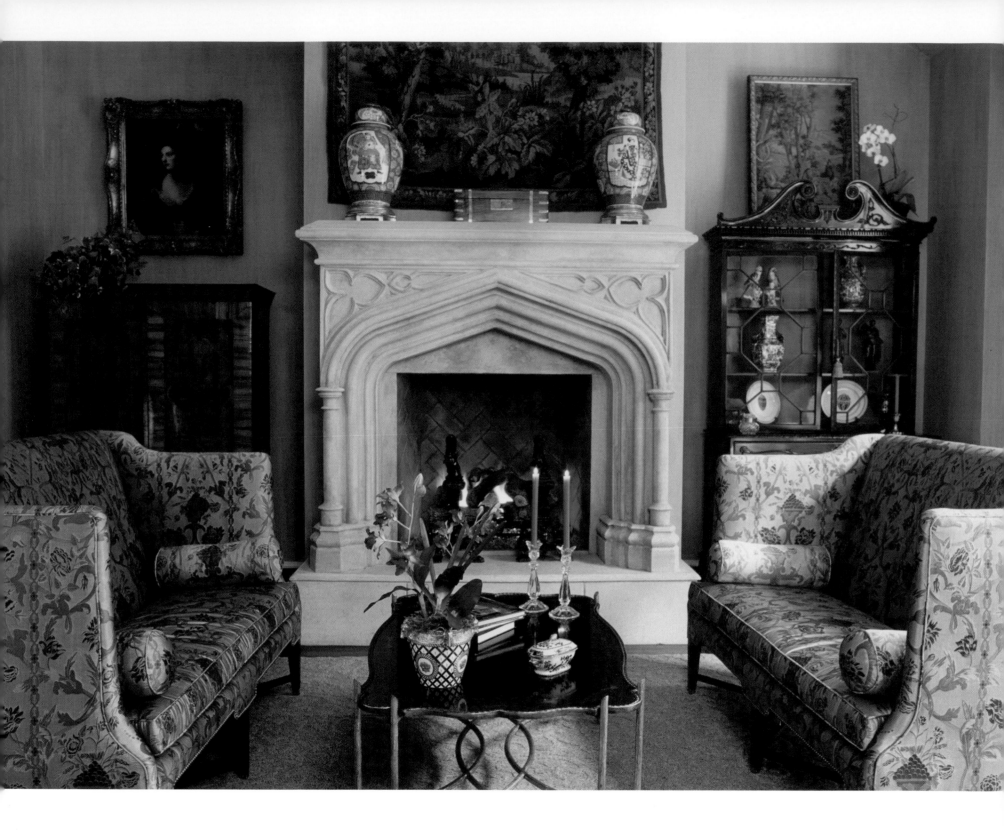

ABOVE The pair of tailored shelter sofas harmonize well with the heavy limestone fireplace and antique collection in this living room. Imari vases flank a French tapestry above the fireplace.

TOP RIGHT Hand painted silk wallpaper and tailored silk swag amd jabot draperies provide a sumptuous backdrop for this dining room.

BOTTOM RIGHT A broken island makes for relaxed cooking and sitting area in the middle of a very large kitchen. French light fixtures both new and antique. Cherry cabinetry with granite counters contrasting against a stone floor laid in a herringbone pattern.

tional quality and also producing innovative commercial offices. Although his style clearly has an old-world influence and inspiration, it meshes seamlessly with projects ranging from historical to contemporary. Jeff conceptualizes a project as sculpture in the round and thinks it of utmost importance that the interior design and the exterior architecture, including the gardens and grounds, are harmonious and complement each other. He truly appreciates a client who is imaginative and knowledgeable, but finds a novice with a blank canvas irresistible. An Anglophile at heart, Jeff increasingly finds eclectic design intriguing and searches for new ways to incorporate his love of historical elements into the modern lifestyle.

Naturally communicative and a gifted listener, Jeff appreciates working with a diverse client base and collaborating with other artists and professionals. He is interested in the ideas of clients and colleagues, but stands forthright in his own beliefs. He educates and enables clients to use their imaginations and expand their knowledge. Above all, he encourages them to choose only things that please their eye and are of the best quality they can afford. It is Jeff's belief that fine art, great antiques and rare decorative objects endure over time and can appreciate exponentially, and with his knowledge of fine European antiques and art, he can advise clients as they embark on a rewarding lifetime of collecting objects that they love.

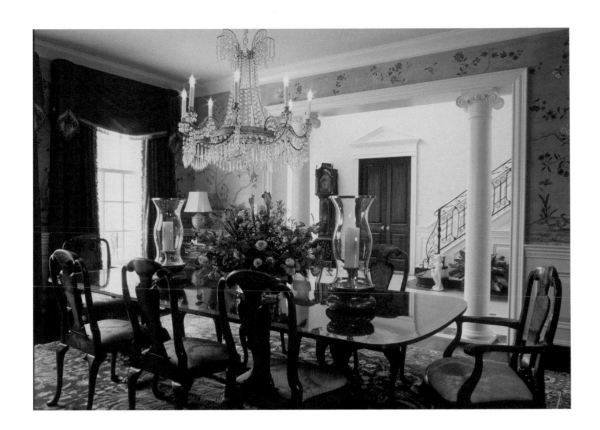

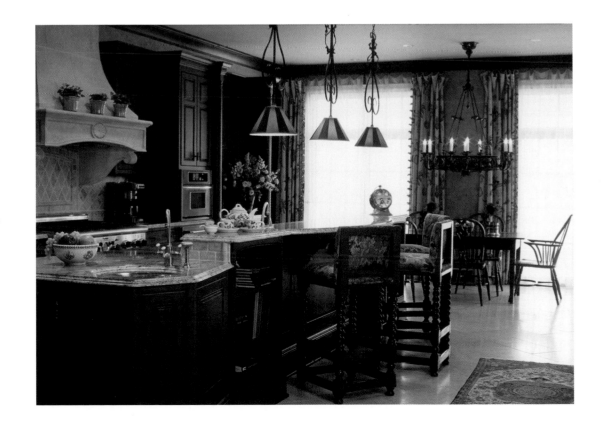

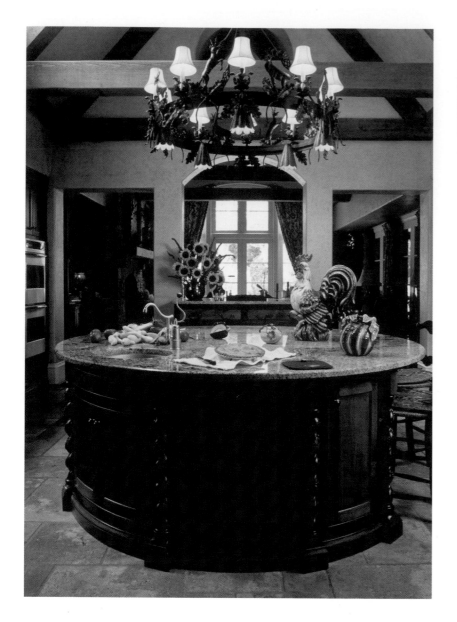

Jeff and his wife Sharon welcome everyone to their elegant, English-inspired home, garden, and workplace and they share their love for flowers and gardens with the community and friends. Jeff has won numerous awards over the years and has been chairman of the Metro Beautification Bureau for the city of Nashville for several terms. He has also chaired many committees for various civic organizations and events. Jeff also likes Christmas but that's another story.

ABOVE LEFT A circular granite-topped kitchen island grounds the twenty-foot beamed ceilings of this homes kitchen and family room.

ABOVE RIGHT A ten-foot crystal chandelier in this sumptuous dining room makes the waxed, Venetian plaster walls gleam during the day and night. Queen Anne table and chairs with their origianl tapestry seats.

FACING PAGE This voluminous living room is bathed in fantastic light. Aqua glazed walls, silk draperies and light colored fabrics seem to float on the exuberant colored Sarouk Oriental rug.

More about Jeff ...

NAME ONE THING MOST PEOPLE DON'T KNOW ABOUT YOU.

"I would give them the shirt off my back if they needed it," says Jeff.

WHO HAS BEEN THE BIGGEST INFLUENCE ON YOUR CAREER?

"Probably Thomas Jefferson. In his lifetime he had amazing accomplishments."

DO YOU HAVE ANY FAVORITE SAYINGS?

"From Oscar Wilde on his deathbed: 'Either that wallpaper goes, or I do.'"

WHAT IS A SINGLE THING YOU WOULD DO TO BRING A DULL HOUSE TO LIFE?

"I would process everything in the house and decide what should be kept, culled or hidden. I would then reorganize the place with function, personality and an artful eye," says Jeff.

ADKISSON DESIGN
Jeffrey Adkisson
Registered Interior Designer in Tennessee
417 Westview Avenue
Nashville, TN 37205
615-269-0898
www.adkissondesign.com

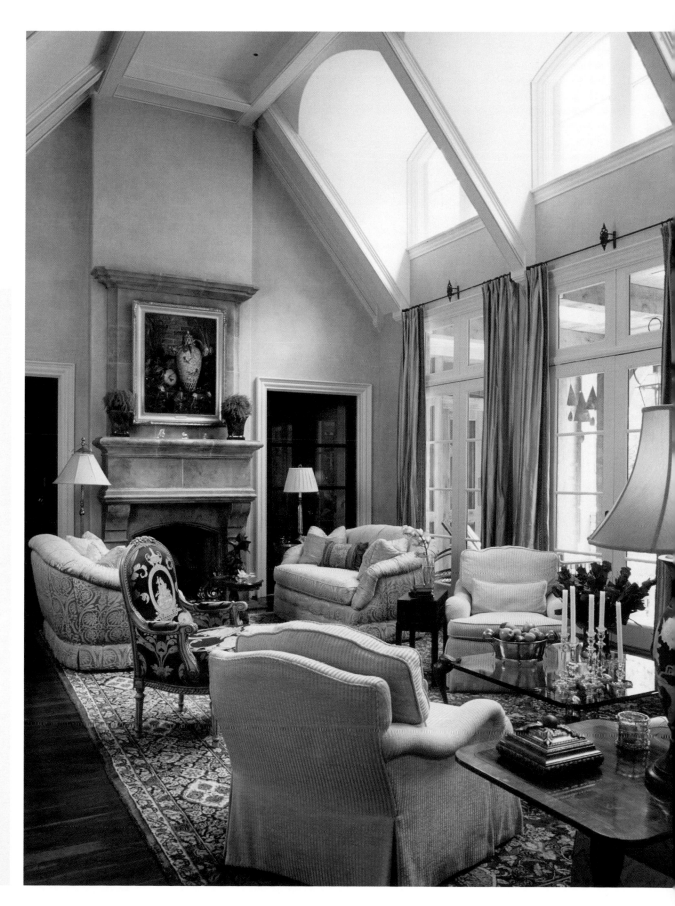

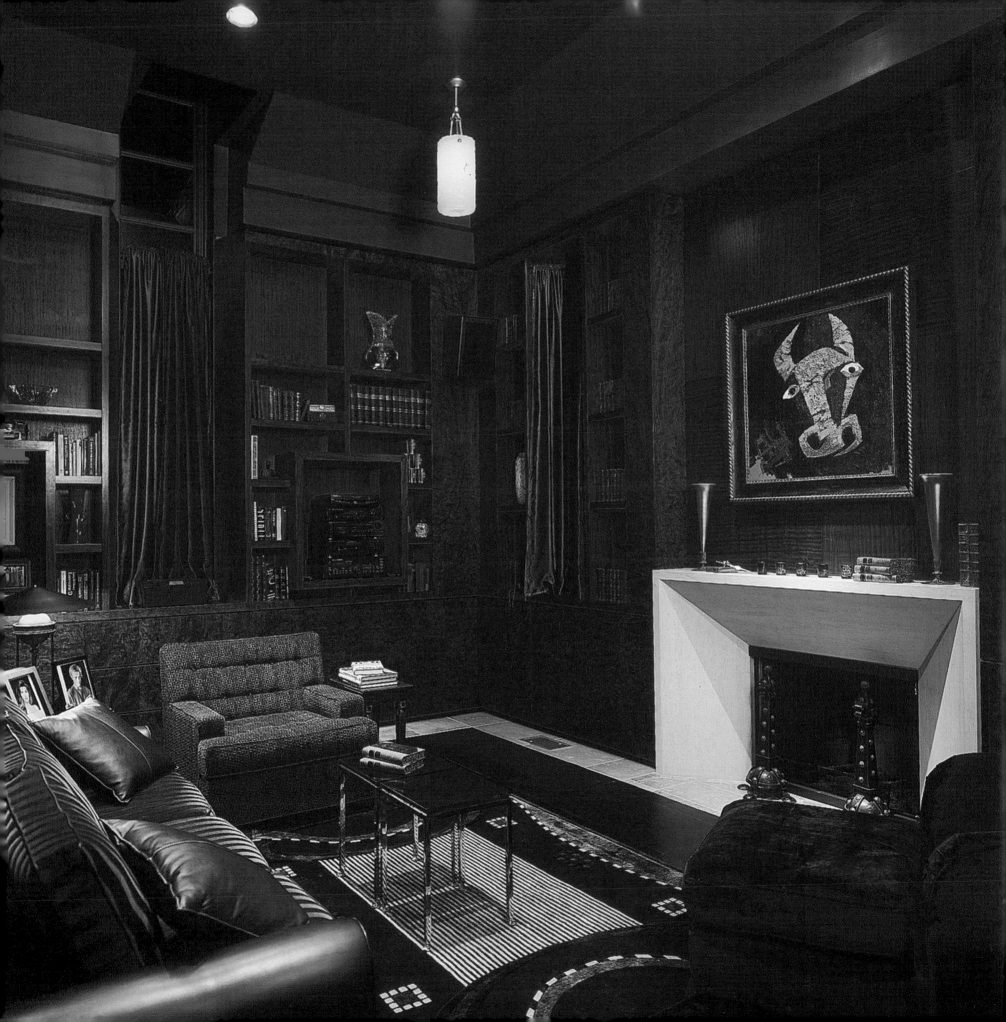

KATHY ANDERSON

ANDERSON DESIGN STUDIO

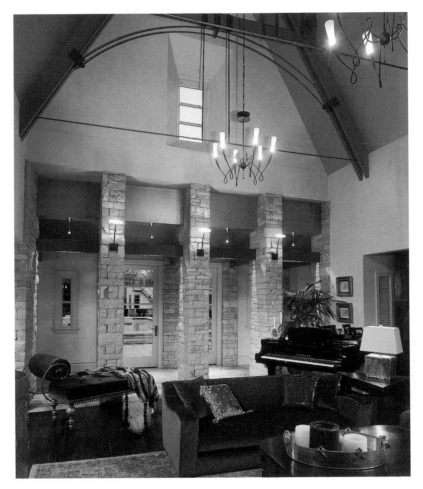

Nashville based interior designer Kathy Anderson is best known for sleek, luxurious and warm contemporary spaces. Her talented team at Anderson Design Studio is also famed for its ability to create sophisticated interiors for businesses as well as for homes that suit the personalities of their owners. Indeed, commercial projects form half of the firm's portfolio, which also includes residences for a number of top names in the entertainment industry. Kathy notes that the technical documentation, codes and budgets required for commercial projects translate to a more professional design process on residential projects. "The residential work makes me a more sensitive commercial designer."

Kathy's intuitive eye for graceful, finely detailed style was nurtured by a stint in California, where she graduated from UCLA and later worked for an Asian design firm. For the past 17 years, her firm's interior architecture work has reflected a clean and comfortable aesthetic, augmented by a solid knowledge of construction practices and a serious commitment to personal client relationships. "I love the opportunity to meet different people," says Kathy. "My clients teach me something on every project, too," noting that it could be art, travel or even spiritual. "It's a real sharing of ideas and information and I love that part. I love creating a home where in the end, they love living there."

ABOVE Venetian plaster and Vermont limestone surround this cozy living space which looks into the pool area. Mahogany trusses and metal tension rods give a graceful look to the soaring ceiling.

LEFT Custom made deco influenced Bubinga wood cabinets incorporate the sound components for this listening room and study. The leather floor is bordered with limestone. The rug is a Jack Lenor Larsen design.

ANDERSON DESIGN STUDIO
Kathy Anderson, IIDA
1625 Broadway, Suite 600
Nashville, TN 37203
615-255-0022
FAX 615-255-0039
www.andersondesignstudio.com

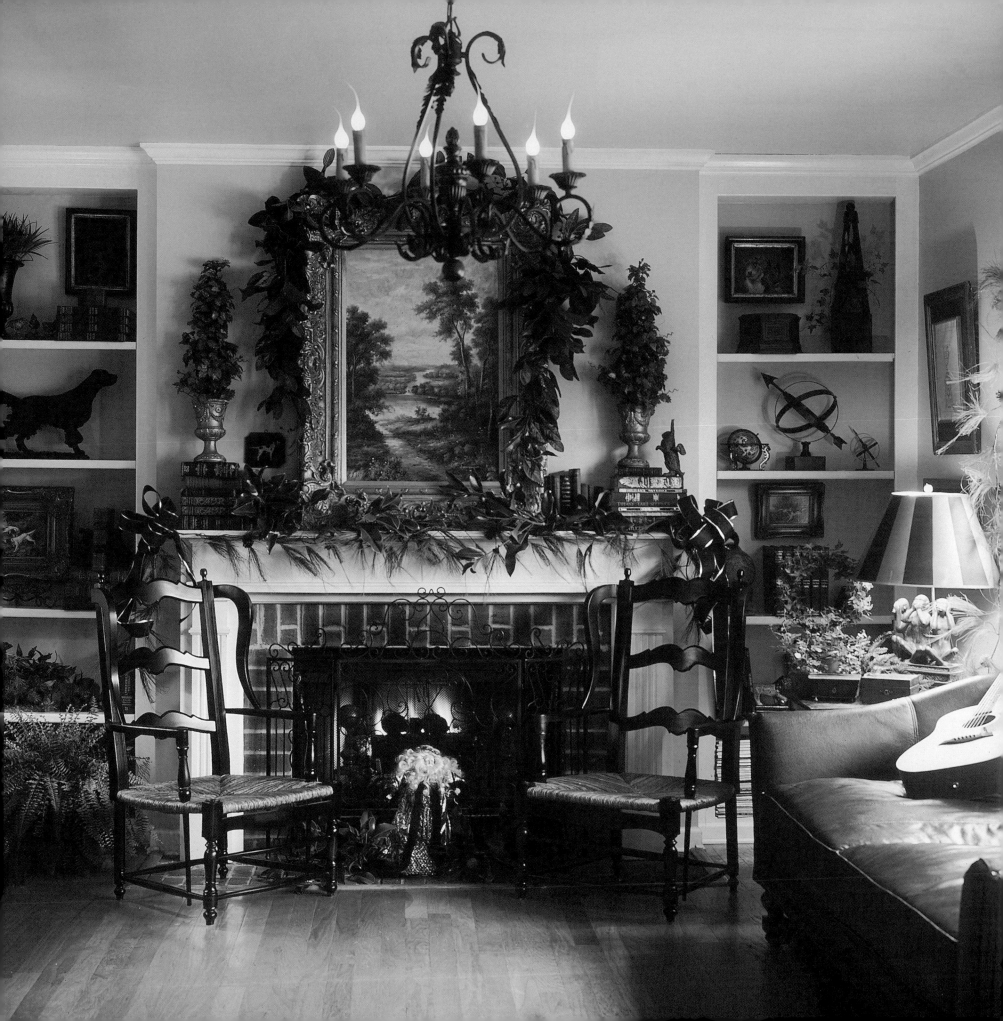

LISA & STEPHEN BIGGERS & KELLY HARWOOD

J.J. ASHLEY FINE INTERIORS

Step inside J.J. Ashley's Fine Interiors, Lisa Biggers' cozy showroom located in historic downtown Franklin, and you are immediately enveloped in traditional style. "We started out selling mostly antique furnishings," says Lisa, who notes that full-service interior design is just one component of her multifaceted shop, which she opened in 1993 and now takes up 6,500 square feet of what was formerly Franklin's feed store. "We still import, but it's mostly English country and country French reproductions." With the freedom to buy new items rather than exhaustively source antiques, Lisa has enjoyed the opportunity to indulge in new finds and still be able to discover large unusual pieces for her customers and designers utilizing her showroom. "I love retail because it's instant gratification," says Lisa, who loves putting together an eclectic look. "I get to live out my shopping fetish within my retail shop!"

When it comes to accessories, J.J. Ashley's is most famous for winning several local People's Choice awards for Best Accessories Store. Even though accessories are such a small part of any design installation, they are very important. In Lisa's opinion, "this is were you can throw in a little funk, add a little fun, keep things up-to-date, more relaxed and certainly more interesting!" she says. "It's like a wedding cake without the icing!"

When visiting J.J. Ashley's, people are "wowed" by the sheer volume of merchandise under one roof. However, if you happen not to see what

ABOVE This small handpainted console conceals the family games. The antique girandoles from Clomonts of Chattanooga were converted into lamps to warmly light this old french mirror and some of the owners favorite treasures.

LEFT A delightful mix of Country French and English Country makes this cozy place to keep warm and toasty. The French fireside chairs fromm J.J. Ashley's nestle around this fireplace with shelves that are filled to the brim with everything from antique books, Aunt Grace's sewing box, to portrairts of the family dogs.

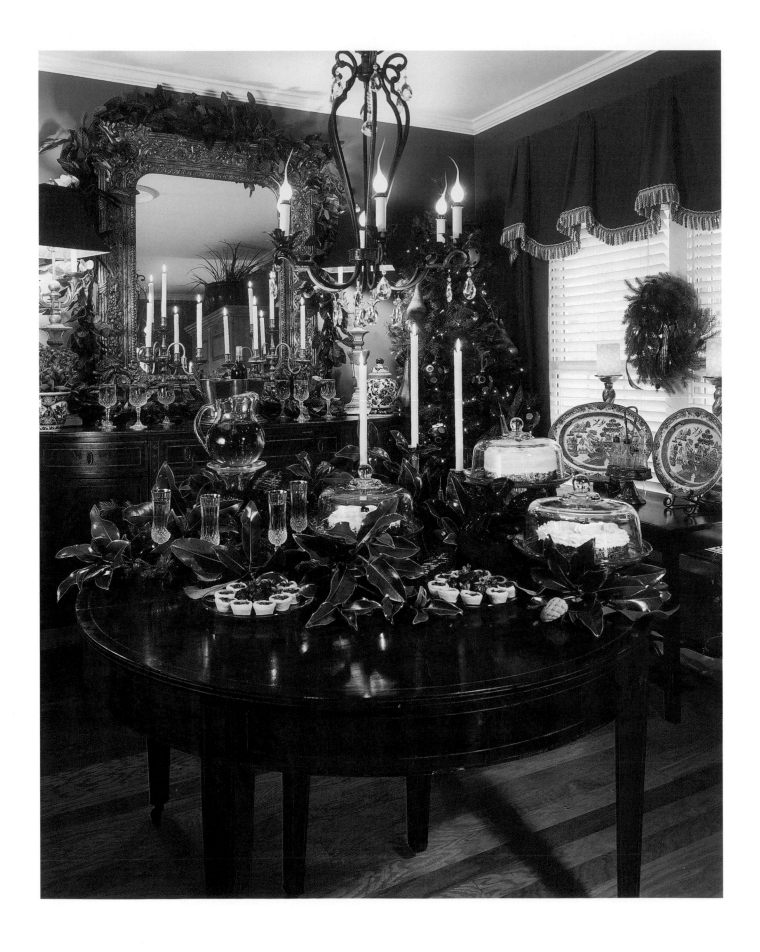

you're looking for, just ask: J.J. Ashley's 12,000-square-foot warehouse might just turn up whatever your heart desires.

Over the years, Lisa has had the privilege of working on many homes, offices and even yachts, and the J.J. Ashley's design team has won the last three out of four Parade of Homes "People's Choice" awards among other design awards. "We're very proud of our focus on quality customer service," says Lisa. "We're a family-owned and operated business; therefore, we consider everyone who works here and shops here regularly family," says Lisa. "So expect just about anything when you visit J.J. Ashley's including great music piped throughout the store, dogs, kids, rabbits, moms, dads, a mess, but most of all expect to have fun!"

ABOVE This walnut, barley twist table , circa 1890 , and set of four antique mahogany Queen Anne chairs, made their way to Franklin, Tennessee via Austin, Texas atop the family's sedan!

LEFT Dressed for Holiday Celebration, the 1830's Georgian English Mahogany sideboard is paired with a 1890's Round French mahogany table. The room is traditionally accessorized with family Chris Crystal combined with blue and whote transferware. One of the family's most prized possessions is the six-foot, very old gold-leaf mirror weighing well over two hundred-fifty pounds.

More about Lisa ...

WHAT IS THE BEST PART ABOUT BEING AN INTERIOR DESIGNER?
Buying, says Lisa. "There are all kinds of glorious parts but I'd be lying if I didn't say 'buying' was my favorite!" she says. "When I go to market, Charleston, Savannah, wherever, I go crazy! It's an addiction I just can't stop!"

WHAT IS THE BEST ADVICE YOU'VE GIVEN OVER THE YEARS?
Lisa has always advised her clients and customers to invest in classic furniture that's perhaps just a step beyond what they can afford. "By doing so, that furniture will always be special to you," she says.

WHAT IS THE HIGHEST COMPLIMENT YOU'VE RECEIVED PROFESSIONALLY?
"On a particularly bad day, one of my favorite clients put her arms around me and said, 'I believe the Gods have sent you to me.'"

J.J.ASHLEY FINE INTERIORS
Lisa & Stephen Biggers, Owner
Kelly Harwood, Associate Designer
125 South Margin
Franklin, TN 37064
615-791-0011
FAX 615-791-8583

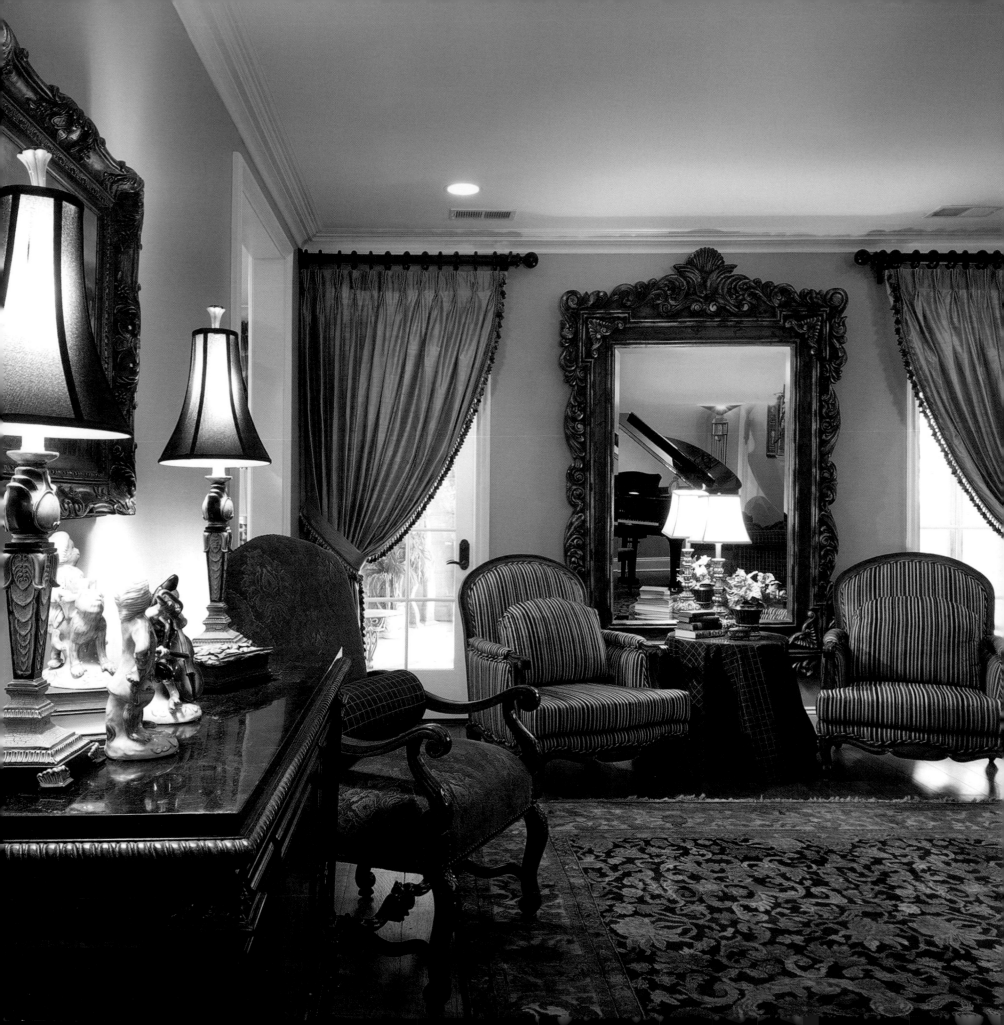

SHANDRA BLACKWELL

SHEA-NOEL INTERIORS, INC.

At 28, Memphis-based Shandra Blackwell may be considered a young entrepreneur when it comes to managing her interior design firm, but she's certainly no beginner. As the president of Shea-Noel Interiors for the past three and a half years, Shandra has built her business by stressing personal service paired with a solid attention to detail and tech-savvy processes that result in a streamlined, professional experience for clients. For example, the firm's 3-D software is capable of providing a room-by-room walk-through of any project, regardless of size, while staying on top of what's in stock and exactly how much everything costs is a point of pride.

"There are no surprises," says Shandra, who has worked in design for the past nine years and believes in running a down-to-earth company that's also serious about individuality. So serious, in fact, that Shea-Noel only uses a fabric once—if it goes in a client's home, it won't be repeated for another client, even in a different color. "The home is such a personal place," she explains, adding that using a fabric again would unnerve her because it goes against the purpose of being creative. "We take such an artistic approach to what we do."

Style-wise, while Shea-Noel has received a lot of attention for its contemporary-style projects, Shandra notes that about 95% of

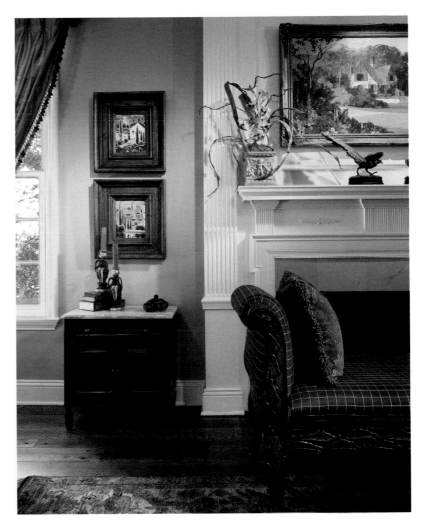

ABOVE A colorful painting above the classic mantel in this home helps pull together all of the fabrics and colors in the room. Note how the large frames draw attention to the small paintings on the left.

LEFT An overscale mirror dominates this colorful living room and serves as a dramatic focal point between sumptuous curtains.

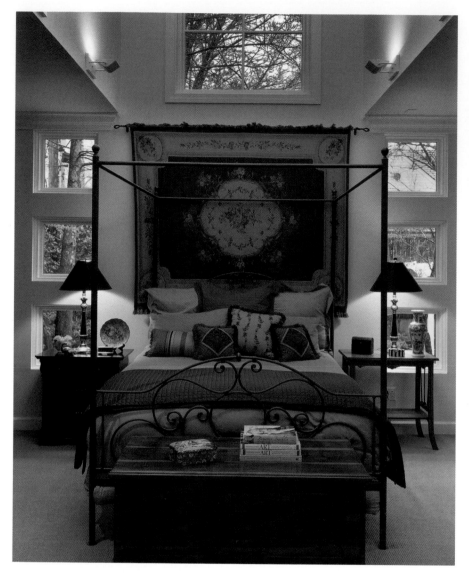

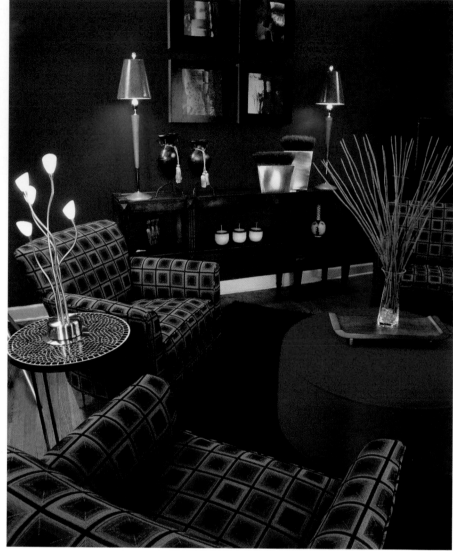

the firm's work is traditional, and to date the company has completed homes in Colorado, California, Ohio, Georgia, Florida and Mississippi as well as across Tennessee. "Our most important thing is that we don't have a particular style," she says. "Our clients have a great time with us and it's a fun process, which is exactly what design should be."

One of Shea-Noel's most recent projects is also among their most important. The firm is coordinating the Millington Makeover, an all-volunteer effort to renovate and complete an addition to the home of a young boy who was seriously injured in a fire. "I am so passionate about what I do," says Shandra about her design work in general. The Millington Makeover also clearly demonstrates that she's passionate about her community, too.

ABOVE LEFT Vivid, saturated color contrasts with the airy metal bed and complements the architecture in this contemporary bedroom, which is punctuated by a series of dramatic windows.

ABOVE RIGHT A perky ottoman provides extra seating and a different version of a cocktail table in this fun room.

FACING PAGE This dramatic dome in a client's elegant master bedroom is a superb example of inspired design: the dome was formed from a recycled satellite dish.

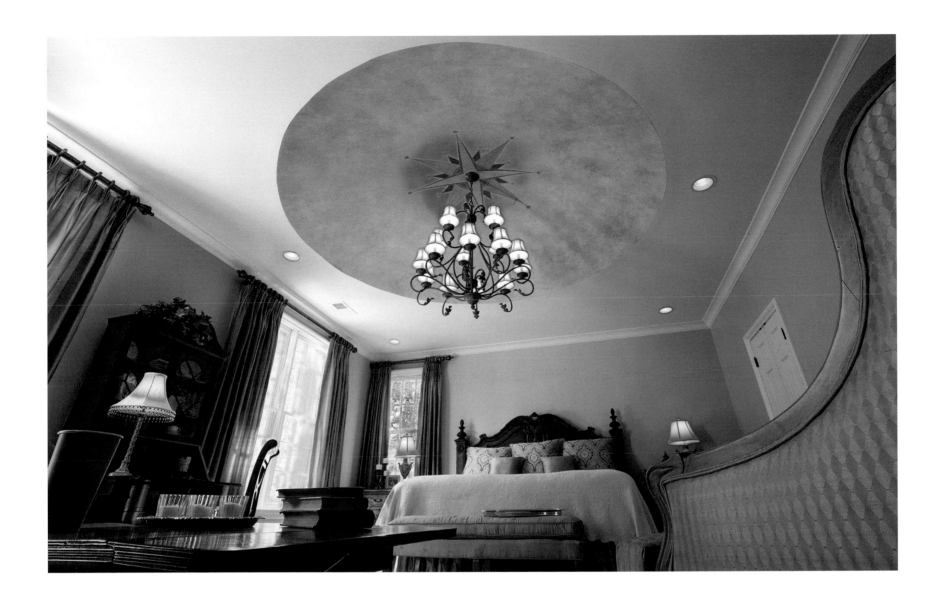

More about Shandra...

Shandra's most unusual technique to date involved reusing an old 10-foot satellite dish. "I turned it upside down and had a client's builder mount it within the ceiling joists and sheetrock over the dish to create a dramatic rotunda ceiling in a master bedroom," says Shandra, who then commissioned a talented artist to paint a medallion in the center. "After hanging a chandelier, it turned out to be a great architectural feature of the home."

NAME ONE THING MOST PEOPLE DON'T KNOW ABOUT YOU.

Shandra is an avid boater and enjoys wakeboarding.

WHAT IS THE HIGHEST COMPLIMENT THAT YOU'VE RECEIVED, PROFESSIONALLY?

"After designing a client's home, she recently told me, 'Each of my homes have a completely different feel, and yet you manage to capture the essence of my soul in each of them —I don't know how you do it.' I was very flattered."

SHEA-NOEL INTERIORS, INC.
Shandra Blackwell, president
901-751-2228
FAX 901-751-2338
toll-free: 1-888-751-2338
www.shea-noel.com

BAYLOR ANNE BONE
& GAIL C. COOK

BAYLOR BONE INTERIORS

Known for their dramatic, eclectic take on design, quick turnaround and comfortable, colorful rooms, Baylor Anne Bone and Gail Cook of Baylor Bone Interiors are always inspired by their travels and their clients. "I think we do a unique job of coupling creativity and efficiency," says Baylor Anne, who has been in the design business for the last 22 years. Together, Baylor Anne and Gail have worked on numerous residences in Tennessee, as well as large projects in Maryland, Florida, Texas, Arizona, and New Jersey, just to name a few locations. Along the way, the firm has won many accolades, from an ASID award for commercial design last year to numerous awards for their interiors at the Parade of Homes, a bi-annual event that showcases new residential construction. Exceptional customer service, too, is another strength that longtime good friends Baylor Anne and Gail emphasize in their work. "We really strive to come in ahead of schedule and under budget," says Baylor Anne.

ABOVE Rich, embossed bronze wallpaper, unexpected light fixtures and a Moroccan-inspired mirror combine to make a small space outstanding.
LEFT An eclectic color combination of chocolate and fuchsia sets the tone for the unique use of two marble tables in this dining room.

A noted source for luxurious furnishings and accessories, Baylor Bone Interiors has two large Nashville area showrooms. While the retail side of the firm began with antiques, over the years the company has refined and dominated its niche with a sophisticated mix of modern objects with a romantic, glamorous look, from glass-and-gilt cocktail tables to fine lamps and rich, textured fabrics and surfaces.

For their design clients, Baylor Anne and Gail believe that comfort and color are key components of successful rooms, and that their goal is for clients to walk into a room and want to stay there. As part of creating that experience, they choose paint colors last in order to tie together diverse pieces in a room, from items a client may already own to new furnishings. "The palettes are changing so quickly these days that you need to worry about what you love and not what the latest trend is," advises Gail. Learning about what their clients tastes are and how they want their homes to function is a wonderful part of the journey for the designers. "We want to make a difference in their lives as well as their homes," says Baylor Anne about the firm's clients. "And every day is different."

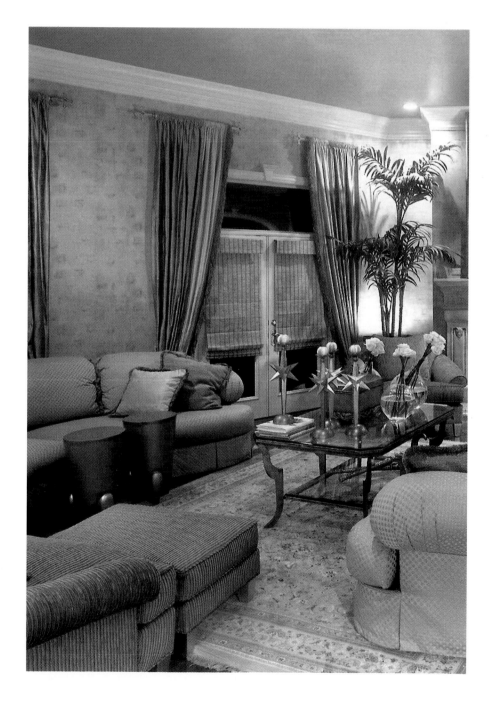

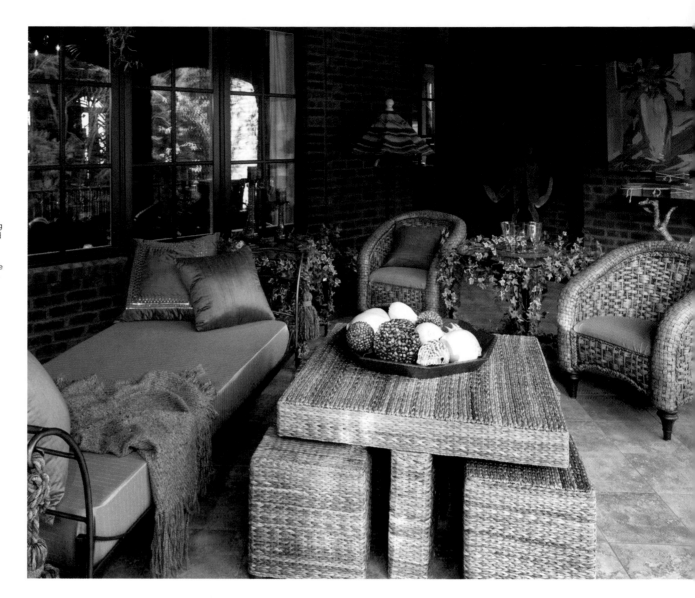

FAR LEFT This award-winning foyer features a stunning living area anchored by four oversized corner chairs and a 54" glass-and-iron table.

NEAR LEFT A washed silver metallic ceiling reflects the rich textures of silks, linens, and velvets, which are complemented by a faux-finished wallpaper.

RIGHT An iron daybed in a fine fabric adds to the profusion of color in this outdoor living area.

More about Baylor Anne and Gail ...

WHAT IS THE HIGHEST COMPLIMENT YOU'VE RECEIVED PROFESSIONALLY?

The greatest compliment, says Baylor Anne, is when a client's friends step inside a newly designed space and say 'this looks just like you,' to the client. Baylor Anne and Gail also remember when another client told them that seeing their finished work was the best day of her life, including her wedding day.

WHAT IS THE BEST PART OF BEING AN INTERIOR DESIGNER?

For Baylor Anne, the chance to express her creativity, coupled with the people she gets to meet make her job wonderful. For Gail, "making people's homes a better surrounding for their families" is hugely satisfying.

IF YOU COULD ELIMINATE ONE DESIGN/ARCHITECTURAL/BUILDING TECHNIQUE FROM THE WORLD, WHAT WOULD IT BE?

Baylor Anne would decree that televisions and mirrors would not ever be placed above mantels. For Gail, white trim would disappear from the vocabulary of design.

BAYLOR BONE INTERIORS
Baylor Anne Bone, Allied Member ASID
Gail C. Cook, Allied Member ASID
248 West Main Street
Hendersonville, TN 37075
615-822-3199

6000 Highway 100, Suite 122
Nashville, TN 37205
615-354-0058
www.baylorboneinteriors.com

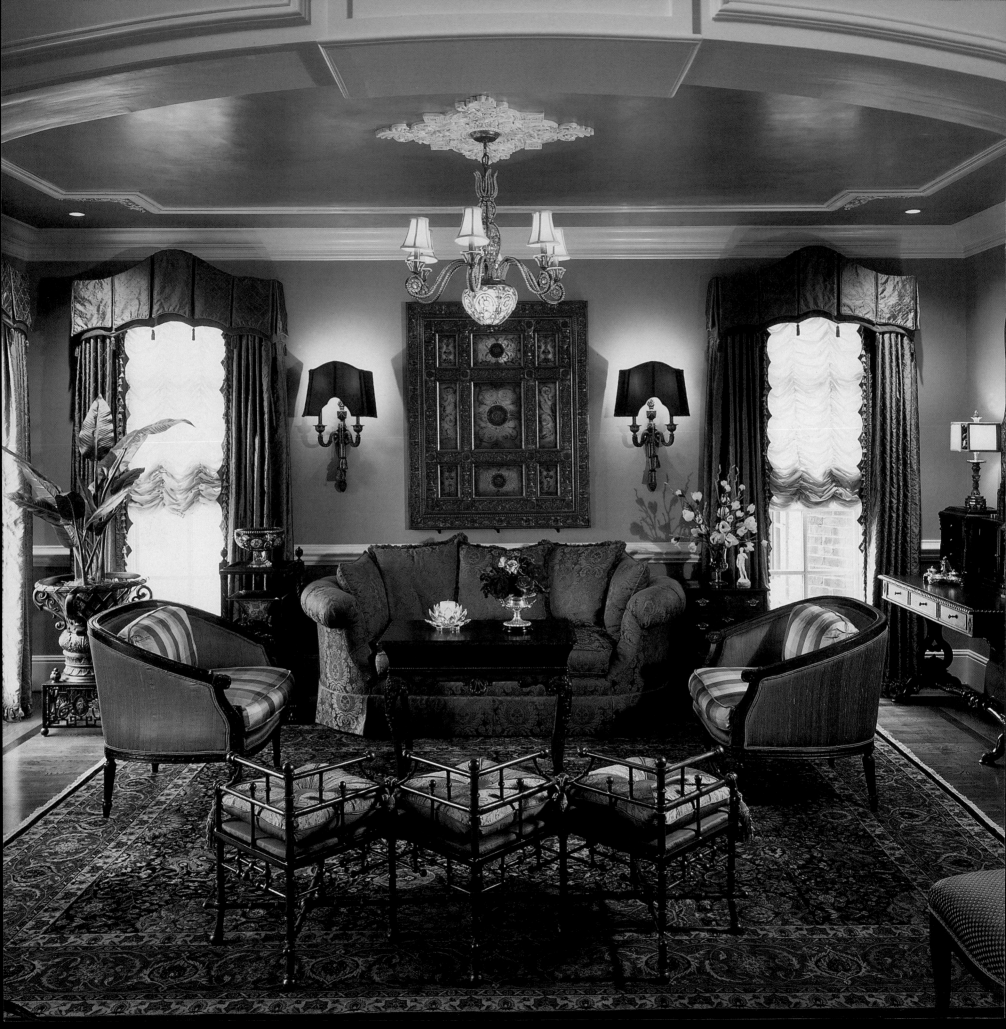

KATHRYN BROADWATER

Interior designer Kathryn Broadwater jokes that she uses her background in psychology every day, but it's true: communication is number one with Kathryn, and her exceptional skills in this area make her a valued asset to clients and subcontractors alike. A designer in Tennessee since 1985, Kathryn founded her business in 1988, although the name New Directions hails from her previous life spent renovating old houses and completing various design projects in California. That invaluable hands-on experience in construction, combined with a creative stint in the garment industry, gives her an upper edge with her design projects. It also makes her particularly adept at bringing people together in cooperation and talking them through a project from start to finish.

New Directions handles both renovations and new construction, although Kathryn notes that a lot of her work involves consulting between the client, their builder and architect as they begin and go through the construction process. "I like the challenge a new project brings to my creative nature, whether it's critiquing a house plan, creating intricate built-ins and trim details, unique drapery treatments or custom furniture. I do a lot of specifying most people either don't know or wouldn't expect from a designer," she says, adding that she usually asks more questions than her clients in order to discern how they really live and what they truly want in their homes. Listening is her greatest

ABOVE The grand dining room in this Brentwood home includes walls hand-painted and textured by Artist Illusions Studio to replicate silk.

LEFT It took a week of labor to glaze, wash and polish the ceiling in the parlor to create a reflective quality that accents a collection of reproduction furnishings and silk fabrics in blues, taupes, and browns.

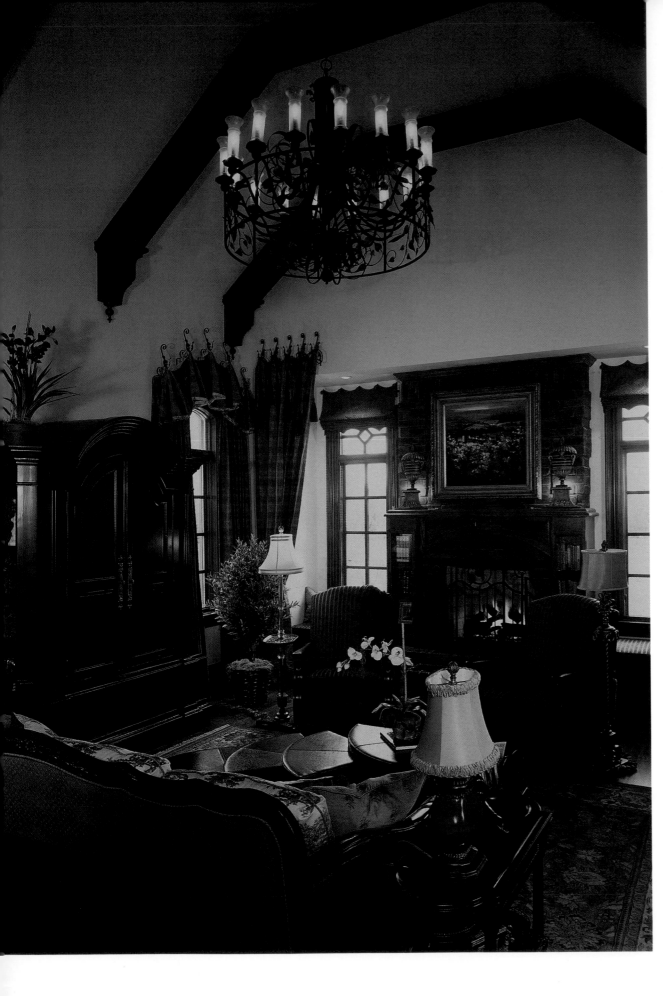

gift, which gives her a creative license to invent environments that express her clients' inner styles.

Although her work is very diverse, Kathryn describes her style as "transitional eclectic," which she defines as a mix of updated traditional and treasured finds, from modern to antiques. " I like counterpoint pieces," she says, referring to a unique opposite style as an eye-catching counterpoint to the rest of the furnishings. She believes they create a more interesting design because they add an unexpected element in keeping with the quality of the rest of the room. "Such as an Art Deco armoire or an unusual, distressed day bed as extra seating in a really traditional room," she explains. It results in visually active spaces that catch the eye yet are still completely functional. "I like to make the design work, even when clients insist to throw something in the mix that doesn't necessarily work. I love a challenge," she says.

LEFT A magnificent Windsor-style iron chandelier four feet in width hangs in the colorful and inviting hearth room off the kitchen. Custom shepherds' hooks hold the draperies under a massive beamed ceiling. Side panels with glass doors, which reveal shelves for collectibles or books, flank the mantel.

BELOW LEFT A Peruvian mahogany coffered ceiling soars above the grand salon, which is dressed in comfortable chenilles, linens and silks. Tonal glazed walls, antique-finished cabinets and a seven-foot trumeau mirror help create a light-filled space. The wall lanterns above the shelves are also seven feet tall.

BELOW RIGHT This study and a hexagonal, two-story conservatory connected to this room were conceived from raw, furniture-grade mahogany purchased by the homeowner. Enough was left over to design additional beams, brackets, and a pair of exceptional inlaid custom serving tables for the living room.

Her designs have brought attention and awards, too, and throughout her career Kathryn has created seven award-winning show houses, numerous model homes and custom homes. Recently, a substantial new Brentwood-area residence was completed in time to open to the public for tours to benefit a charity. Another project was featured on an HGTV Victorian Christmas special, and her interiors and architectural details for the 2003 SunTrust Bank Parade of Homes, a prestigious local showcase of new construction, garnered Best of Show and won nine out of 10 categories for the Peoples' Choice Awards.

ABOVE The home's central hall offers a panoramic view of the grand salon, breakfast banquette, hearth room and back entry. The columns were skimmed with marble dust and hand-polished for an Old-World finish and feel.

FAR RIGHT The homeowners' college-age son enjoys summers at home in a masculine bedroom that features his favorite colors of blue and green, with textured fabrics and rich mahogany furnishings.

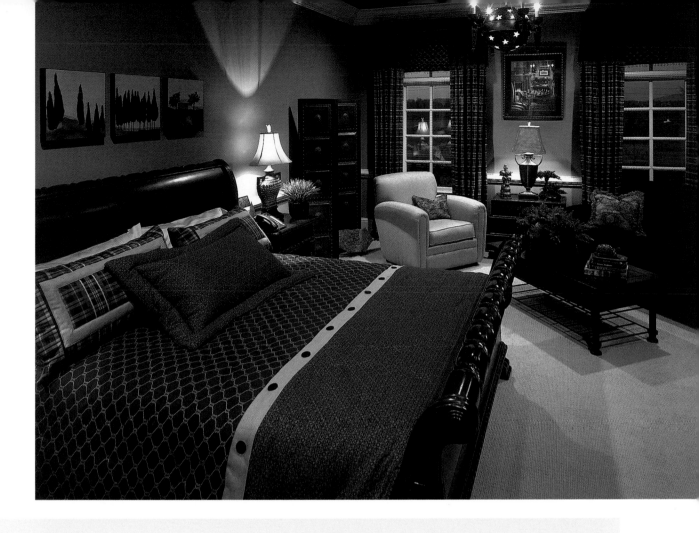

More about Kathryn ...

Kathryn has always been creative and self-motivated, so while she doesn't truly have a mentor in the traditional sense, "I do love Frank Lloyd Wright," she says. "I always flip through the many books I have on his work to inspire me."

For Kathryn, creating environments that her clients haven't even dreamed about is a truly satisfying job.

"I want the client always to feel I created their style and met their needs rather than reflecting my own personal design style," says Kathryn about her approach, which is exceptionally detail-oriented. "I want them to be a strong part of the decision-making. I want all of my projects to be individually suited to each client."

Her philosophy is that we all have different tastes and appeals, but that color palettes, with their psychological effect on mood and well-being, are critical to creating a comfortable home.

When a builder or an architect notes her talent and ability to work well with others on the construction site and praises her positive, "can-do" attitude, Kathryn knows she's done her job. She loves working with her clients and everyone else associated with a project, and her sense of humor helps keep things moving forward in a good "New Direction."

NEW DIRECTIONS
Kathryn Broadwater, Interior Design Society (IDS),
Registered Interior Designer in Tennessee
Brentwood, TN 37027
615-371-9796
FAX 615-370-4294
www.nashvilledesigner.com

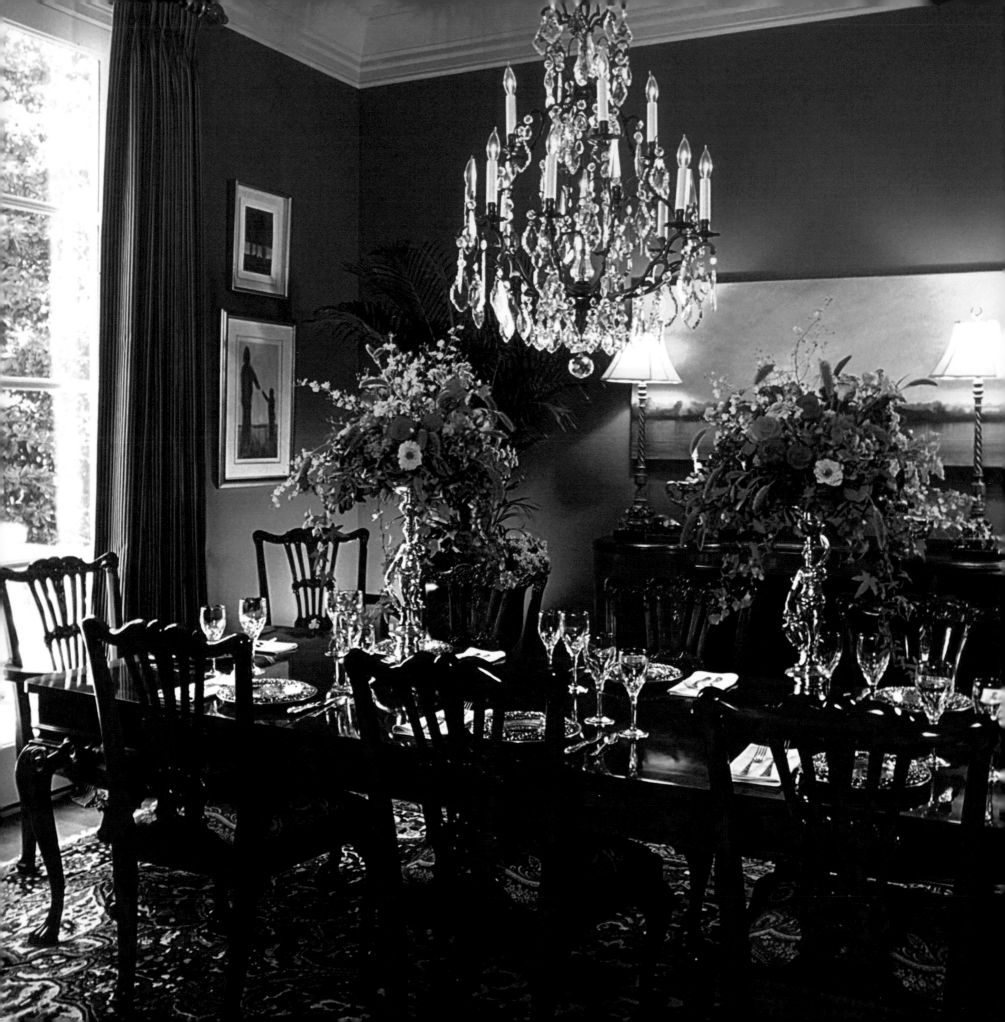

BRADFORD COLLIER

B W COLLIER INC.

ABOVE Rough-hewn beams and hand-toweled stucco add Old-World charm to this contemporary space.
LEFT The dramatic dining room in this award winning home in mid-town Memphis showcases Bradford Collier's architectural and decorative expertise.

If he weren't turning heads as a talented interior designer, Memphis-based Bradford Collier would most certainly be a noted architect. Today, Brad is one of those rare breeds in the design world: he can shift from developing complete floor plans for a large new residence to creating a marvelously furnished master suite down to the last finial. What he offers through his full-service firm is the kind of total design that many busy clients increasingly need. "We can put an entire bidding package together," he says, noting that his clients can not only achieve a clear vision of the design and adornment of their home, but also give them a budget with which to work. "That gives us an edge," he says about how his architectural and engineering background benefits clients considering building or renovating. "We can go into these old houses and we have a sense of what is truly possible," he says. "Also, because of my architectural background, I can add to the beauty and grace of the existing structure."

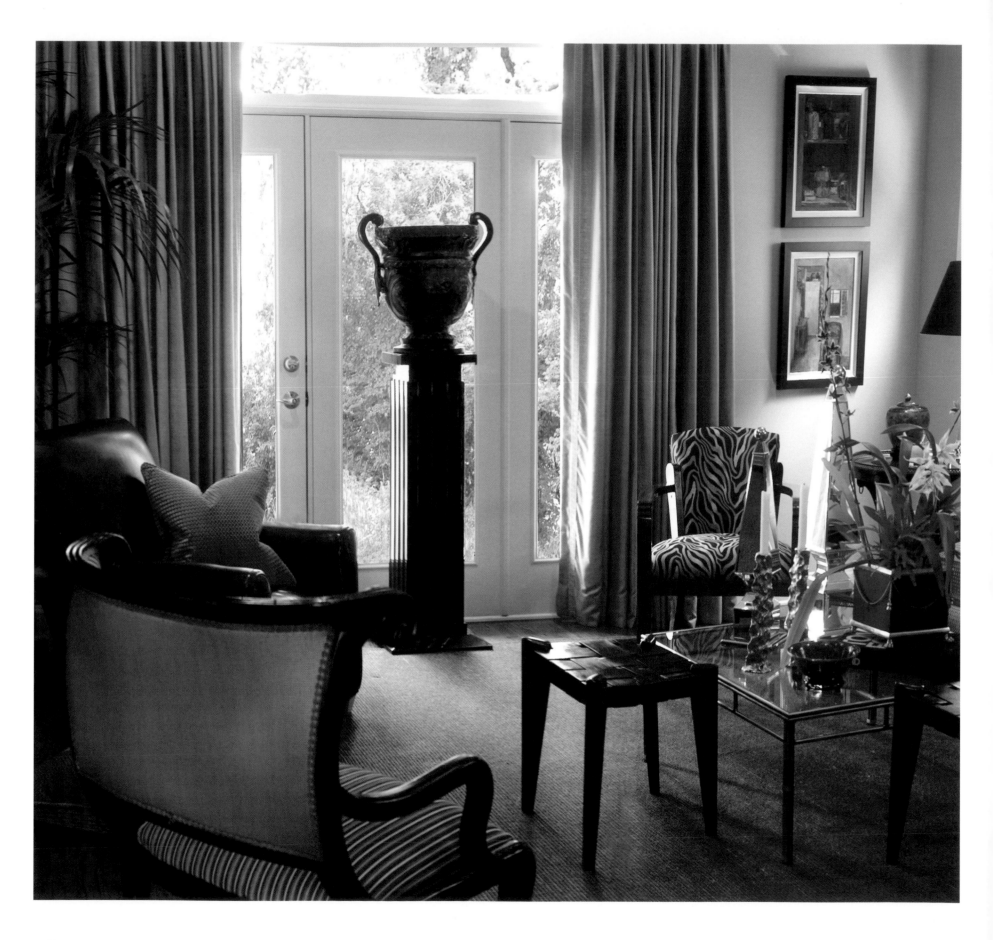

Brad began his lifelong interest in design as a child, and indeed at 14, he worked with his engineer father and designed the home where his parents still live. After finishing his education, he worked with various designers and then founded his own firm five years ago. Known for its sophisticated interiors with a relaxed feel, B W Collier is urbane in aesthetic but also quite practical. "I love working with different textures and rich colors to make rooms sumptuous, beautiful and comfortable. What we do is very polished, not all of it is formal," he explains. "A lot of our clients have children, so we have to marry polish with practical."

Filled with graceful antiques, the new showroom at B W Collier is filled with a diverse variety of objects Brad chooses

LEFT Fabulous period Art-Deco pieces and other rare antiques contribute to the clean simplicity in this elegant room.
ABOVE This dining room focuses around a painting by the owner's friend.

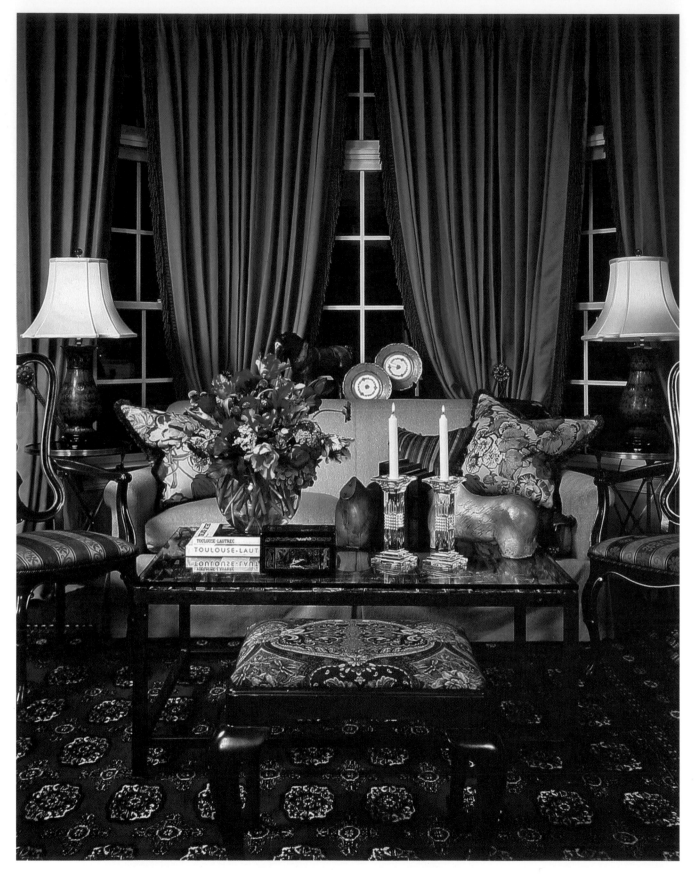

ABOVE This cozy sitting room with a bay window is enveloped in Scalamandré's saffron Belgian linen.
RIGHT The backdrop for this dramatic living room is a beautiful woven leopard chenille by B. Berger.

More about Brad ...

DESCRIBE YOUR STYLE OR DESIGN PREFERENCES

Brad prefers a more urban aesthetic that is sophisticated, not rustic or country. "There is a polish to everything I do," he says.

WHAT IS THE HIGHEST COMPLIMENT YOU'VE RECEIVED PROFESSIONALLY?

"A client who has gone through several other designers finally has begun to do his entire home (a historic estate) with us," says Brad. Another major accolade came when the exterior of a house he designed from the ground up won "Best New Construction in a Historic District," as part of an annual competition by the Memphis Heritage Society.

WHAT SEPARATES YOU FROM YOUR COMPETITION?

Brad's extensive background in architecture and engineering allows him to provide complete design services, from creating plans in-house from scratch and planning large-scale renovations to the final details of decorating. His firm also includes an in-house drapery workroom and a master upholsterer, so clients benefit from a quick turnaround and an extensive menu of services if they so desire.

B W COLLIER INC.
Bradford Collier, Allied Member, ASID
3092 Poplar Avenue, Suite 16
Memphis, TN 38111
901-324-4150
FAX 901-324-0878

for their superb lines and functionality, such as a pair of beautiful white onyx square lamps with a contemporary flair. "Memphis was an incredibly traditional city just 10 years ago, and now people are kind of loosening up a little and it's fun," he says. "I absolutely love what I'm doing."

KENNETH W. CUMMINS

KENNETH CUMMINS INTERIOR DESIGN

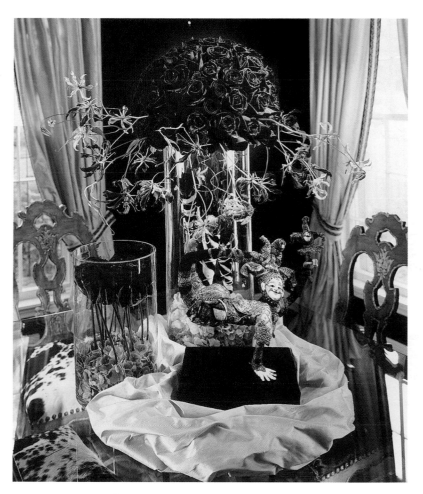

ABOVE Set for a party, wood roses, exotic lilies and hydrangeas provide a colorful backdrop for California artist Barbara Chapman's "Jester" sculpture in this elegant Memphis dining room.

LEFT The neutral palette of this study provides the opportunity to paint the room with objects and color as with this original painting by Peter Opheim. The warmth of the sun through the window adds a cozy touch, making it the perfect place to curl up with your favorite book. Chairs from Minton Spidell. Pillow fabric from Groundworks.

Kenneth Cummins may be at home in the pages of *Veranda* magazine for a sophisticated Memphis house with a French flair, but he's just as at home handling a simple beach cottage or a refined condominium. "I do new construction, renovations, single spaces, pretty much the full gamut," says the friendly Mississippi native, who opened his own firm in 1993 and has since worked across Tennessee and the Southeast as well as designed vacation homes in Colorado and Utah. "I think you can have a beautiful home but it can also be comfortable. I think the days of 'don't touch' rooms are gone." In that sense, the main residences he designs are just as relaxed and comfortable as the getaway homes.

Explaining that his job is to fine-tune his clients' wants and desires, Kenneth works in a variety of styles, from very contemporary to very traditional, and he excels at both. "I do like to mix a few contemporary things into a room if I can," he says, noting that he personally finds contemporary paintings compelling, and he likes to use contemporary art in his projects if they work with the setting and the client's wishes. Kenneth has accumulated a substantial personal collection of regional,

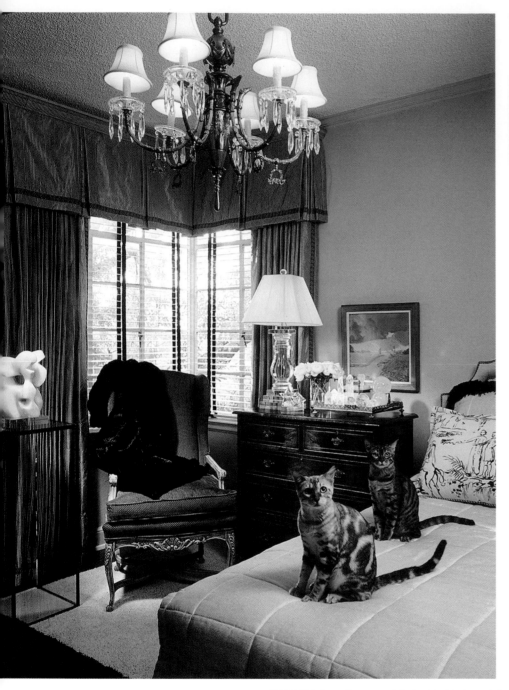

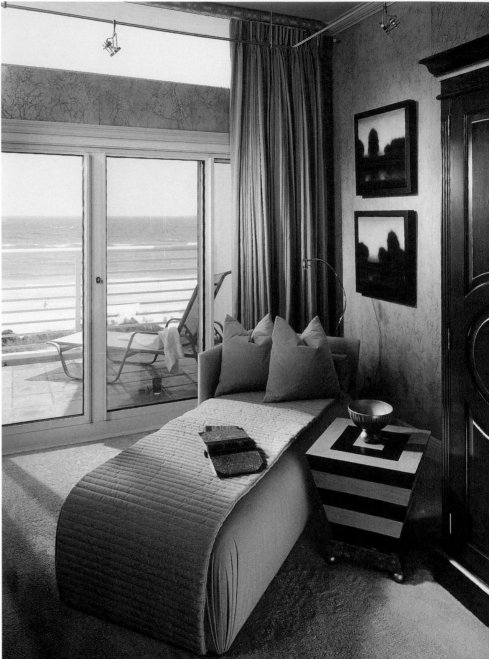

TOP LEFT Bengal cats guard the bed in this dramatic bedroom. Chair fabric by Osbourne & Little. Painting by Mississippi artist Gerald Deloach. Sculpture by Oregon artist Julie Warren Conn.

TOP RIGHT John Saladino's spiral chaise, along with "Earth and Sky 410" and Earth and Sky 411" by Barry Masteller, provide a wonderful respite to read while listening to the surf and enjoying the cool breeze off the Gulf in this Florida master bedroom.

LEFT This private office, with an oversized leather club chair and leather door panels with nail-head details is washed in soft light, which is reflected in the faux-finished walls. "Cigars" by Razzia and marble sculpture by Julie Warren Conn further distinguish the room. The colorful armchair fabric is from Groundworks.

national and international art and is always looking for pieces that "speak to him." His collection includes mostly framed pieces with a few sculptures, both large and small, thrown in for good measure.

While in the past Kenneth has owned several retail locations, these days his full-service design studio solely concentrates on interior design. "A relationship with a designer is a very personal thing," says Kenneth, who works hard to make sure he and his clients are on the same page when it comes to a project—he's very keen that it be a joint effort. " You have to be a good listener and you really have to know their lifestyle," he says about his approach. He enjoys people, and that means that interior design is not only his vocation but his avocation as well. "I'm very fortunate to do what I do because I completely enjoy it," he says.

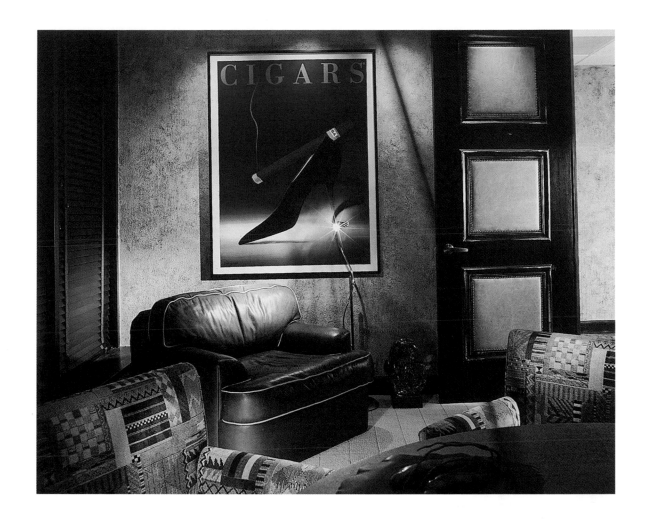

More about Ken ...

WHAT IS THE HIGHEST COMPLIMENT YOU'VE RECEIVED PROFESSIONALLY?

Ken's clients heap praise on him for his work and he's also been nationally published in magazines over the years, but he was thrilled to win Designer of the Year in 2001 by the Tennessee chapter of the American Society of Interior Designers (ASID). Formerly president of the Tennessee chapter of ASID, he followed up his win by taking home the Kenneth Kimbrough Award of Excellence, also through ASID, in 2002.

WHAT HAS BEEN YOUR MOST CHALLENGING PROJECT?

"My most challenging project has been the rehabilitation of a 1927 neoclassical home in a historical neighborhood. The home was designed and built as one of the first speculative ventures in an area that would become known as Central Gardens. Unique proportions and matchbook symmetry made this large family home suitable for a two-family conversion after World War II. Now lovingly restored to serve for the next 100 years with state-of-the-art mechanical and electrical systems, the floor plan has been updated for today's lifestyle."

FROM WHERE DO YOU DRAW YOUR INSPIRATION?

Travel is one of Ken's many sources of inspiration. "I find it fascinating to tour historical European chateaux, country homes and even small flats. I also enjoy touring renowned gardens throughout this country, as well as in Canada and Europe. From these many and varied sources, I find interesting colors, textures and design concepts that are readily adaptable to our current living environments."

KENNETH CUMMINS INTERIOR DESIGN
Kenneth W. Cummins, ASID
1503 Union Avenue, Suite 203
Memphis, TN 38104
901-278-1987
FAX 901-278-2460

GWEN DRISCOLL

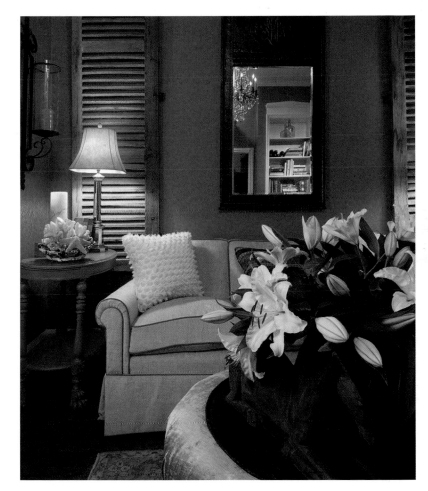

ABOVE An antique Oushak rug and Clarence House wallpaper contribute to the color and warmth that envelops readers in this comfortable library, which is perfect for reading a book or enjoying a lively conversation. Rustic antique French shutters and a custom painted mirror set off vintage chrome column lamps.

LEFT This elegant and sophisticated master bedroom suite is an oasis and retreat for the homeowner. The antique English Regency-style walnut Bible stand and Dutch burl walnut desk are paired with vintage lamps and bedding from Leontine Linens.

The idea of home has always appealed to Memphis-based Gwen Driscoll, a dedicated young designer known for her classic, traditional interiors that always include a hip twist, such as an unexpected piece of glass. Growing up in Kentucky and Tennessee, Gwen defines herself as, "the kid who loved to go to historic homes." After a decade in the fundraising/marketing business, she decided to pursue her interest in history and follow her passion for all things design-related. She started working for a local designer and launched Gwen Driscoll Designs in 2003.

History has continued to influence Gwen. "There's something incredibly grounding about the history of our country," she says, noting that while traditional interiors have been a strong influence, she doesn't like anything staid or boring. "It can't just be straight vanilla," she explains. "Give me a rustic cabin and I'm going to set the table with crystal and white bone china. I'm not going to set it with pewter and wood chargers," she says. "I really do live by the rule that opposites attract. It's more about using beautiful things in a casual way." She's also serious when it comes to forging long-term relationships and focusing on pleasing the client. "I want everything I work on to say, 'this is the best it could be and my heart and soul are in it.'"

GWEN DRISCOLL DESIGNS
Gwen Driscoll
130 North Perkins Road
Memphis, TN 38117
901-767-1340
FAX 901-767-1364

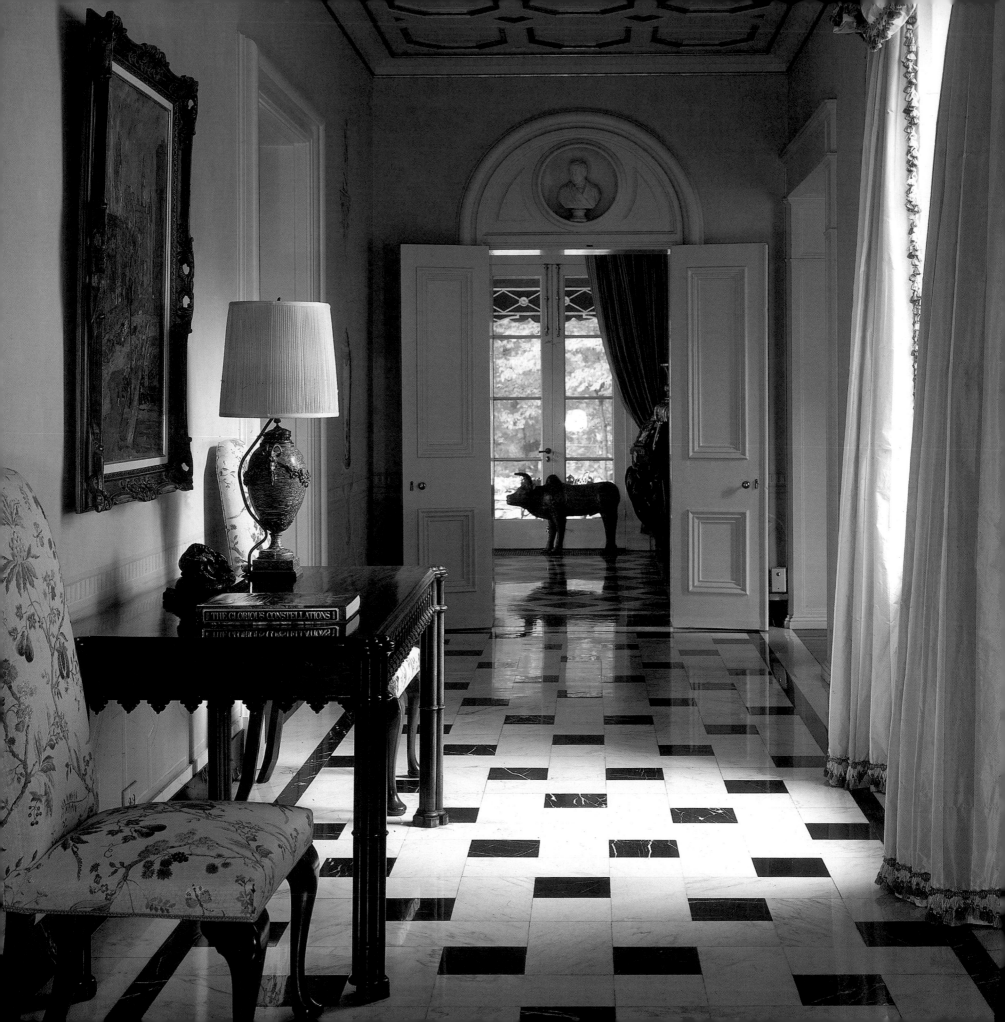

JOE ERWIN, MARY FOLLIN & DAVID WHITE

ERWIN, FOLLIN & WHITE

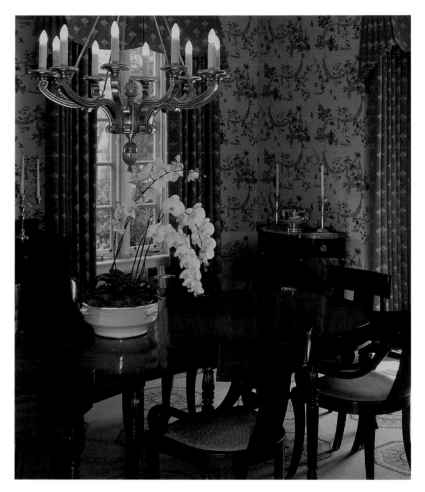

ABOVE An elegant dining room featuring Nancy Corzine chairs, a custom Hokanson area rug and Boussac fabric is punctuated with a Louis XVI dessert table.

LEFT A view through the vestibule at "Watersmeet" is a fine example of classical architecture and elegance.

Founded in 1984, Erwin & White and Mary Follin Design became Erwin, Follin & White, a design group that consists of principal designers and Nashville natives Joe Erwin, Mary Follin, and David White. Along with two key staff members and several other designers, they are a full-service firm offering interior design and architectural consultation, in both residential and commercial projects not only in Tennessee but also throughout the Southeast. All three principal designers are distinguished veterans in the world of interior design. In 2003, Joe was elected to the Design Hall of Fame at the Atlanta Decorative Arts Center (ADAC), which is given to only one individual from the Southeast each year. Mary studied architecture and art history at Tulane University, and Joe and David were both certified in design at the prestigious New York School of Interior Design.

Famed for their sophisticated yet timeless style and attention to detail, the firm is not afraid to step away from traditional design. For the 2004 Junior League of Nashville Decorators' Show House, Erwin, Follin & White's

smart master bedroom, with its inspiration taken from 1940s French Moderne, was a head-turner. Whether working on a home from the architectural inception to completion or within an existing room, the team at Erwin, Follin & White loves to combine beautiful antiques with custom furniture and elegant textiles to create warm, functional rooms that are the perfect setting for their clients. "Our job is to express our client's taste and style," says Mary. "We create interesting environments that our clients will share with their friends and families."

Believing that bigger is not always better and that design succeeds when the scale is correct, Mary, David and Joe begin a project by focusing on the interior architecture. "The quality of the project is what

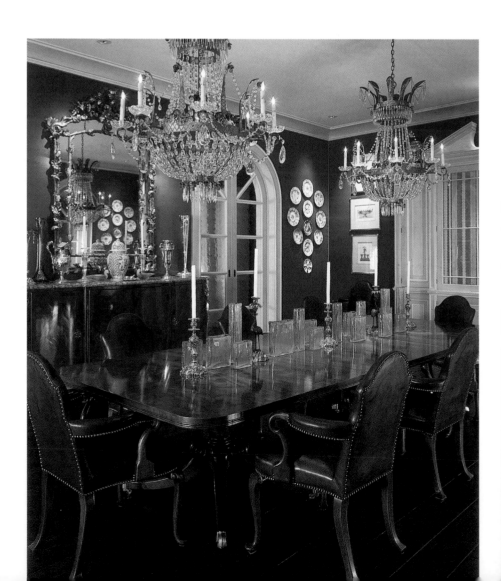

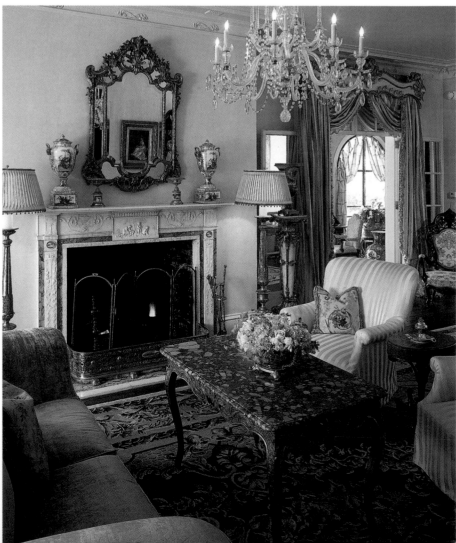

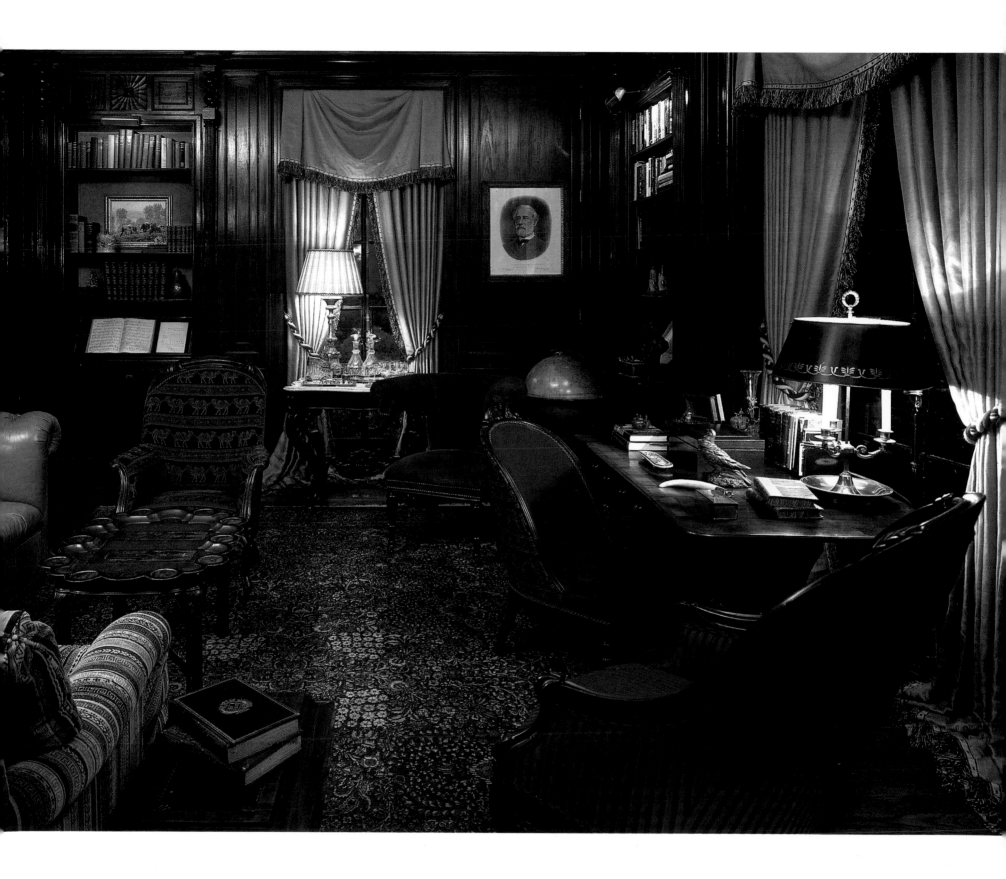

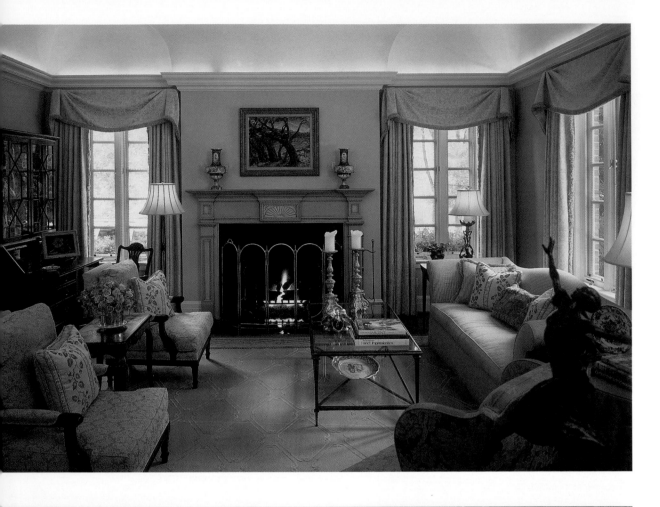

matters," explains Mary, "whether it is one room or an entire home, it needs to have appropriate proportions." Taking their cues from their clients, the trio is exceptionally skilled as listeners. "You need to pay close attention to clients," says David, "I ask a lot of questions to gain insight into clients' lifestyles and preferences. You have to read between the lines." Joe believes that a person's color palette is the expression of their personality. "This is where interior decoration begins," he quips.

Design challenges bring out the best of the firm's ability to refine a project. With a base of trusting clients, a relaxed sense of humor and a reverence for creating beautiful, yet functional rooms for real people in which to live, each designer at Erwin, Follin & White listens to his clients and creates settings that they can't resist, no matter the style.

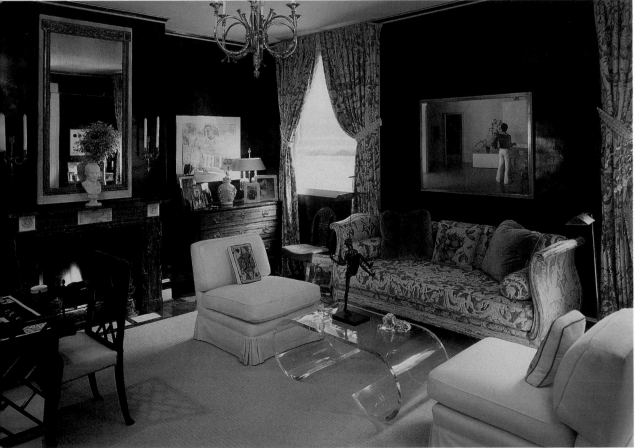

TOP LEFT The simple yet sophisticated fabrics and furnishings of this living room reflect the understated elegance of this home.

LEFT Chocolate lacquer walls and the use of Fortuny fabrics give a timeless look to the card room at "Brookhouse".

RIGHT The carved and painted Santos of Saint John presides over this cheerful sunroom at "Longleat."

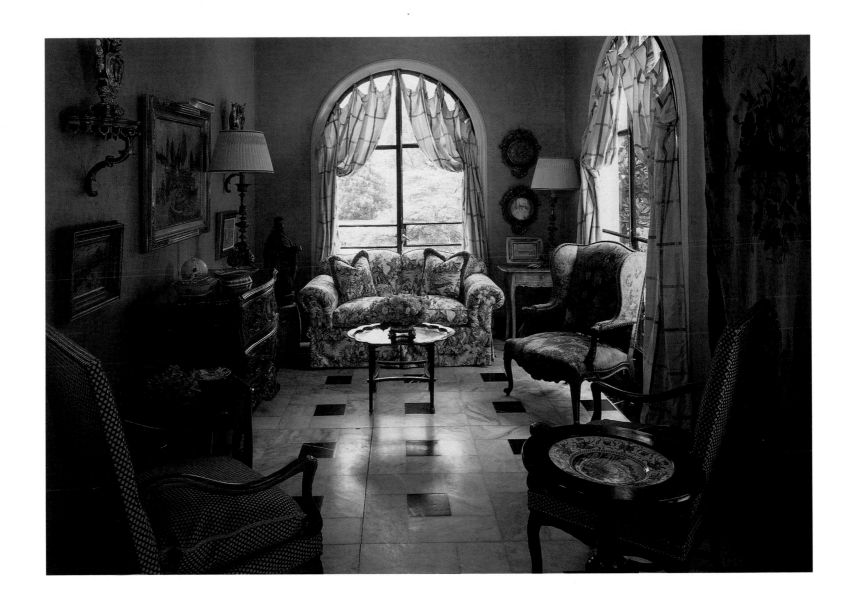

More about Joe, Mary and David ...

NAME ONE THING MOST PEOPLE DON'T KNOW ABOUT YOU.

"We are all great cooks and we love to entertain," says David about himself, Mary and Joe. "Like our work, it is a combination of good elements and joie de vivre."

WHAT IS THE BEST PART OF BEING AN INTERIOR DESIGNER?

"The fact that we get to express our creativity on a daily basis," says Mary.

WHAT IS THE HIGHEST COMPLIMENT YOU'VE RECEIVED PROFESSIONALLY?

"Thank you."

WHAT ONE ELEMENT OF STYLE OR PHILOSOPHY HAVE YOU STAYED WITH OVER THE YEARS THAT STILL WORKS TODAY?

"Put the sofa on the long wall," says David.

WHAT COLOR BEST DESCRIBES YOU AND WHY?

"Green," says Mary. "In nature there are many shades of green just as we work in many styles of design."

JOE ERWIN, MARY FOLLIN & DAVID WHITE
5825 Old Harding Road
Nashville, TN 37205
615-356-8090
FAX 615-356-8092

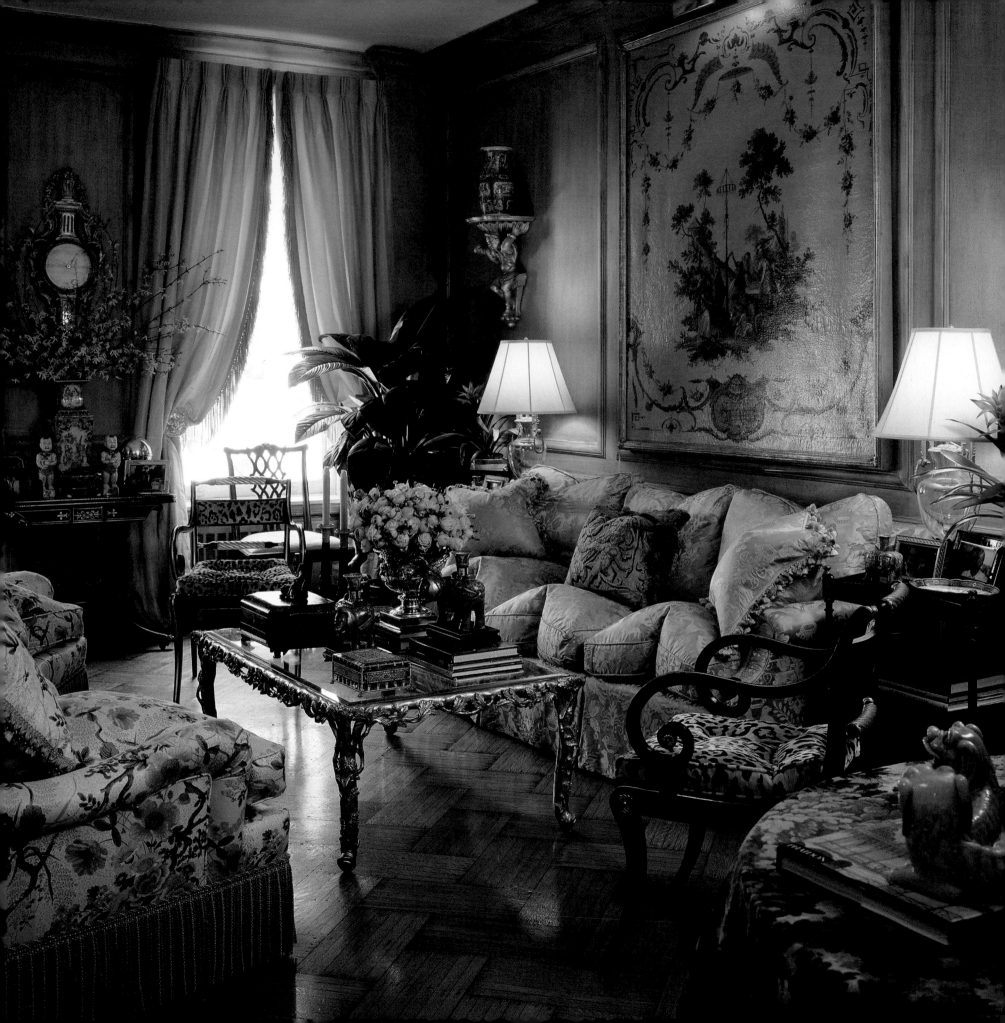

WILLIAM R. EUBANKS

WILLIAM R. EUBANKS INTERIOR DESIGN, INC.

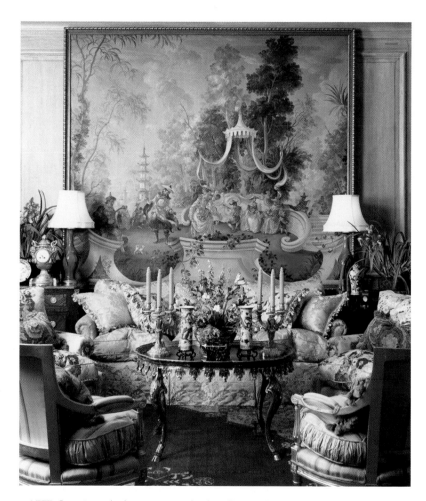

LEFT Georgian style drawing room in bright yellows and greens. Yellow gold Scalamandré silk on downfilled sofa. 18th-century oil on canvas panel over the sofa in the manner of Pillement. Club chairs in Colefax and Fowler "Tree Poppy" chintz. Pair of Edwardian Giltwood Manchurian-Figured Wall Brackets flanking painting. Louis XV Giltwood Barometer over Regency Mahogany Games Table, ca. 1810. Regency Ebonised Armchairs with Cheetah velvet upholstery, ca. 1810.

ABOVE Chinoiserie style drawing room centered around large oil on canvas of "fête champêtre" in the Chinese taste, early 20th century. Downfilled sofa covered in Scalamandré silk. Pair of period Louis XVI giltwood fauteuils covered in Clarence House silk stripe. Pair of Chinese export turquoise vase lamps from the estate of Lady Mary Rothermere, 19th century Italian style cocktail table from Brunschwig and Fils.

Veteran award-winning interior designer William R. Eubanks may have spread his interior design and antiques business to New York and Palm Beach, but his original company remains a fixture in his Tennessee hometown of Memphis. Known for his unerring eye for remarkable 17th and 18th century antiques, rooms imbued with an unmistakable continental grace and use of rich, textured fabrics and tapestries, Bill is a master of creating a collected look and, indeed, of creating collections for his firm's clients. "We like a room to look as if it's always been there," he says. "We love to have a look that is easy to settle into and looks just as good 20 years from now as the day we installed it." That doesn't mean, however, that he only works on traditionally-inspired spaces. What most people don't know is that in the 1970s his showroom was highly contemporary. "This is what time has done," quips Bill about the antiques he currently carries and the old-world look that he does so well. "It is a passion and I love it, but I like all aspects

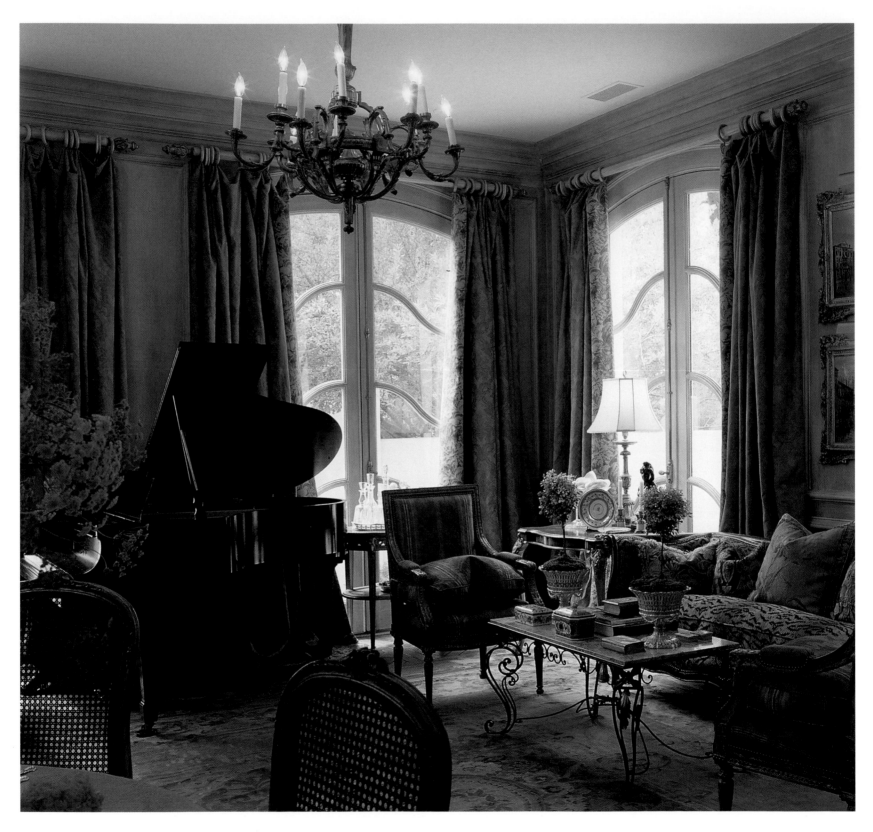

ABOVE French salon in the 18ᵗʰ century taste. Pair of Louis XVI style fauteuils. Louis XV style canapé. Late 18ᵗʰ-century aubusson carpet.

of design," he says, "and we still love contemporary design...it's nice to be able to have a variety in what we do. All of our clients are individual, and when that front door opens, we should feel the energy of our clients, not William R. Eubanks Interior Design."

With a worldwide reach when it comes to projects, Bill's firm excels in taking exceptional care of those clients, too. Besides the main location in Memphis, a 3,500-square-foot, sunlit space in the heart of Palm Beach includes a library, showroom and office with a full design staff. When

BELOW LEFT Early 18th century style European bedroom decorated around six panel Anglo-Dutch leather screen painted with various types of birds in the manner of Hondius, ca. 1710. Charles II black lacquered cabinet on giltwood stand, ca. 1685 with early 19th century Chinese export blue and white baluster vase on top. George II walnut sidechair with Clarence House green silk (one of a pair) once belonged to Edward VIII when Prince of Wales. One of a pair of Dutch red lacquered sidechairs, ca. 1710, once belonging to Gloria Vanderbilt. Regence style bronze doré chandelier, 19th century.

BELOW RIGHT Bedhangings and spread in Clarence House silk damask with red, green, and crème inner lining. 18th century Dutch landscape over headboard. Early 19th century large Canton vase on Schumacher custom carpet. Fortuny upholstered George II armchair at desk.

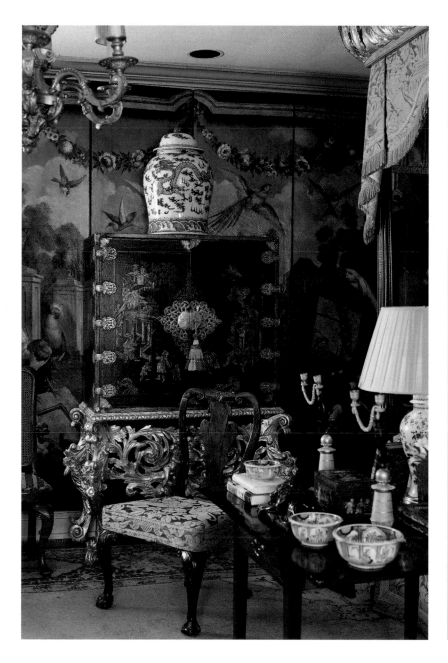

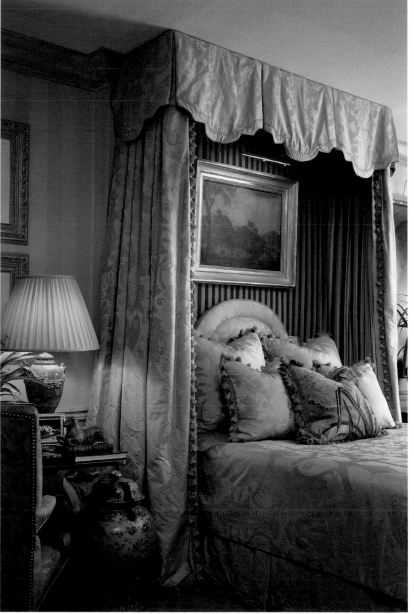

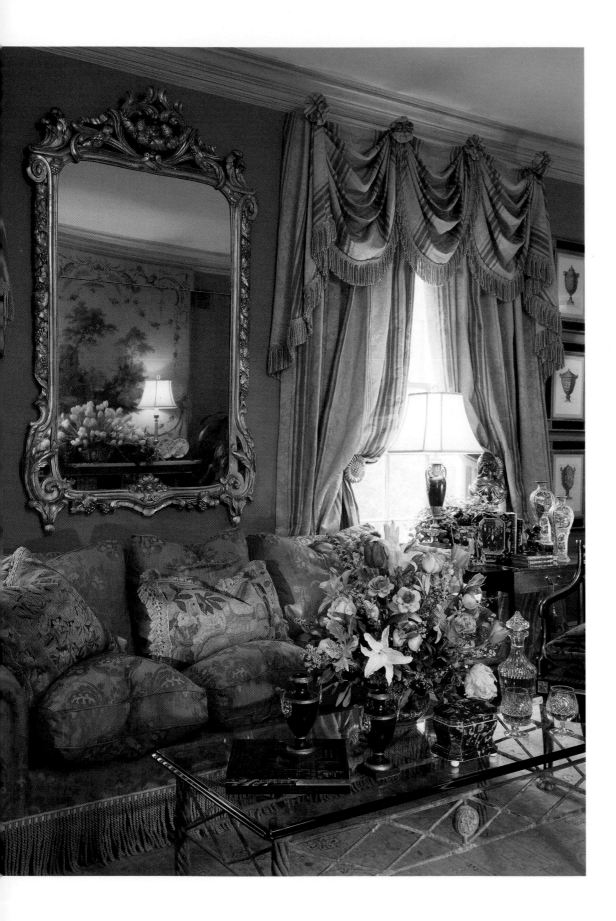

the company found itself working increasingly on the upper East Coast, an office was established in New York. Mitch Brown, vice president of design and showrooms for the firm, is involved both on the design side and with sourcing antiques and styling the showrooms.

A thriving business in its own right, the antiques side of William R. Eubanks Interior Design began in Memphis and spread to Palm Beach in 1995, as the firm found itself completing more and more projects across Florida. Bill remembers sage advice he received from fellow antiquarian and friend Kenneth Neame, a London-based designer, who urged him to have an antiques business alongside his interior design business. "Once you develop a passion for antiques, it's like gambling," says Bill, who enjoys searching for unique pieces across England, Spain, Portugal, and France, just to name a few places. "We are always looking for new and different ideas," he says, noting that travel is a critical, constant education for designers. Since falling in love with the English countryside years ago, Bill continues to be a regular visitor and has been profoundly influenced by the way the English live with gorgeous objects

LEFT Continental drawing room designed around Louis XV period giltwood mirror. Downfilled sofa covered in coral silk damask from Scalamandré with 17th century Flemish tapestry cushions. Draperies in silk stripe from Clarence House. Mirror reflects 18th century French oil on canvas in the manner of Pillement. Framed antique engravings flank both windows.

RIGHT 17th century oak paneled dining room imported from England. Gold silk damask draperies and trim from Christopher Hyland. Set of twelve Regency ebonised dining armchairs with classical scenes of children playing, ca. 1810. Provenance: Lady Nancy Astor. Antique Serape Heriz rug, 19th century. 17th century British portraits. Pair of 17th century Franco-Flemish armchairs with original upholstery. Early 19th century porcelain from Coalport, service made for the Marquess of Hertford.

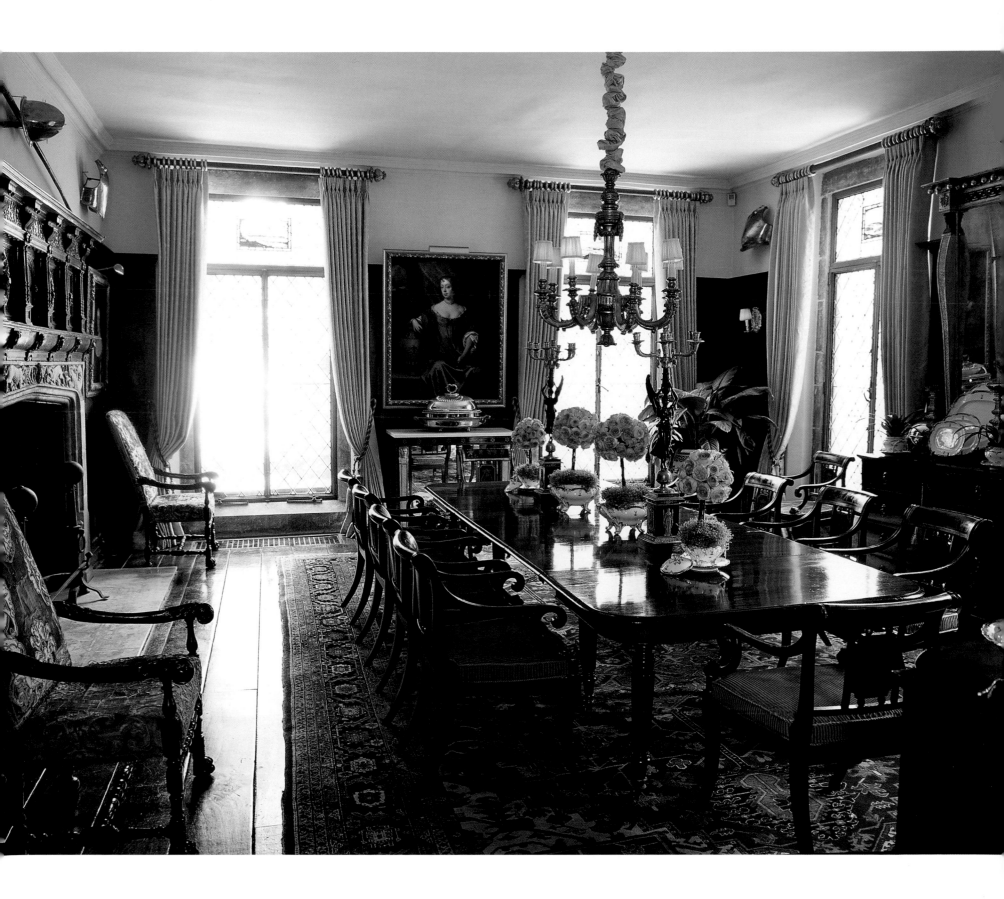

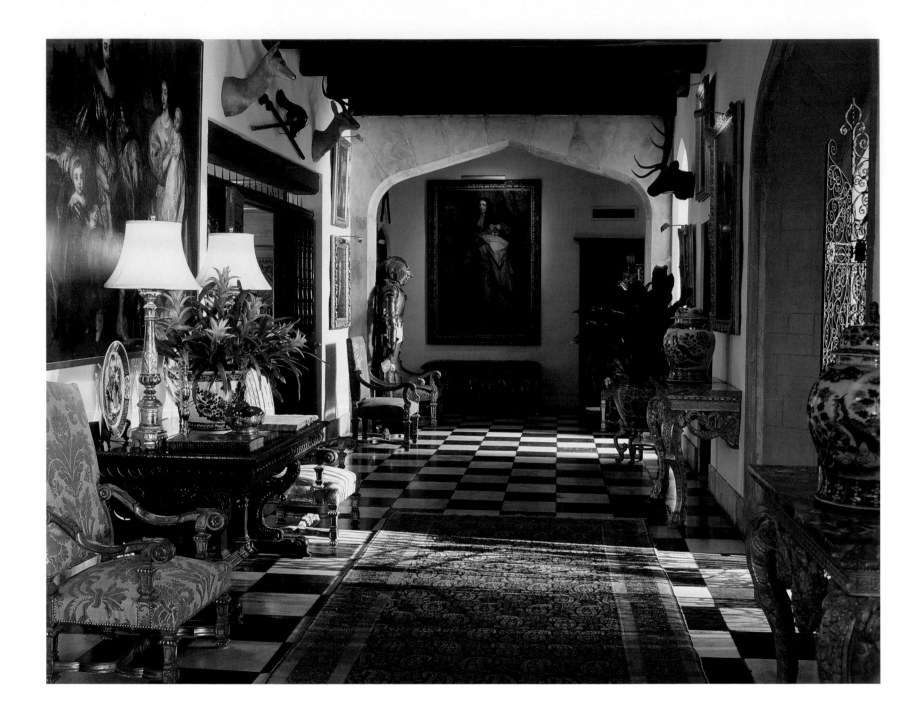

from all eras. Regardless of the destination, however, he believes that "the more we travel, the more we pursue," he says. "It takes us to worlds we would never go otherwise."

With 30 different projects ongoing at any given time, Bill finds joy in the quest for fantastic finds. "Every day brings something new, and that's the beauty of the design business," he says. At the end of the day, it is the connection with the client that truly matters. When a New York client finally saw her apartment on 5th Avenue, she declared that she had never been so happy. "She said 'You've been inside my head,'" recalls Bill. "When a client feels that way, we know we've been successful with what we do. My greatest happiness is experiencing the joy of a pleased client at the end of a project."

More about Bill ...

WHAT IS THE BEST PART OF BEING AN INTERIOR DESIGNER?

While Bill is driven to create beautiful interiors and he loves finding gorgeous objects, "the aspect of my work I prize most is sharing time with my clients, who, as a group, have an almost unlimited array of life experiences," he says, noting that they often become close friends.

NAME ONE THING MOST PEOPLE DON'T KNOW ABOUT YOU.

"I love people and am gregarious," says Bill, "however most people do not know that I am actually quite shy." Also, there's a persistent false rumor that Bill designed the famed Jungle Room at Graceland, Elvis' home in Memphis. While Bill, as a young designer in the 1970s with an all-contemporary showroom at the time, did complete several rooms at Graceland, "Elvis did that one himself," says Bill, who also developed a master plan for the house that was never completely realized. Still, the experience was wonderful, and "we did one of the first media rooms in the country," he says about Elvis' media room.

WHAT COLOR BEST DESCRIBES YOU AND WHY?

Red is Bill's favorite color because it gives vitality and zing to one's surroundings, and it makes any space more exciting. "Every room needs a touch of red," he says.

WHAT PERSONAL INDULGENCE DO YOU SPEND THE MOST MONEY ON?

When he's working, Bill and company vice president Mitch Brown are often traveling to see clients or purchasing antiques abroad. Whenever possible, they enjoy fabulous food and great wine on the road. "These are my personal pleasures away from home," says Bill. "When I am not working, my greatest indulgence is travel. Although I frequently work while I am in England and France, I enjoy those countries and many other destinations in my personal travel."

DESCRIBE YOUR STYLE OR DESIGN PREFERENCES

"I have a preference for 17th and 18th century continental and English design, but I enjoy working in all periods," says Bill. To wit: he recently finished a sleek and modern seaside residence.

WILLIAM R. EUBANKS INTERIOR DESIGN, INC.
William R. Eubanks, Allied Member, ASID, Associate Member, IIDA, Professional Member of the Institute of Classical Architecture and Classical America, Member of Shelter Interiors Design Alliance Advisory Board, Associate Member of the International Interior Design Association
David Mitchell Brown, Vice-President of Design and Showrooms
Memphis, TN 38112
901-452-6975
www.williamreubanks.com

WILLIAM R. EUBANKS, INC.
40 East 63rd Street, Suite 2
New York, NY 10021
212-753-1842

WILLIAM R. EUBANKS, INC.
400 Hibiscus Avenue
Palm Beach, FL 33480
561-805-9335

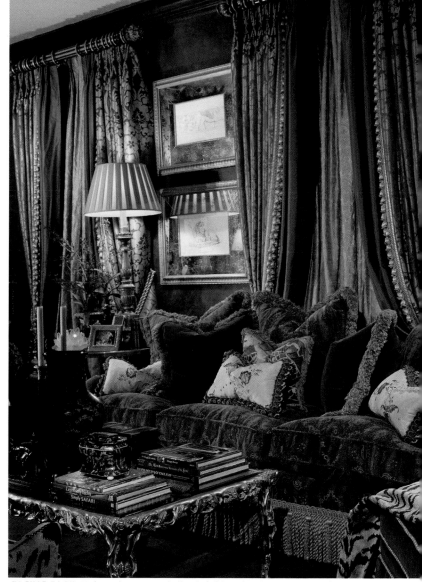

FACING PAGE Tudor style entrance hall with full-length 17th century portrait of Rupert of the Rhine from the school of Sir Godfrey Kneller hangs over 16th century carved giltwood Italian cassone. Suit of armor is Italian. Renaissance style oak entrance hall center table with Louis XIV period leather bound books. Blue and white Chinese export porcelain is early 19th century. Antique black and white marble floor imported from England.

ABOVE Silk draperies and trim, velvet downfilled sofa, and tiger velvet upholstery and throw from Christopher Hyland. Giltwood treeform cocktail table in the manner of Sir Thomas Johnson. Set of six mirrored antique engravings.

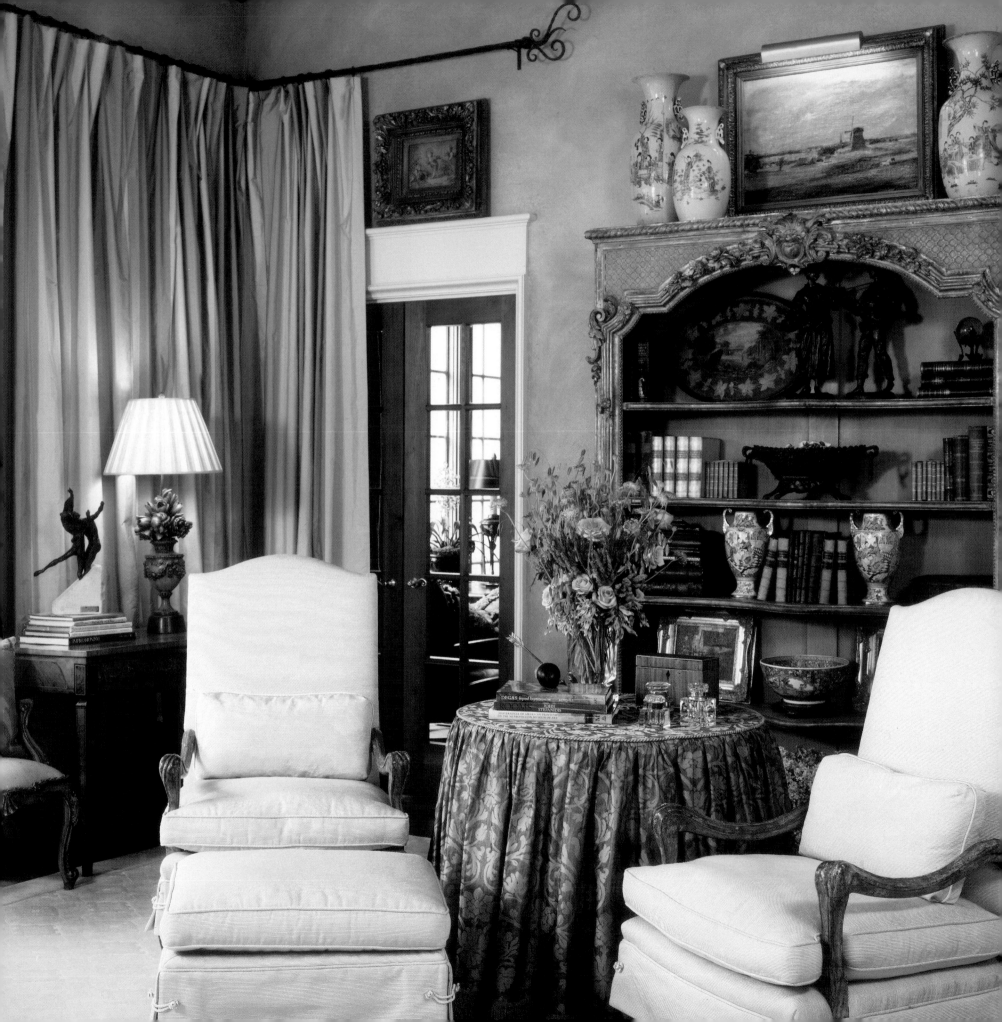

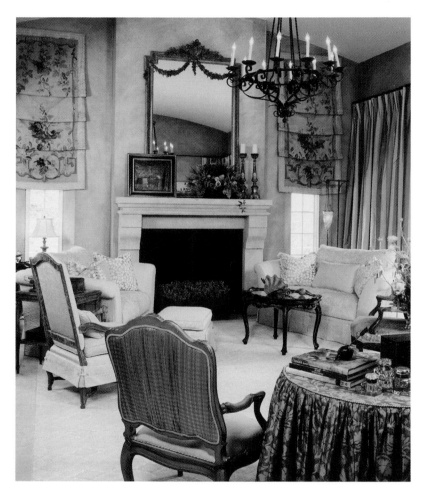

N ashville-based interior designer Landy Gardner has steadily carved out a highly successful design philosophy and work ethic that has proven to be a mainstay throughout his 26 year career as a designer. Through purposeful and artful creativity Landy's projects range in inspiration from sleek contemporary to old-world European in style. His attention to detail and ability to engage each client's design needs and wishes are of the utmost importance to him and the firm he began in 1990 after working for many years under the tutelage of noted Nashville designer, Bill Hamilton. Landy says quality and crafts-manship are what he is most particular about. "I love so many different styles, and I run the whole gamut as long as the quality is there."

Growing up in a family with a flair for the artistic, Landy developed a creative style and love for beautiful and interesting things as a child. While working in various positions in the design trade as a young man, and even traveling abroad to study art history in Europe, he still thought his calling would be in the world of science. He earned a degree in biological science and chemistry and planned to enter dental school. While waiting for an opening at a school in Nashville, Tennessee, Landy started a small design shop in Franklin to make ends meet. From there, he never looked back. A success from the beginning, it became apparent the design world was where he thrived.

When asked what separates Landy from his competition he says, "I don't think I am limited to any one style. I have as many clients whose tastes lean toward contemporary as I do traditional clients. The goal is to never have someone define my 'look.' There is a level of quality I want to maintain no matter what the clients' personal tastes." Landy says that a wonderful compliment to his career is the thrill of being published in notable magazines such as Veranda, Southern Accents,

ABOVE Antique Aubusson runners were made into window shades in the formal Living Room. A French mirror is featured above the fireplace.

LEFT An antique Trumeau mirror frame converted to a bookcase is the highlight of an inti-mate sitting area in the Living Room. Custom silk draperies and a double-layered custom table skirt add interest to the neutral upholstery in the room.

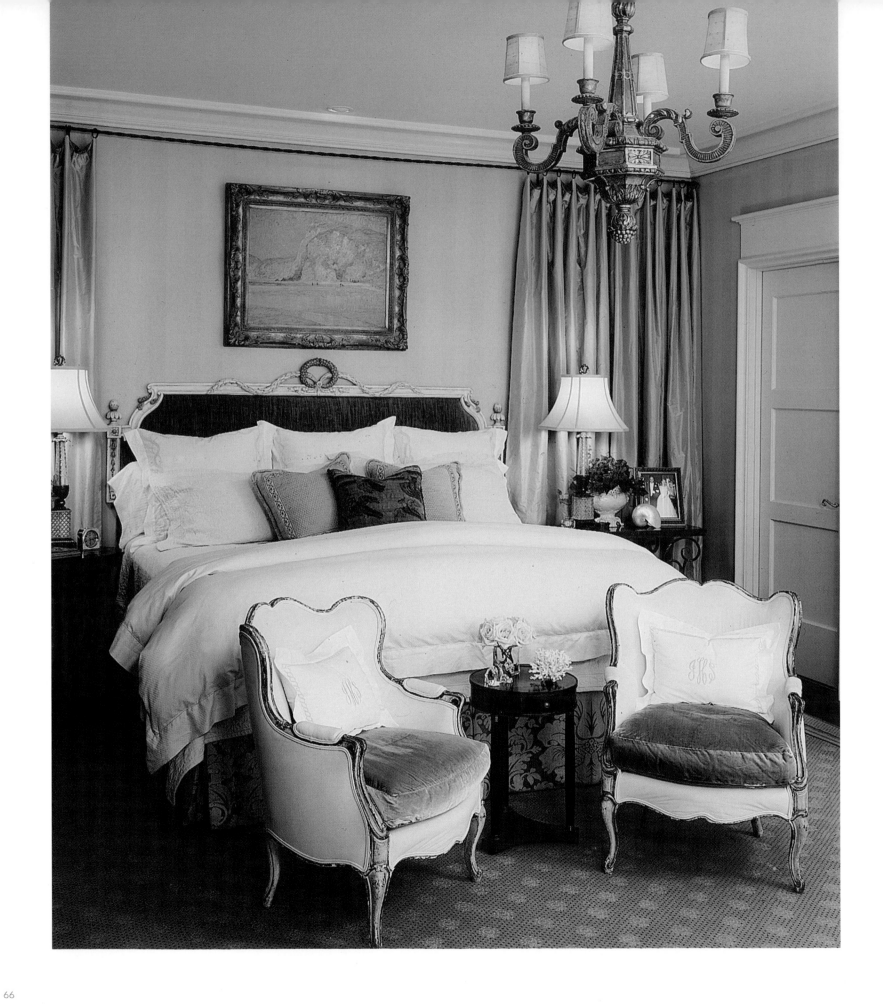

and Traditional Home, as well as being featured on the ever popular HGTV, but says his greatest satisfaction comes from knowing his clients trust him time and again to translate their personalities into the style of their home. "A client's home is very personal to them. How they work, play, entertain, and relax all must be taken into account when designing a home."

Named "Southeast Designer of the Year" in 2001 by the Atlanta Decorative Arts Center (ADAC), Landy and his firm have projects across the country from Los Angeles to the British Cayman Islands. The marriage of skill and knowledge of the latest products and techniques results in award winning design. Besides the firm's main responsibility in custom residential and commercial design, Landy Gardner Interiors is also a retail showroom space with fine antiques, lamps, art, furniture and more.

Landy told us he is excited about the opportunity to be a part of Spectacular Homes of Tennessee because of the notable changes he has seen over the last several years. "Tennessee is becoming more sophisticated, which is very exciting. I think it is a place most of the country doesn't recognize as having great designers and architects. This will be a way to showcase those resources."

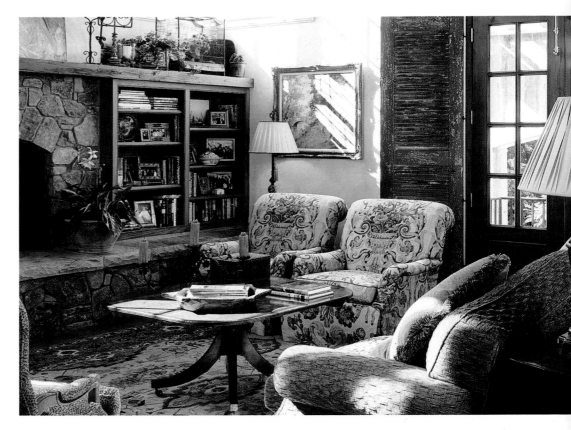

ABOVE A custom built stone fireplace and weathered shutters create a rustic feel, while Scalamandre-covered Charles Stewart chairs lend a refined element to this Keeping Room.

FAR LEFT A warm and sophisticated Master Bedroom contains antique French chairs covered in muslin with silk velvet seat cushions, an antique carved headboard with a silk strie velvet upholstered panel, silk wall draperies, and custom tailored bedding.

More about Landy ...

WHAT SEPARATES YOU FROM YOUR COMPETITION?

"I don't think I am limited to any one style," says Landy. "I have as many clients whose tastes lean toward contemporary as I do traditional clients. The goal is to never have someone define my "look"—there is a level of quality I want to maintain no matter what the clients' personal tastes."

WHAT IS THE HIGHEST COMPLIMENT YOU HAVE RECEIVED PROFESSIONALLY?

Throughout his career, Landy has been published in numerous shelter magazines, including *Veranda, Southern Accents,* and *Traditional Home* and has also appeared several times on HGTV's "Interiors By Design" show. In 2001 he was named "Southeast Designer of the Year" by the Atlanta Decorative Arts Center (ADAC).

Despite all of his national and regional accolades, he achieves great satisfaction from knowing his clients trust him with their homes and return to him again and again, and also that they recommend him to others.

WHAT EXCITES YOU MOST ABOUT BEING PART OF SPECTACULAR HOMES OF TENNESSEE?

"Tennessee is becoming more sophisticated, which is very exciting. I think it is a place most of the country doesn't recognize as having great designers and architects," says Landy. "This will be a way to showcase those resources."

LANDY GARDNER INTERIORS
Landy Gardner, Allied Member, ASID
Phillip Suits, Associate Designer
2212 Bandywood Drive
Nashville, TN 37215
615-383-1880
FAX 615-383-4167

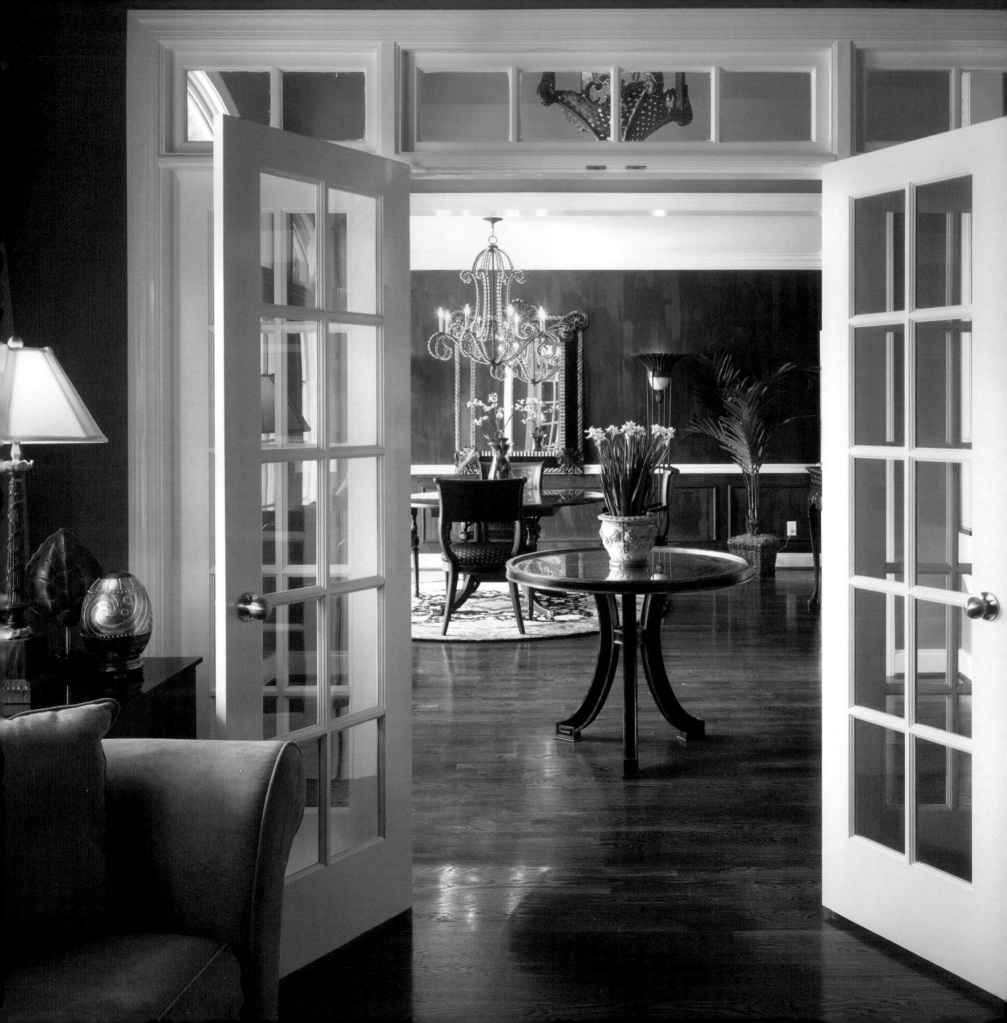

SARA GILLUM
SARA GILLUM INTERIORS

Comfortable elegance comes naturally to Nashville-based interior designer Sara Gillum, who loves fine things and making everyone she meets feel completely at ease. "Often, people are intimidated by designers, and we try to diffuse that," says Tennessee native Sara, who opened her own full-service firm in 1983. "It has always been a goal to make it that loose, comfortable, grand experience that makes them say, 'oh, let's do this again.' I will never walk into someone's house and say 'none of this works, let's get rid of it.'"

For the first decade of her career, Sara worked mostly on new construction, but in recent years, her jobs have been mixed between renovations and new homes, and she loves both. Creating a comfortable home is a top priority, regardless of setting. "Your home is not a museum, it's a home," she says, noting that it's also a collection that's intensely personal. "Perfect is just not a goal." She's a fan of colored ceilings, whether they are pale tints or deep tones. To her, they're an often-forgotten surface that needs attention and, indeed, drama in order to finish a room. And she's not afraid of dark walls, either, noting that a good lighting plan is the key to success with dark tones. "There's

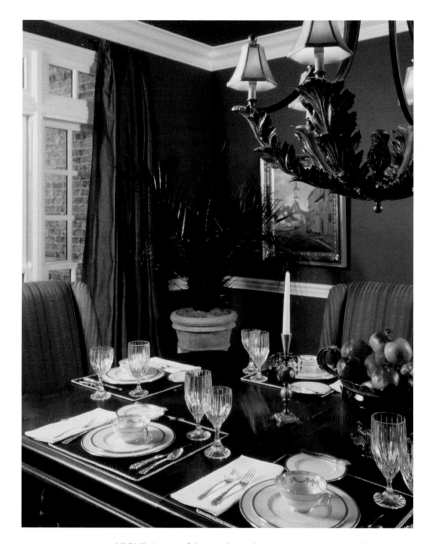

ABOVE Layers of deep color and texture create drama in dining room.

FACING PAGE The french doors help create depth with the combination of mirror placement and masterfull use of color.

a huge difference between dull and drab and deep and rich," she adds. Clearly, she's achieving the latter. "I think that your home should be as pretty as any resort you visit," says Sara. "Your surroundings truly influence your comfort zone and your ability to relax."

Sara's new love is French and Italian Deco furniture from the 1920s and 1930s because of their beautiful lines and attitude. "They played on the wood," she says, "and it's a little exaggerated." She's constantly on a quest to find pieces, much like her quest to create homes for her clients

and stay hands-on with the details. "I am so much happier on the job site than behind a desk," she admits. Regardless of where she is, Sara's positive attitude flavors her work on a daily basis and brings joy to those around her. "I like a little whimsy in every corner of life," she says. "I'm flippantly disrespectful of convention."

FAR RIGHT Mirror placement and color placement contribute to the feeling of depth.

FAR LEFT A blend of contemporary and antique furniture makes this converted tobacco warehouse an inviting enviroment.

BELOW The bench made furniture showcased in this 1920's home is as elegant today.

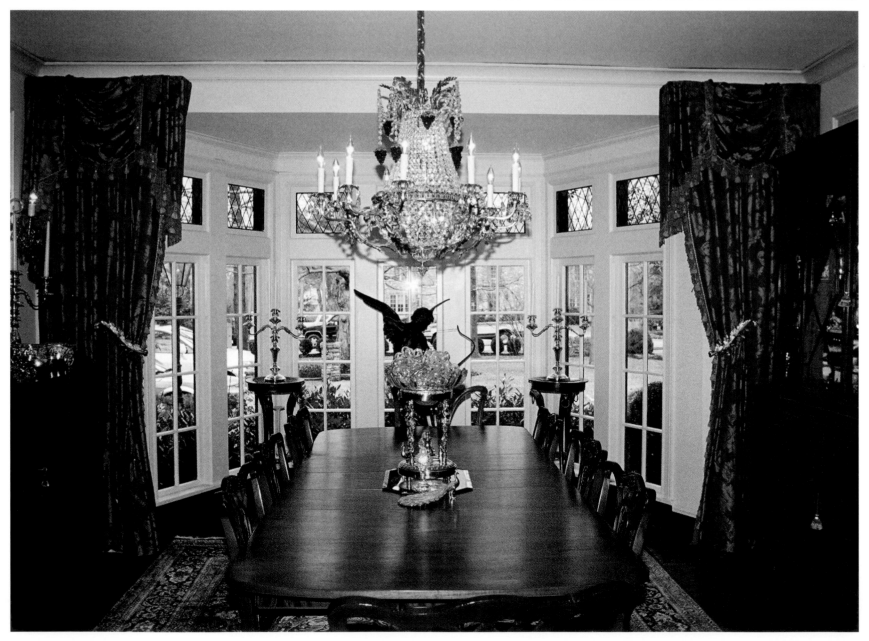

More about Sara ...

WHO HAS HAD THE BIGGEST INFLUENCE ON YOUR CAREER?

Sara credits the late Mark Hampton, a famed New York-based designer, for both his approach to design and the results he achieved for clients. "I never had the opportunity to meet him, but through the years, I could spot his work in publications before I even read the caption on the photo. His interiors had a feeling of comfortable elegance and that is a goal that I try to achieve in every project."

WHAT PERSONAL INDULGENCE DO YOU SPEND THE MOST MONEY ON?

Sara loves great shoes and original art. "Paintings are the 'candy' in my life," says Sara. "They allow me to be surrounded by so many good memories. I really have a hard time passing on one that triggers an emotion."

WHAT IS THE BEST PART OF BEING AN INTERIOR DESIGNER?

"The people I meet and am able to help bring their dreams to reality," says Sara, who loves the fact that her job is always different—there are different goals, needs and histories with each project. "I spend a good deal of time planning with a client, listening, trying to be sure that I hear what they're NOT saying," she says.

SARA GILLUM INTERIORS
Sara Gillum, Registered Interior Designer in Tennessee
1607 Linden Avenue
Nashville, TN 37212
615-292-5517
FAX 615-292-2640
www.saragilluminteriors.com

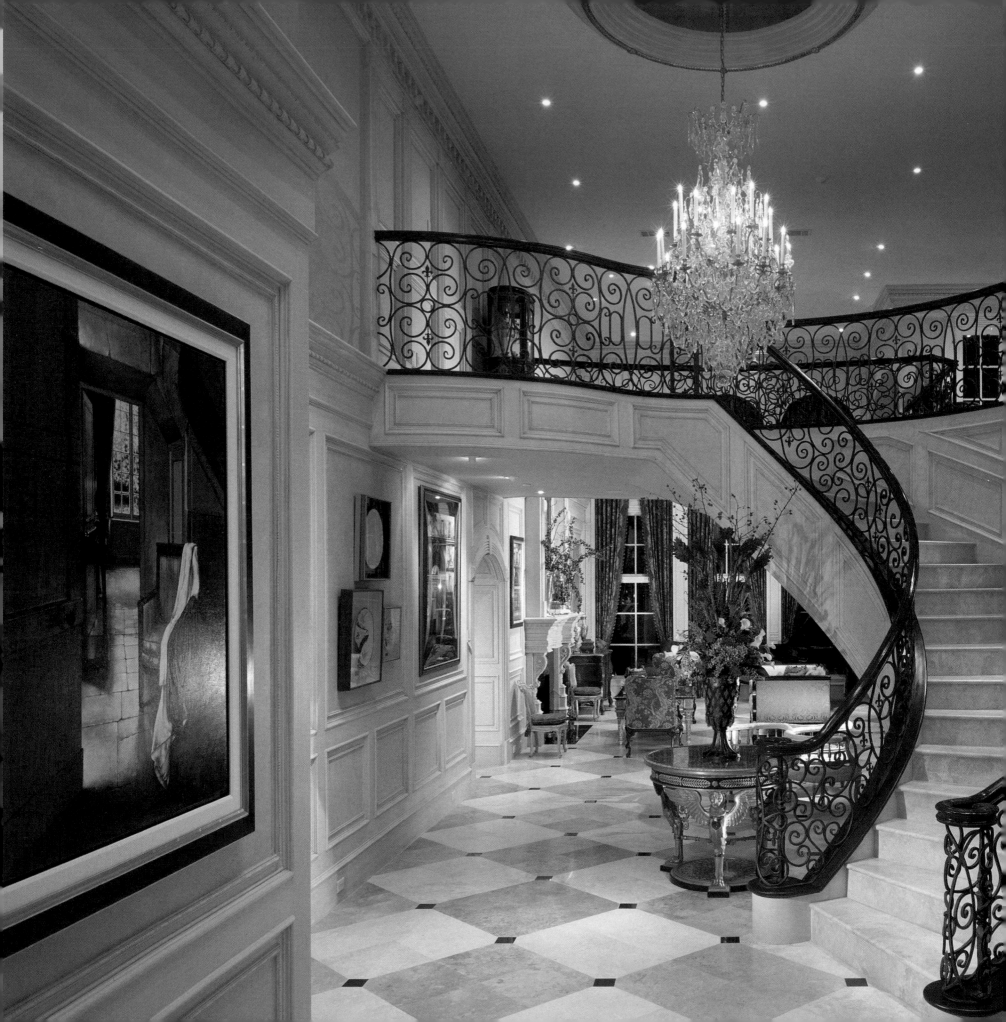

MARJORIE FELTUS HAWKINS

FELTUS | HAWKINS DESIGN, LLC

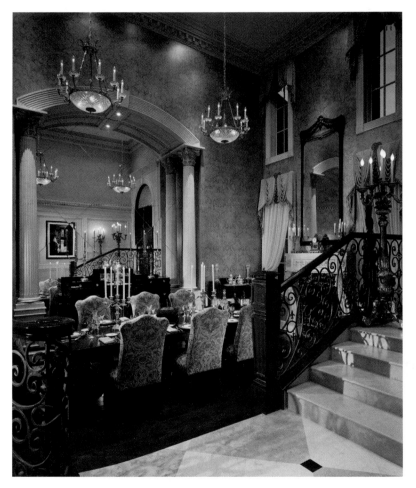

ABOVE In this dramatic dining room, a large expanse of wall was minimized by faux-finished walls and an arched niche designed with 48" x 48" mirrors and gilded columns. The antique furnishings are from Europe and Natchez, Mississippi.

LEFT Detailed paneling provides a human scale in this 24' entrance hall, which showcases part of the clients' extensive art collection. Flooring is travertine with granite insets, and the furnishings and chandelier are from Paris.

It's no surprise that Nashville-based interior designer Marjorie Feltus Hawkins has an experienced eye for cutting-edge design blending antiques with a contemporary flair. She grew up amid stylish surroundings at Linden, her family's circa 1790 home in Natchez, Mississippi, and spent countless hours with her mother, also an interior designer, on buying trips and visits to antebellum homes throughout the region. As the sixth generation to grow up at Linden, Marjorie was steeped in style from an early age, and later honed her skills with a design degree followed by further studies in art history in Rome, Italy. Since 1990, her full-service boutique design firm, Feltus|Hawkins Design, has specialized in luxury resorts, clubs, and restaurants, in addition to large-scale custom residences throughout the country.

"Our tagline is 'your space is your signature, don't scribble,'" says Marjorie, whose award-winning firm includes her husband David A. Hawkins, an architect, and focuses

on interior architecture and space planning from conceptual design to project completion. "We approach design from a marketing and imagery standpoint. You have that one opportunity to make an impression. We have an understanding of operational issues, and we learn about our clients' businesses. Your space is part of your marketing package," she says. "To me, your home or facility is your signature."

Marjorie's skills and background, plus her natural sense of graciousness make her a sought-after designer on lifestyle projects that involve welcoming others, whether a resort or a private home built for entertaining. Making spaces comfortable and functional as well as beautiful is a priority, and while she's fluent when it comes to fine antiques, her firm is completely at home with contemporary design. She especially loves to mix contemporary art and accessories with antiques. "I think it's a balance and they complement each other," she adds.

As a practicing interior designer for the last 25 years, Marjorie likes to point out that her firm's style is based on their clients' images. Regardless of the style she's working with, however, her passion for correct details and proportions imbues all of her projects with a timeless, classic quality.

TOP LEFT Known as The Bistro Room, this Old World-style space is where one client loves to have wine tastings and entertain guests. The walls are actually wall covering that was cut and installed to replicate stone. The embossed leather chairs are from France.

BOTTOM LEFT Members are greeted inside Walnut Cove's Tudor-style clubhouse with a flooring combination of leather strips and slate. Walnut paneling, rich textiles and warm, colorful furnishings contribute to the cozy yet sophisticated feel.

RIGHT Period Greek Revival furnishings complement the double Empire chandeliers and limestone flooring in this graceful entry hall. The fabrics are from Scalamandré and Schumacher.

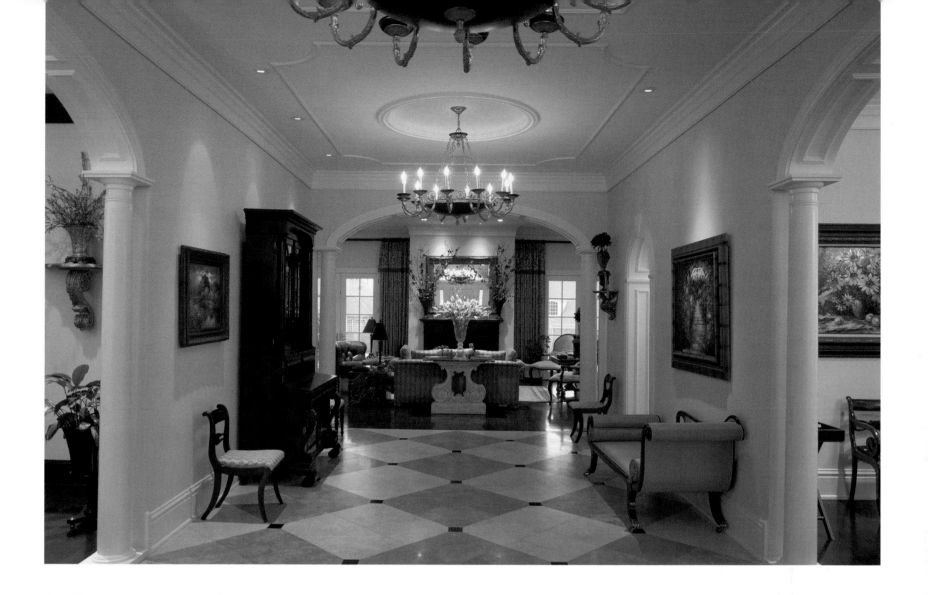

More about Marjorie ...

WHAT SEPARATES YOU FROM YOUR COMPETITION?

"We are an interior architectural design firm providing turnkey services ranging from programming to space planning, to the preparation of stamped construction drawings, to the selection of finishes and equipment to the installation of furniture and accessories," says Marjorie. We hire only senior-level interior designers with a minimum of 10 years' experience. We do not put junior designers in charge of projects where they learn on our clients' dimes."

WHO HAS HAD THE BIGGEST INFLUENCE ON YOUR CAREER?

"My mother, who was an interior designer and who worked on a lot of the antebellum homes in Natchez. I would work with her on some of her projects when I was in high school and I think I learned a lot by osmosis, especially a feel for antiques. That is her passion and now it is mine, too. I started antiquing with her when I was eight or nine."

IF YOU COULD ELIMINATE ONE DESIGN/ARCHITECTURAL/ BUILDING TECHNIQUE OR STYLE, WHAT WOULD IT BE?

"No style per se," she says but poor architecture in general, especially the incorrect scale and proportion of Southern-style architecture. We see so many new homes where the scale, style and proportion are out of balance, and to us, this negates everything the South stands for in terms of gracious design."

FELTUS|HAWKINS DESIGN, LLC
Marjorie Feltus Hawkins, IIDA, NCIDQ-certified, Registered Interior Designer in Tennessee
5114 Annesway Drive
Nashville, TN 37205
615-244-4328
FAX 615-244-3899
www.feltusdesign.com

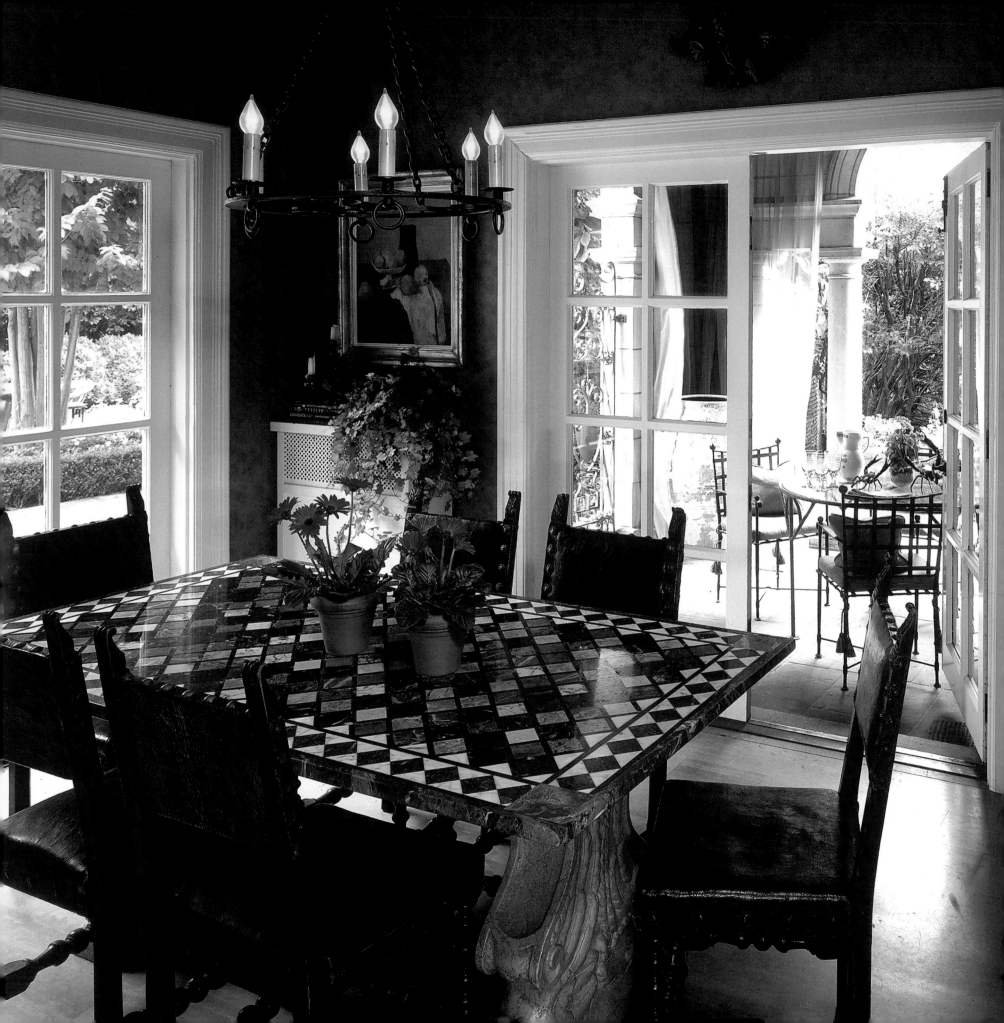

KEITH HEADLEY

HEADLEY MENZIES INTERIOR DESIGN

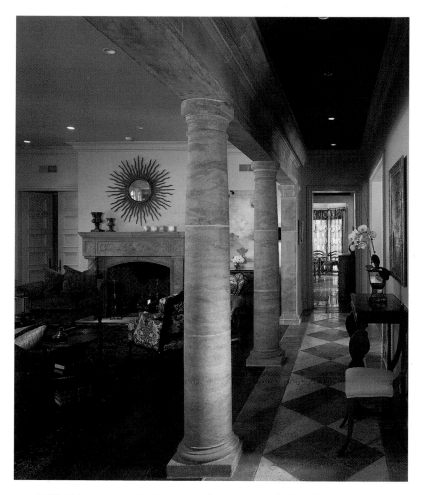

LEFT Rich patterns and bold colored wallcovering carry this breakfast room and exterior loggia. Inlaid marble top table on carved Italian marble base with 17th c. Italian chairs.

ABOVE Bold floor pattern in limestone and interior columns lend a strong architectural flavor to this gallery and living room.

A s designers, we just like to help people," says Memphis native Keith Headley, who has worked as a designer since 1981 and has owned his own full-service firm, Headley Menzies Interior Design, since 1999. "In this Internet age, there is so much product available on the market and most consumers do not know how to deal with all of the options and decisions that have to be made. That's where the value of our service comes in, to be able to bring together a personalized collection of what is appropriate for the client's needs and budget, and most importantly make it happen." Indeed, finding what is right for the client is the backbone of this successful firm's work, which runs the gamut from contemporary to traditional. Although Memphis still proves to be a wonderful home base with a loyal clientele, Keith finds himself more and more on the road with projects in New York City, New Jersey, Florida, Colorado and beyond.

Keith is known for his friendly, kind personality and his European-flavored rooms that are livable and classical in inspiration. "People run from the word traditional," he says, noting that a lot of clients, especially younger ones, immediately think of stiff, period-style rooms.

"Warm doesn't have to be dark or boring," he says about his creative twist on traditional style, which doesn't fit a specific label. "I love lush, well-appointed rooms with rich fabrics—alive with pattern and color—and period antique furniture, as well as clean interiors edging on modern or contemporary, but they still have to be warm, functional and inviting," he explains.

An entrepreneur at an early age, Keith obtained his real estate license at 18 and spent several years buying and renovating residential properties. He loved the creative aspect of transforming homes and was working while also attending the University of Memphis when he decided to attend the Art Institute in Atlanta and pursue design. After graduation, Keith landed in Memphis at Rodgers Menzies Interior Design. Now at the helm of the firm,

Keith notes that he enjoys how design changes all of the time as our lives change and new generations emerge. As a result he sees a shift in what people ask for these days, and he seeks to deliver. "People today for the most part want things more tailored, cleaned-up," he says, noting that he strongly promotes design that is enduring, not too trendy and disposable.

Another aspect of Headley Menzies is the showroom, which is stocked with treasures that Keith personally selects while he travels to Europe several times a year—directly importing both antique and contemporary items. He also attends three to four domestic markets annually, scooping up exceptional lamps, furniture, and accessories for the shop. Keith notes that the firm will celebrate its 25th anniversary in business in 2006 and

LEFT Custom cabinetry and hand painted finishes are a focal point for this grand master bath; the oversized limestone floor tiles, patterned wallcovering and warm red ceiling color all help to make this spacious bath intimate.

TOP RIGHT European influences come together in this dining room with a combination of antiques and reproductions featuring trompe l'oeil wallcoverings by Scalamandré, original oil on canvas by Jeff Muhs, antique Persian rug and antique urns from Berlin.

BOTTOM RIGHT Vignette of the master suite of a guest house – warm neutral tones and subtle patterns create a tranquil retreat.

ABOVE Guest suite with a collection of 18th c. Italian furniture featuring a Sienese marriage bed, pair of walnut commodes and Venetian chest from the Piedmont region; semi antique Oushak (Turkish) rug.

FAR RIGHT This multi-functional sunroom was inspired by the vintage Kisabeth sofa inherited by the young couple from his grandmother; the existing marble floor is softened by the natural cowhide and the driftwood sculpture loosens things up a bit.

that Headley Menzies looks forward
to many more years of creating distinctive
interiors with a solid sense of presence and
sophistication. And he continues his
emphasis on extraordinary service,
pointing out that creating a home that's
functional and reflects a client's interests
is a top priority. "We really strive to build
long-term relationships," he says.

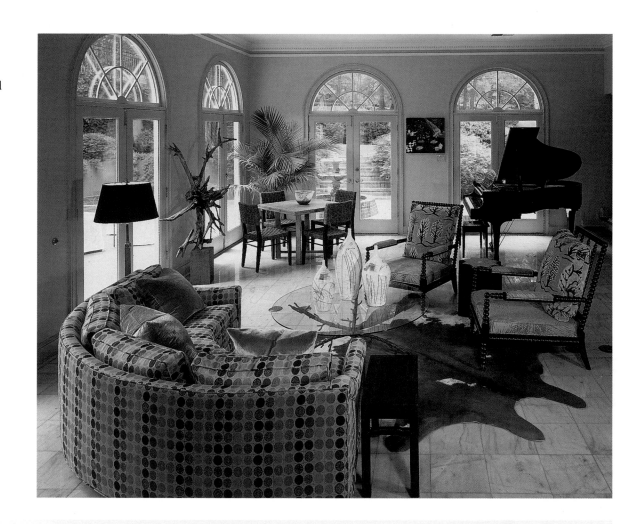

More about Keith ...

WHO HAS HAD THE BIGGEST INFLUENCE ON YOUR CAREER?

"Although I have gained and continue to gain inspiration from so many talented
people that I have observed over the years, I would have to credit Rodgers Menzies
since I spent the first 18 years of my career working with him," says Keith. In 1999,
he purchased the firm from Rodgers, then named Rodgers Menzies Interior Design,
where Rodgers still remains today as an active designer.

WHAT IS THE BEST PART OF BEING AN INTERIOR DESIGNER?

"Helping clients navigate their way through the daunting task of creating a livable
home," says Keith, "all the while never running out of things to learn, interpret and
share with them."

**WHAT ELEMENT OF STYLE OR PHILOSOPHY HAVE YOU STAYED
TRUE TO AND THAT STILL WORKS FOR YOU TODAY?**

Keith asks himself: "What is appropriate for this client?"

HOW LARGE IS HEADLEY-MENZIES INTERIOR DESIGN?

Seventeen employees compose the full-service design firm, which includes three full-
time interior designers with assistants, two part-time designers and a nine-member
support team.

**WHAT IS THE HIGHEST COMPLIMENT THAT YOU'VE RECEIVED
PROFESSIONALLY?**

Although Keith's work has been nationally published in *Veranda* magazine, the
Showcase of Interior Design and other publications, he says that the best compliment
he could have is when a client says "thank you we love it! You have changed our lives.."

HEADLEY MENZIES INTERIOR DESIGN
Keith Headley, Registered Interior Designer in Tennessee
766 S. White Station Road
Memphis, TN 38117
901-761-3161
FAX 901-763-3993
www.headleymenzies.com

Karen W. Healy & Meg M. Thomas

ABOVE Dramatic lighting, a mosaic glass backsplash, and rich mahogany custom cabinetry create this functional kitchen's crisp character.

LEFT Rich color, soft glowing light and a unique square table are sure to evoke stimulating conversation in this striking dining room.

Mother-and-daughter interior designers aren't all that common, so Karen Healy and Meg Thomas, who together form Healy & Associates, like that fact plus their reputation for uncommon design. Clients benefit from Karen's 25 years in the design business, along with Meg's lifetime of living with a designer, and the combined talents of two generations who are serious when it comes to delivering comfort, function and style that's on time and within a budget. Being located in a building that includes a custom builder and an architecture firm also means that Healy & Associates can provide design-build services from the ground up for residential and small commercial clients.

A full-service firm whose projects are evenly split between large-scale new custom homes and remodeling projects, Healy & Associates pays a great deal of attention to meeting their clients' needs, and a large part of that is helping them enjoy the process. "This is such a positive thing," says Karen about working with clients to create a home. "You're doing your dream home, and we're going to help you get there." That "can-do" approach puts homeowners at ease, says Meg, and results in a solid working relationship that's also fun and relaxed—just as it should be.

"We'll do the most serious and formal of houses but whether it's art, sculpture, or a funky lamp there's always a place for whimsy," she adds.

While often called upon to create and execute richly layered, colorful interiors that are inspired by Europe and especially France and Italy, Meg and Karen are equally comfortable working on beach houses in Florida. At the moment, a large project on the boards consists of a full-scale remodel of a contemporary residence in Nashville. "We just truly listen to the clients and their needs and wants," says Meg, who notes that

textured wall finishes are a favorite component when they work within the context of a project. "We're definitely not cookie-cutter."

Design-wise, Karen and Meg have a passion for people, and that is demonstrated through their commitment to excellence, and to the reality of creating functional places where people live. "Overall, this is a great profession and it's a wonderful way to make a difference in people's lives," says Karen.

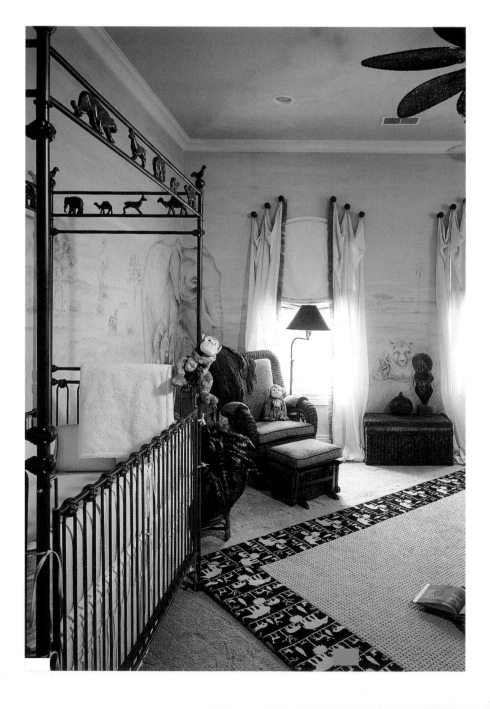

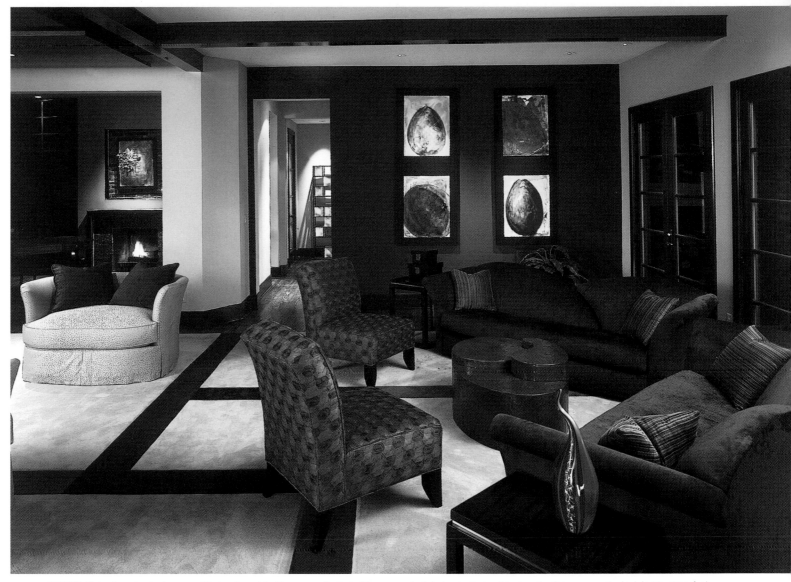

ABOVE Rich, vibrant color tones and textural combinations, coordinated with unexpected abstract art give this stunning living space its sleek but inviting feel.

FAR LEFT The hand-honed spline ceiling and skillfully crafted wall insert provide three-dimensional angles for light reflection in this hallway.

NEAR LEFT A mother's African safari inspired this sophisticated yet magical nursery that celebrates "Mother and Child."

More about Karen and Meg ...

WHAT IS THE BEST PART OF BEING AN INTERIOR DESIGNER?

Helping clients realize their own creative dreams is a thrill for Karen and Meg, who love to be inspired by simple and unlikely things.

WHAT IS THE MOST UNUSUAL/EXPENSIVE/DIFFICULT DESIGN OR TECHNIQUE YOU'VE USED IN ONE OF YOUR PROJECTS?

The dynamic mother-and-daughter duo once used an antique stained-glass light fixture that was 10 feet in diameter for a focal point in the kitchen of a show house.

WHAT SEPARATES YOU FROM YOUR COMPETITION?

"People choose our firm because we offer something out of the norm," says Karen, "which is truly striving to find out what the client needs and desires, even if they don't know themselves."

HEALY & ASSOCIATES
Karen W. Healy, Allied Member ASID;
Registered Interior Designer in Tennessee
Meg M. Thomas, Associate Designer
7113 Peach Court, Suite 101
Brentwood, TN 37027
615-460-9500
FAX 615-460-9517

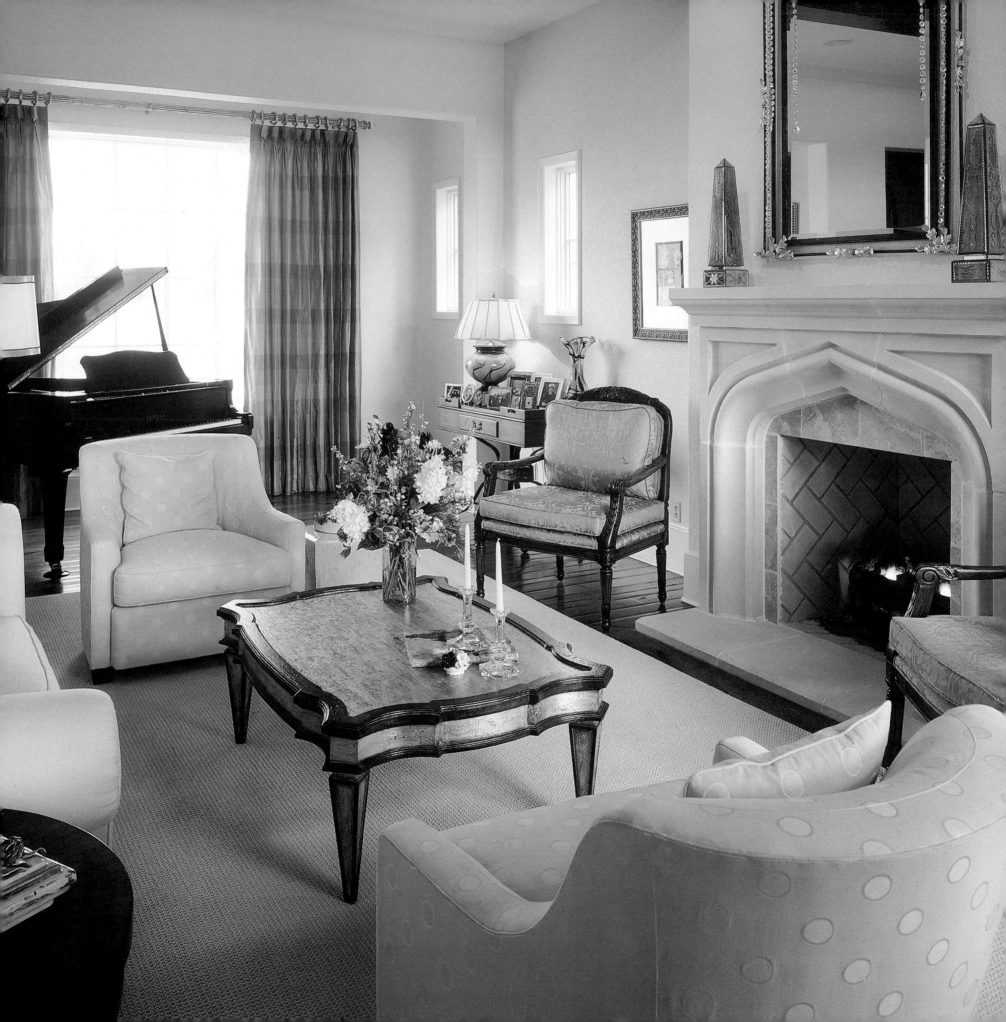

JILL E. HERTZ
JILL HERTZ INTERIOR DESIGN

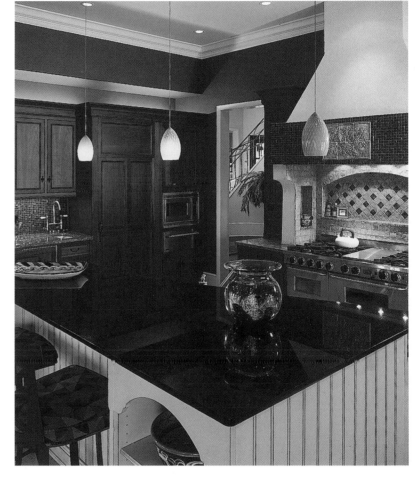

ABOVE Old world style cabinetry, cooktop and hood stand out against irridescent tile, hand-blown glass pendants, and unexpected violet color, providing a fun and engaging space for creative cuisine.

LEFT Polka dots and splashes on luminous color take a polished living room to a whole new level of traditional sophistication.

Memphis-based interior designer Jill E. Hertz, ASID, hails from a design dynasty. Her designer parents both studied at the New York School of Interior Design and her great-grandfather began the famed Sam Fortas House Furnishing Co. over a century ago in Memphis. After earning a degree in interior architecture at the University of North Carolina, Jill spent a decade in the furniture business as a merchandiser and buyer for a national retailer. Five years ago, she founded her own independent, full-service firm that handles both residential design as well as specialized retail consulting throughout the mid-South.

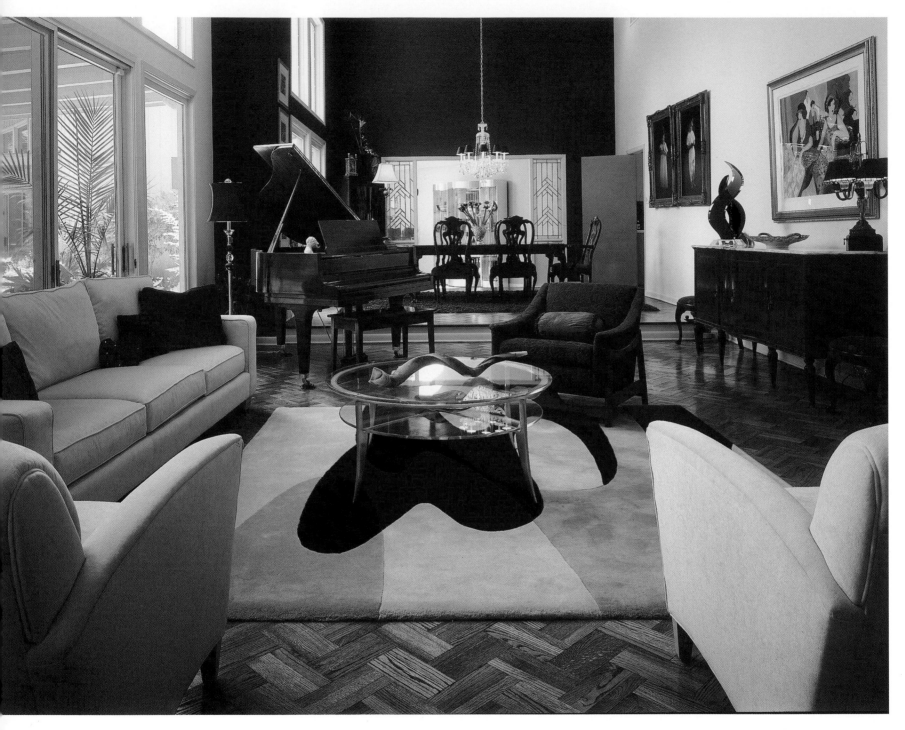

"I love to use color and I'm known to be daring," says Jill, who meets twice annually with a select group of international design professionals as a member of the Color Marketing Group, which does forecasting across multiple industries. Her confidence with color and pattern is apparent in her fondness for colored ceilings and sophisticated wallpapers in appropriate settings. She's also skilled with renovations, especially large new kitchens, and is currently in the process of obtaining her general contractor's license in order to streamline projects for her clients. "It's just more informative design," she says about her quest to broaden her knowledge. "It's important that we concentrate on real-world, day-to-day design that works for our clients."

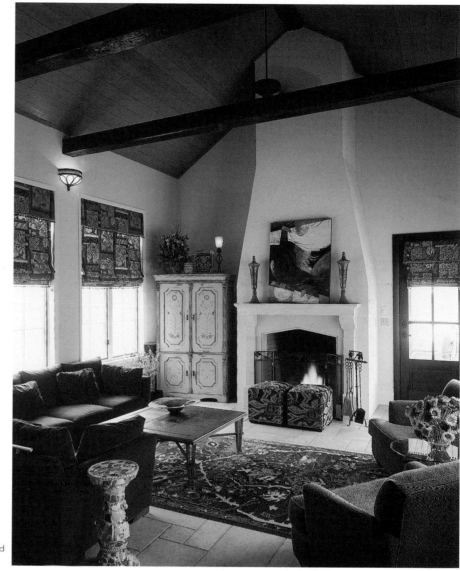

LEFT Multi levels and vibrant color—blocking, pulled together with artwork and custom designed rugs, transforms this once drab and unexciting living room into a perfect backdrop for fun and entertainment.

RIGHT A colorful twist on traditional decor, rough-hewn wooden beams, stained ceilings, and colorful upholstery brings warmth and a feeling of coziness to this expansive hearth room.

More about Jill ...

WHAT COLOR BEST DESCRIBES YOU AND WHY?

"Berry reds. These shades of red are full of energy, fun, bright, and positive. These colors can be mature and serious, or they can let you be intouch with your inner child.

WHAT IS THE HIGHEST COMPLIMENT YOU HAVE RECEIVED PROFESSIONALLY?

"The highest compliment I have recieved have been those from my peers. The best example is the Chapter Service Award from the American Society of Interior Designers, Tennessee Chapter."

WHAT IS THE BEST PART OF BEING AN INTERIOR DESIGNER?

"After a job has been completed, the client calls to say 'We love the new space and we now spend more time there as a family. Thank you so much!' "

JILL HERTZ INTERIOR DESIGN
Jill E. Hertz
ASID, Member of CMG - Color Marketing Group,
Registered Interior Designer in Tennessee
850 South White Station Road
Memphis, TN 38117
901-767-8616°

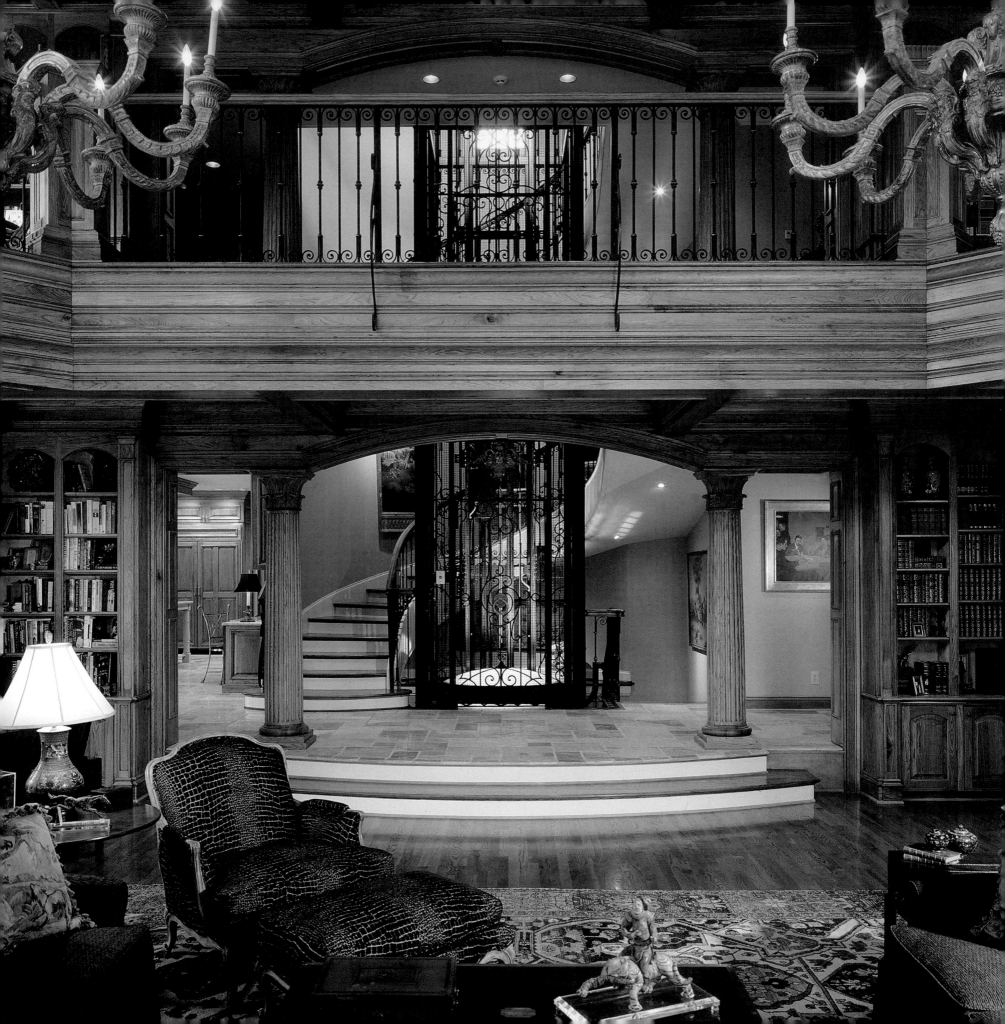

Shirley Horowitz, Natalie Hart & Jason Arnold

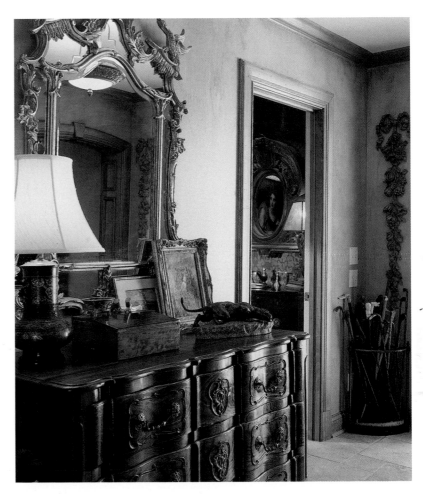

ABOVE A 19th-century champlevé lamp, two French oil paintings and a bronze lion compile the grouping on top of this chestnut 18th-century Louis XV serpentine chest. The mirror is Louis Solomon. In the background, an oil painting by Halle is reflected in the old mansard roof window, which was found in France and transformed into a mirror for the powder room.

LEFT A Chinese roof figure sits atop an antique billiard game box on stand serving as a coffee table in the library of this Nashville home. The European-style elevator moves from the garage level to the 3rd floor observatory, with stops on the main floor and 2nd floor library balcony.

Shirley Daniels Horowitz has designed classic interiors for over 30 years. Drawing from a broad depth of experience and love of fine arts, she creates interiors that are timeless and functional. Her company, Davishire Interiors, celebrating its 20th anniversary this year, continues in that tradition. Every design project includes a wonderful selection of antiques, accessories and beautiful artwork.

Davishire Interiors, a full-service interior design firm with a 10,000-square-foot showroom and gallery, is located just outside Nashville's historic Hillsboro Village near the Vanderbilt University campus. Shirley and a seasoned staff of designers that includes Deborah Tallent, Natalie Hart, Jason Arnold, Terry Richardson, and Amélie de Gaulle are skilled in every aspect of interior design from renovating a small powder room to new construction from the ground up.

"We start with space planning before we do the first color or fabric," Shirley says, "and we're just as comfortable with Art Deco as we are with 18th century French." While many designers who sell antiques depend on the Internet or "pickers," the trade name for those who source vintage items, Shirley selects Davishire's inventory personally. She

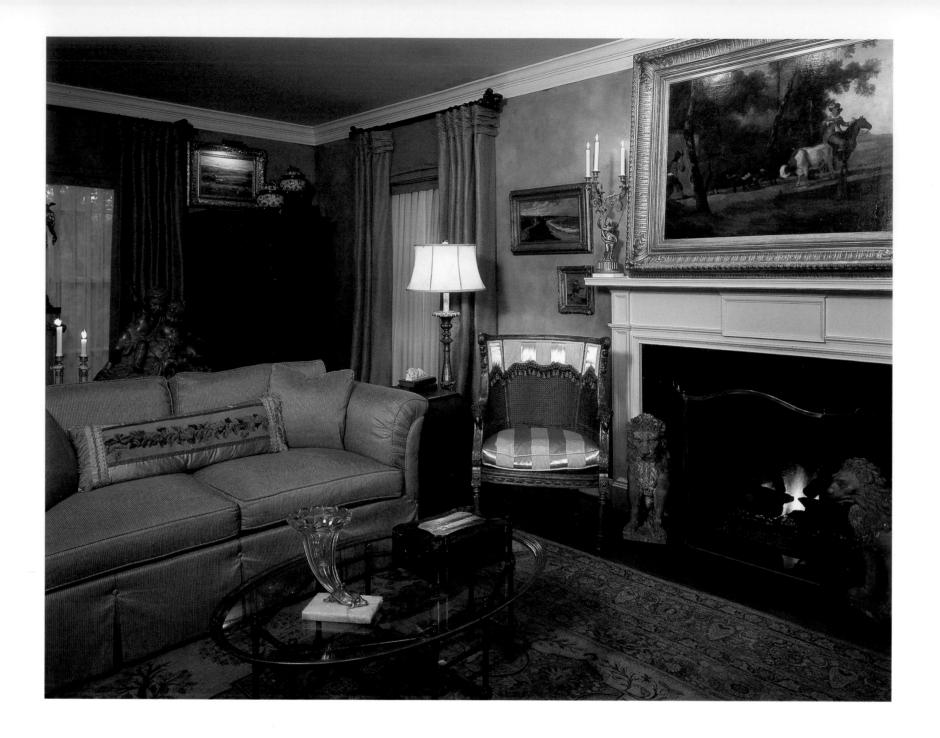

travels to Europe, South America, and across the United States constantly searching for new resources and revisiting the old, always mindful that her clients are discriminating and expect something out of the ordinary. This personal approach provides the high quality of antiques and unique one-of-a-kind pieces for which Davishire has become known.

Beautiful art breathes life into a room. This fundamental philosophy that Shirley and her design team consisting of Natalie Hart and Jason Arnold share makes selecting artwork as important in the design process as the scale of furniture and color of fabric. Each client is unique and the artwork they choose to live with reflects that. Shirley considers it a privilege to help her clients build lasting art

collections. Shirley has introduced Nashvillians to Minneapolis-based Malcolm Liepke, whose work has shown in her gallery showroom for over a decade. Davishire has also carried the work of respected artists such as Tarkay, Hessam, Yuroz, and Maimon and the renowned sculptor Richard MacDonald.

Trust is a key element when working with a designer. The easy exchange of dialogue between Shirley and her clients is important to her. And it's through the close process of talking with one another that her clients see the finished product before it's complete. These long-standing relationships have taken Shirley all over the country. Most recently she and her team have completed homes in Little Rock, Arkansas, and

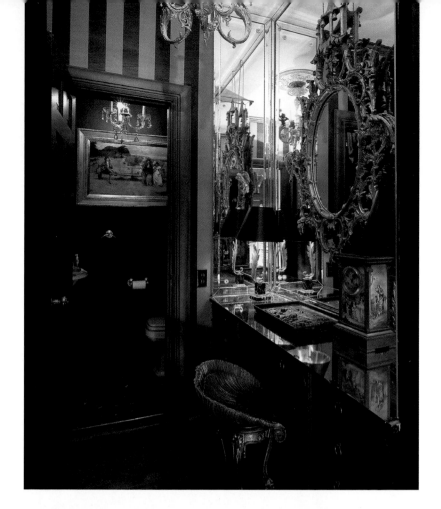

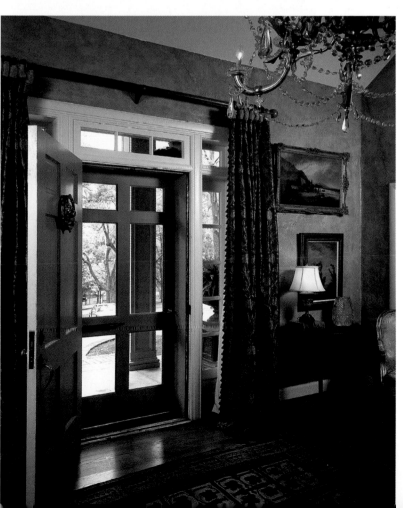

LEFT Hand-cast Italian lions flank the mantel in the living room, which includes an 18th century French chair and an 18th century oil painting leaning on the wall above the mantel. The faille fabric on the sofa and at the windows is by Noblis.

TOP RIGHT A mid-19th-century scalloped music stool provides seating at the mirror-on-mirror vanity. The oil painting is a 19th-century French view by Rolland Holyoake. A gauzed paint technique defines the striped walls.

BOTTOM RIGHT A small bird has taken up residence in the corner of the front entry doorway, which features a bronze-and-crystal chandelier that was formerly a gaslight. The fabric is Stroheim and Roman, and the oil painting on the upper right is a 19th-century seascape. Beneath it, the 18th-century painting features a French child with flowers. The wall treatment is a hand applied cracked Venetian plaster technique.

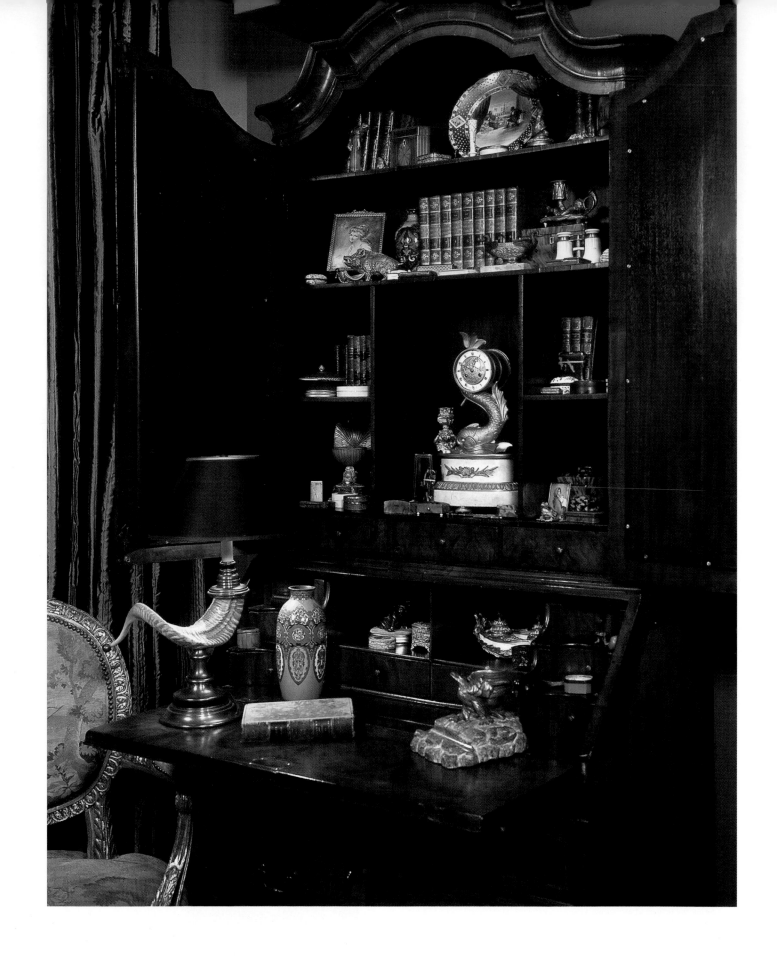

Kiawah Island, South Carolina. They have also finished a co-op on 5th Avenue in Manhattan and a vacation home for a client in Ireland. Nashville remains the core of her business, however, and residences both small and large as well as commercial properties keep Davishire active.

LEFT "The Collector" is an 18th-century English full bonnet walnut secretary."

RIGHT The Nashville skyline can be seen from this 3rd floor observatory, which features a Spanish rug, an antique reading stand and a 19th-century oil painting by German artist Walter Prell. The sheer fabric on the windows is woven horizontally with jute and is by B. Berger.

More about Shirley ...

NAME SOMETHING THAT MOST PEOPLE DON'T KNOW ABOUT YOU

Shirley got her pilot's license when she was 22 years old, she was Miss Nashville 1966, and she was also a cheerleader when she was at the University of Tennessee.

WHAT IS THE BEST PART OF BEING AN INTERIOR DESIGNER?

Placing a beautiful piece of art or an antique that she found while traveling and then knowing that the client loved it for years is a special point of pride for Shirley, who loves searching for just the right thing for her clients.

WHAT IS THE MOST UNUSUAL, EXPENSIVE OR DIFFICULT DESIGN YOU'VE USED IN ONE OF YOUR PROJECTS?

For a large commercial job, Shirley had to specify a hand-tufted rug where the geometric design needed to look parallel and yet there were no parallel walls in the room and no right angles. "As I was measuring with compass, protractor and tape, I thought of my high school geometry teacher many times. It all fit!! Thank you, Mrs. Gaither!"

WHAT IS THE HIGHEST COMPLIMENT YOU'VE RECEIVED PROFESSIONALLY?

The highest compliment Shirley recieved was being selected to redesign the interiors of the Governor's Residence.

WHAT BOOK ARE YOU READING NOW?

The Russians, by Hedrick Smith

DAVISHIRE INTERIORS
Shirley Horowitz, ASID, NCIDQ-qualified,
Licensed Interior Designer in Tennessee;
Natalie Hart; Jason Arnold, Allied member, ASID; Deborah Tallent,
Amélie de Gaulle and Terry Richardson, Allied member, ASID
2106 21st Avenue South
Nashville, TN 37212
615-298-2670
FAX 615-269-6487
www.davishire.com

ROZANNE JACKSON
THE IRON GATE

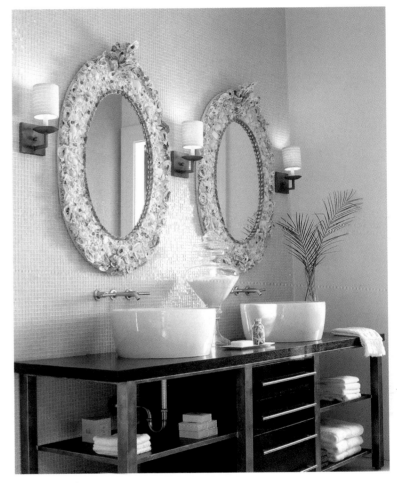

ABOVE This master bathroom suite won first place in the Southern Accents Interior Design Contest in 2005.

LEFT The Family Room at The Junior League Decorator's Show House in 2003 expresses romantic, sophisticated style.

Visitors know they're about to experience something out of the ordinary as soon as they see the stylish chocolate and vanilla awning that distinguishes the entrance to The Iron Gate, which is also the home of Rozanne Jackson Interiors. Known far and wide for its fresh style, which includes a dash of romance in a soft cotton velvet fabric here, a touch of the antique in a metal table there and a sprinkle of the eclectic in the form of a crystal chandelier, a moody lantern or a large seashell, The Iron Gate's distinctive look is based in serenity. Combining French eclecticism with the light, airy qualities of lots of glass objects, the warmth of scented candles and one-of-a-kind antique furniture and accessories, it's an atmospheric setting that has gathered fame and attracted the attention of national design magazines and countless clients.

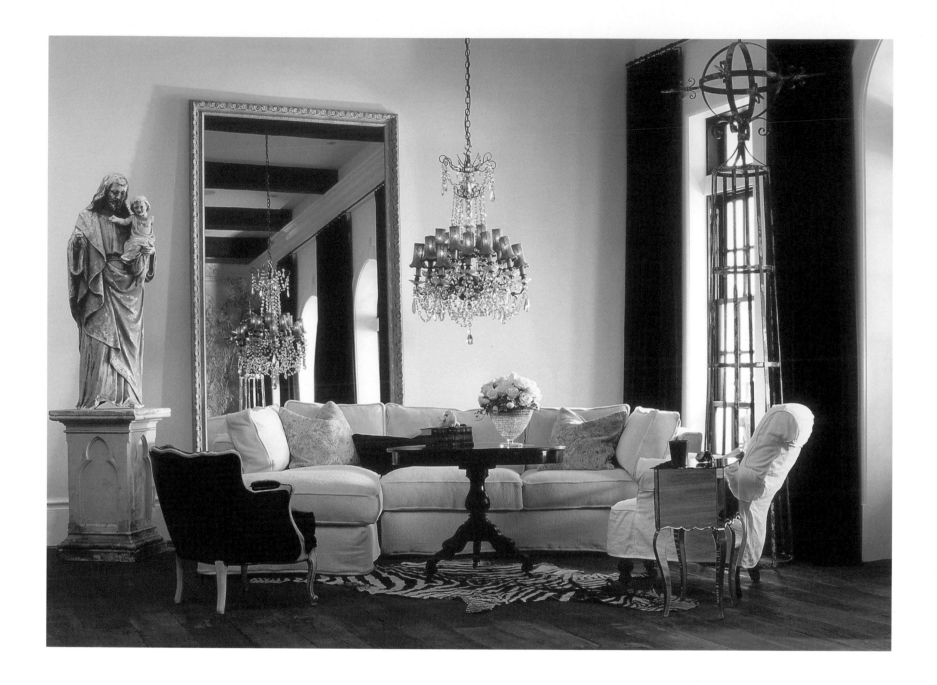

Texas native and 13-year veteran decorator Rozanne Jackson runs the design side of The Iron Gate, while co-owner Bo Boaz manages the retail operation and loves sourcing unusual objects. Together, they're a perfect combination when it comes to creating an environment where clients can see objects, finger fabrics and identify what they want when it comes to their own homes.

The Iron Gate, which is celebrating a decade in business in 2005, allowed Rozanne to spread her wings, and she and Bo found themselves in the decorating business as the store started attracting clients who wanted the same look in their homes. Today, Rozanne has continued to hone the peaceful, comfortable European casual look that makes visitors want to linger. Indeed, a lot of people involved in Nashville's hectic music industry

have been drawn to the sophisticated yet simple style showcased throughout The Iron Gate, and the store's custom capabilities now encompass furniture, lamps, mirrors and luxurious heavy silk curtains. Dreaming things and seeing them come to life is a passion for Rozanne, who knew at a young age that she was destined for a creative career. "I'd rearrange my room every couple of weeks and try to make it look different," says Rozanne, whose father owned an appliance and lighting business during her childhood. It meant that at a young age, she was exposed to retailing and also forged a lifelong affinity for fine lighting, which is a strong element in her interiors.

ABOVE This master suite was designed to create an elegant but relaxing feel.

LEFT "We loved this space because of the high ceilings," says Rozanne Jackson, adding that as a result, scale was very important in this room. Note how the lowered chandelier works with the flanking tall sculpture and garden ornament to balance the space.

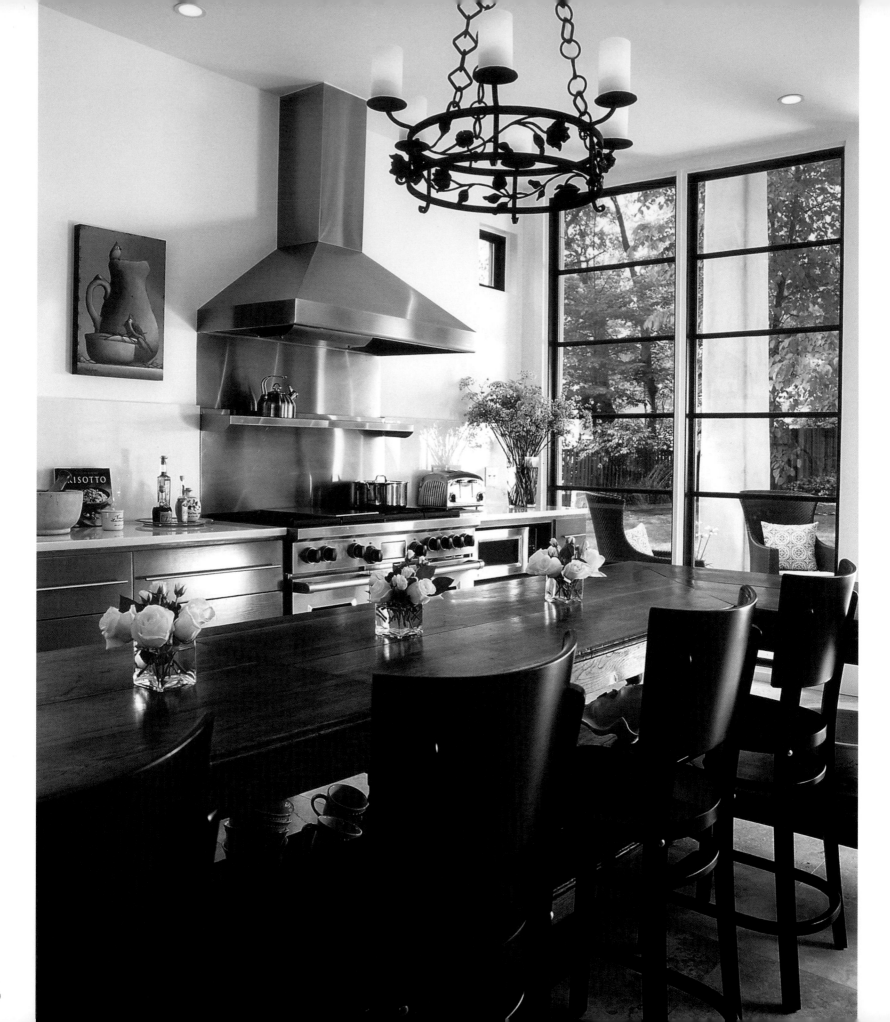

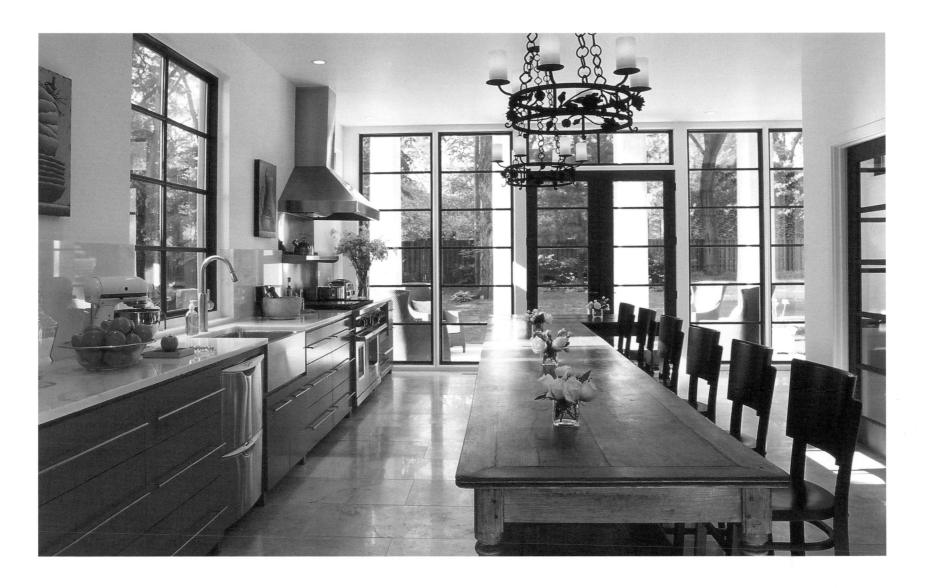

Following her mantra "buy right, buy once," Rozanne loves translating the international, luxurious look of the store into appropriate, comfortable interiors for her clients, whose homes are all over Tennessee and beyond, including the U.S. Virgin Islands and the North Carolina mountains. "I really try to create a space that people would like to live in for the rest of their lives," she says. "It's about throwing in something interesting or unexpected that keeps things from being boring or redundant." In addition to the custom, one-of-a-kind pieces and antiques, The Iron Gate also includes a complete, in-house Shabby Chic boutique.

"This store is a feeling," says Bo, as he stands on aged wood floors among objects drawn from various centuries in the light-drenched central room of the store's historic building. "It's informal but glamorous."

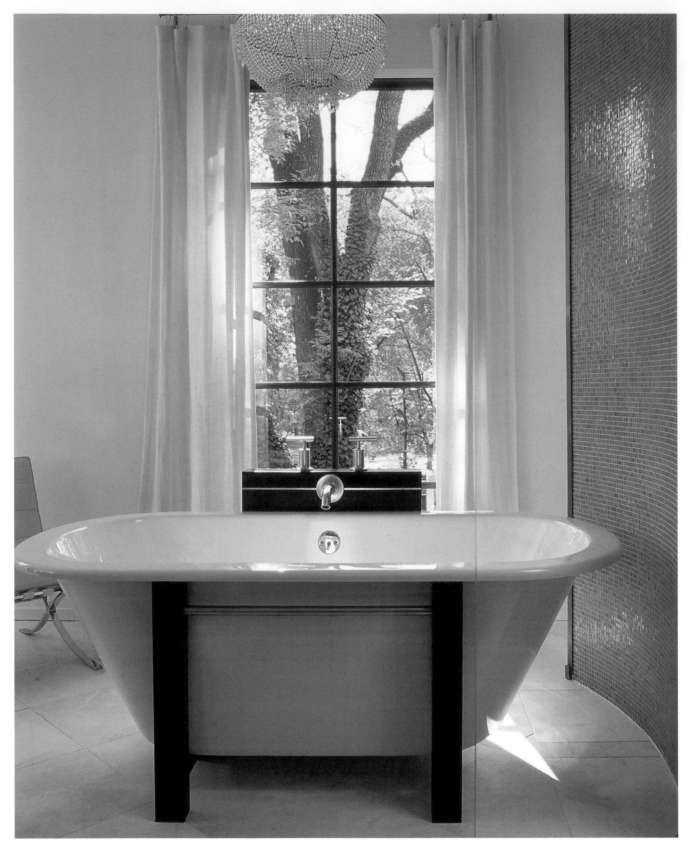

ABOVE & FACING PAGE This award-winning bathroom immediately produces a very Zen-like feeling due to its luxurious simplicity.

More about Rozanne ...

WHAT COLOR BEST DESCRIBES YOU AND WHY?

"Shades of white. You can put any color with white and it has no limits," says Rozanne, who loves to use Porter's Champagne Tint, mixed at half strength.

WHAT IS THE HIGHEST COMPLIMENT YOU HAVE RECEIVED PROFESSIONALLY?

In addition to praise from clients who are grateful for functional, peaceful and beautiful interiors, Rozanne recently won first place for Best Bathroom Design in the *Southern Accents* magazine, and ASID National Interior Design Contest. Her design will be published in late 2005 in Southern Accents. The Iron Gate's work has also been published in *Country Living* and *Romantic Homes* magazines.

WHAT SEPARATES YOU FROM YOUR COMPETITION?

"I don't think I have any competition. My clients enjoy my style as other clients enjoy their designers' styles. It's all about finding the style that best fits your needs. My style is about creating a mix of old and new. Good design is about beauty, interest and of course, function," says Rozanne.

WHAT IS THE BEST PART OF BEING AN INTERIOR DESIGNER?

Rozanne and the team at The Iron Gate love to help the shop's clients and design clients create beautiful spaces where they live. Finding gorgeous objects that lend a distinctive feel is another favorite part, too, since they love discovering the perfect accessory or antique.

WHAT SEPARATES YOU FROM YOUR COMPETITION?

"I don't think I have any competition. My clients enjoy my style as other clients enjoy their designers' styles. It's all about finding the style that best fits your needs. My style is about creating a mix of old and new. Good design is about beauty, interest and of course, function," says Rozanne.

THE IRON GATE
Rozanne Jackson
338 Main Street
Franklin, TN 37064
615-791-7511
FAX 615-791 8432
www.theirongateonline.com

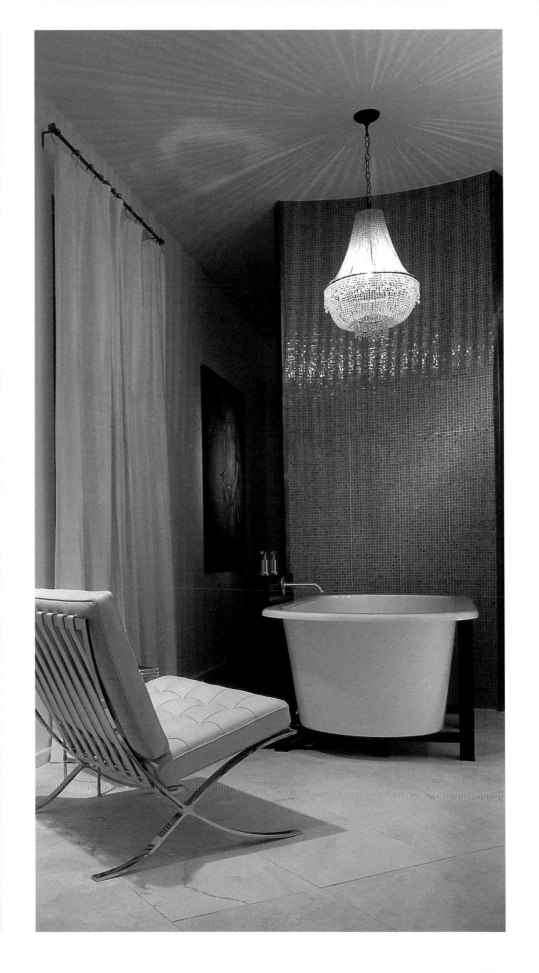

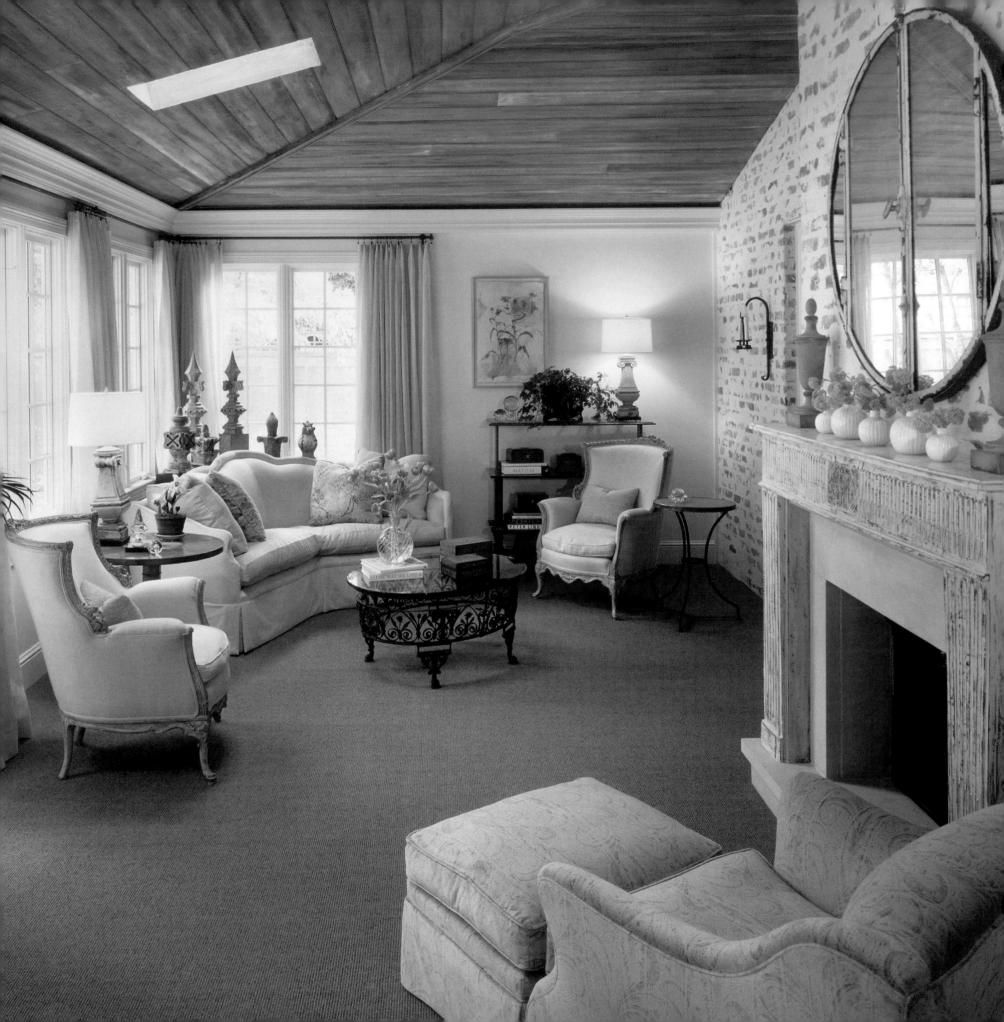

ALLYSON JUSTIS
ALLYSON INTERIORS

ABOVE Cobbled-edge travertine laid in random pattern with dark-stained hardwood border defines the floor in this sunny garden room, which includes black-lacquered wicker furniture paired with contrasting lime accents for a pleasing surprise.

LEFT A weathered cypress ceiling is a dramatic element that adds warmth, character and depth to this sunroom. A textural brick wall smeared with ivory mortar serves as a backdrop for a graceful 19th century French mantel, while soft chamois tones and furniture in natural linens and mohair help keep the feeling light and airy.

When she was in third grade, Nashville-based interior designer Allyson Justis knew she wanted to be an interior designer as soon as she spied a round, hot-pink, crushed-velvet bed in the window of a Los Angeles furniture store. Her father had taken her for ice cream as a reward for her good grades, and while she didn't get that 1960s-era bed that day, she did turn to him and in a confident tone declare: "I'm going to be a decorator."

For 22 years, and for the last 11 as the owner of her own firm, Allyson has practiced her art and honed her listening skills in order to deliver spaces that work for her clients, regardless of style. Her training at Mississippi State University, while focusing on interiors, also included architecture and landscape architecture, which means that her approach to interior design is broadly focused on all aspects of creating a home. Indeed, her clients come to her for that "big-picture" expertise plus her skill in planning and executing truly functional spaces with a touch of French flair and an eclectic, comfortable look with exceptional detailing. "I love to throw something interesting in a room, whether it's a color or an item or perhaps a surprise feature," she says, noting that

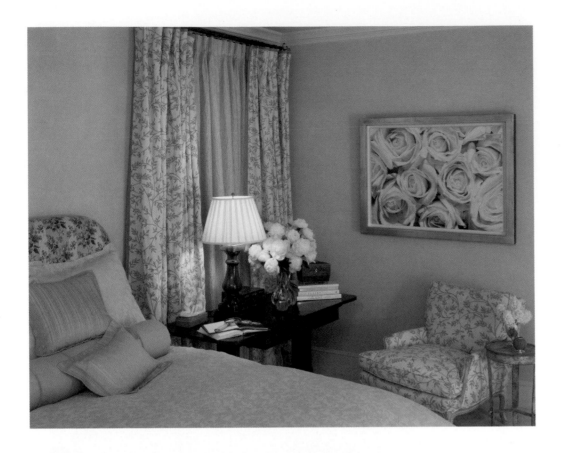

she's always working around a different focal point in each project. Her clients, in locales from Tennessee to California, return to her over the years, too. At the moment, she's working on her sixth project for a couple in upstate New York whom she began working with in Nashville in the late 1980s.

Blessed with an exceptional visual memory and the ability to draft all of her projects by hand—"I know it's old-fashioned but I like to work that way," she says. Allyson is a stickler for research and for lavishing personal attention on each project. Keeping her company relatively small has meant that her clients benefit from a designer who is deadline oriented and an expert problem-solver, plus truly involved with all aspects of a job. "Every room has to start with something," she says, noting that it's never the same thing, and that is what keeps each project so personalized.

Getting the details right is a personal and professional goal for Allyson, who certainly isn't afraid to get her hands dirty. "I'll learn as much of the processes as I can before I specify a feature," she says, noting that veteran Los Angeles designer Rose Tarlow is an inspiration in this regard because

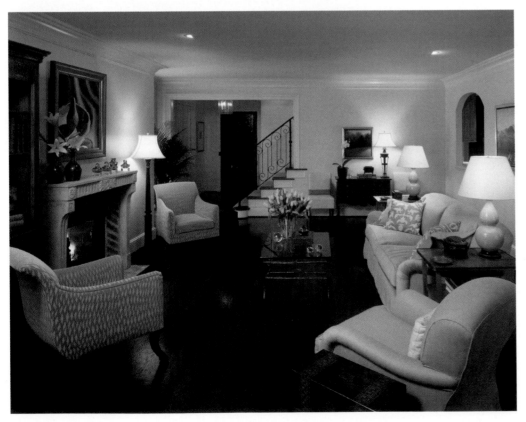

TOP Glazed walls in soft celadon highlight a painting by Tom Darnell in this peaceful, intimate bedroom dressed in pale shades of celadon, cream and icy gray. The linen crewel fabric used on the windows and chair is from Chelsea Editions.

BOTTOM Soft blue-green tones in linens and mohair provide sharp contrast to glossy dark wood floors in this living room, which includes upholstered furniture and honey-colored tiered tables from Rose Tarlow. The custom fireplace is framed by an 18th century Louis XVI stone mantel from a chateau in Vichy, France.

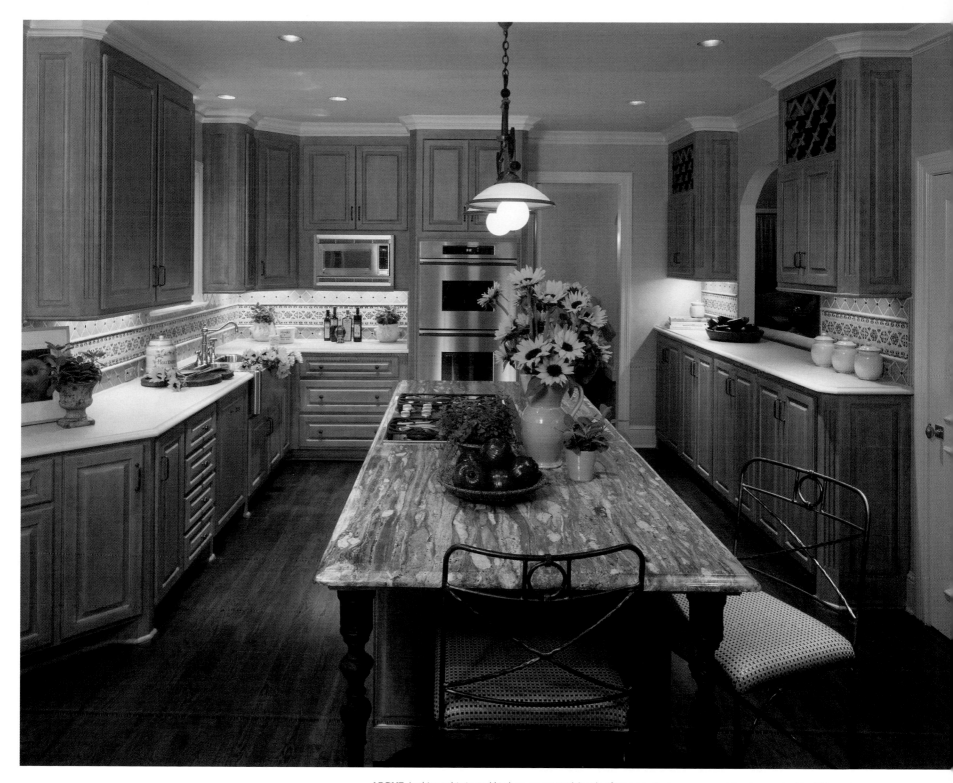

ABOVE In this sophisticated kitchen, an unusual South African granite top graces an island supported by 19th century Parisian newel posts. Ceramic tile and custom mosaic marble tiles in pistachio, light blue, cream and black, weathered oak cabinets and glazed walls in pale blue lend both texture and a calming quality. The custom barstools are hand forged.

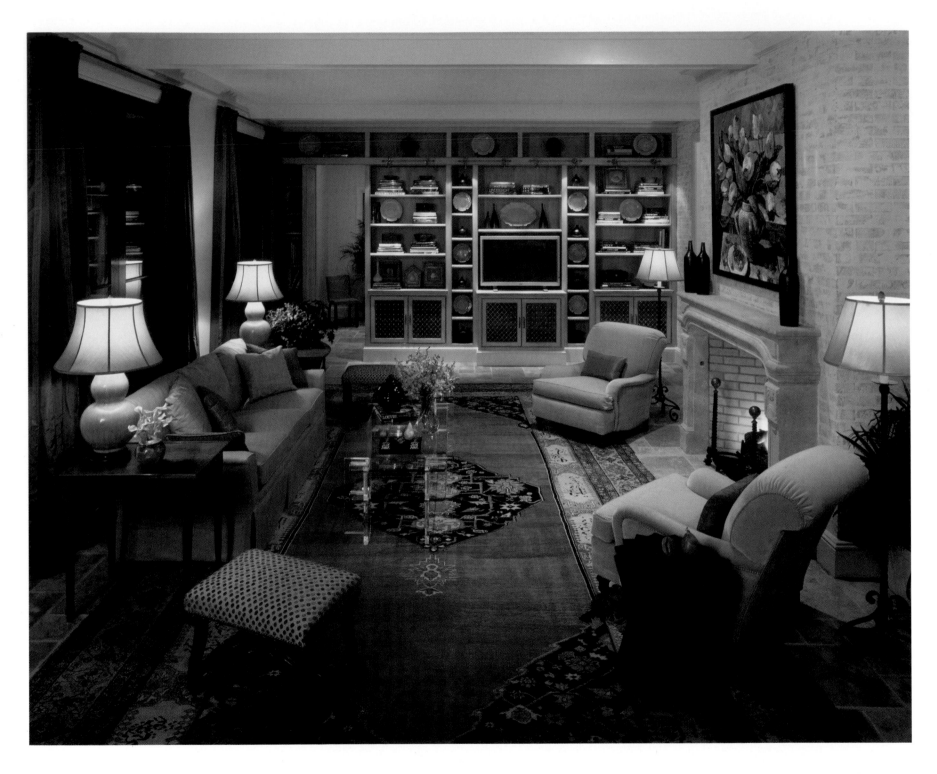

she isn't afraid to rough up a finish on a piece of furniture if it isn't right. "I'll get involved with it, too," says Allyson. "I'll get the paint brush out and work on it." Regardless of her past portfolio, however, she isn't hired for a particular style. "My job is to make it work for them, not for me," says Allyson, who likes tackling difficult projects, especially remodeling jobs that involve solving problems. "When someone presents me with a difficult challenge, I love it," she says with a smile.

ABOVE An antique Serapi rug is teamed with yards of silk curtains over dark-stained mahogany doors in this cozy living room. Comfortable upholstery in shades of camel, celery, persimmon, watercress and eucalyptus is accented by a contemporary cocktail table. The Burgundian stone mantel dates from the late 18th century.

TOP RIGHT Iridescent glass tile, stainless appliances and crisp ivory cabinetry add a contemporary edge that contrasts with an original wooden beam in this renovated kitchen in Nashville. Baccarat's graceful amber crystal pendants illuminate the island.

BOTTOM RIGHT Parchment tones, rich reds and dark blues provide a classic feel to this renovated living room, which includes a ratchet-style sofa covered in Clarence House fabric. French chairs, English tables and a Jacobean folding screen add comfort and elegance.

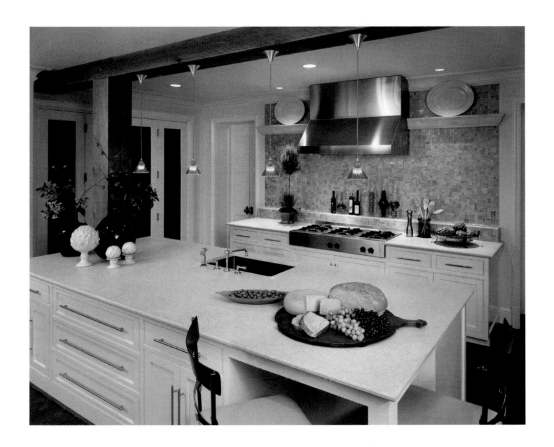

More about Allyson ...

DESCRIBE YOUR STYLE OR DESIGN PREFERENCES:

"I try not to do 'of the moment' so that the design is as current in years to come as it was the day it was completed."

WHO HAS HAD THE BIGGEST INFLUENCE ON YOUR CAREER?

Allyson credits famed Nashville designer Dan Burton, a former employer, for training her to listen to clients' wants and needs and also to always try to work with clients' favored pieces, and not solely from scratch.

WHAT SEPARATES ALLYSON FROM HER COMPETITION?

Allyson is justly proud of her firm's reputation for meticulous and detailed planning, plus personal oversight on every project. She makes clients feel comfortable, works with the space given and makes a point not to force things so that they look contrived. A very hands-on designer, she learns how the work is done when it comes to specialized techniques and how to come up with an end product rather than just a design.

ALLYSON INTERIORS
Allyson Justis
3610 Woodmont Boulevard
Nashville, TN 37215
615-383-7010
FAX 615-383-0280

CINDY McCORD

CINDY McCORD DESIGN, INC.

Memphis native and interior designer Cindy McCord loves creating timeless and traditional interiors with a sophisticated yet comfortable feel. "I like for my projects to have a truly classic yet livable feel," says Cindy, who has been a designer for 24 years and has spent the last 14 at the helm of her own full-service interior design firm. She grounds, and gives her rooms character, with beautiful old rugs and unique antiques. Regardless of color choice or period of furniture used, Cindy always prefers a warm and inviting look. "I like for things to be clean lined and simple," Cindy adds, "and my belief is that a home should have a bit of the past, the present and the future, and always reflect the personality of the client."

Cindy began her career in the commercial arena working in hospitality. While she gained exceptional professional experience, she always dreamed of working on a more personal level with her clients and in the intimate spaces of residential design. Today, her design work is focused 80% on residential, 20% on light commercial, and she tackles about an equal amount of new construction and renovation work in a given year. Cindy also has worked on several vacation homes in and out of town, and one recently published project involved a home on the island of Grenada.

ABOVE The most frequently visited space, the kitchen, needs to have the right combination of colors. This room, sprinkled with light green and yellow citrus colors, making it fresh and happy, is a perfect combination to encourage conversation with family and guests.

LEFT Warm Colors and interesting textures contribute to the casual elegance of this family-friendly room.

CINDY McCORD DESIGN, INC.
Cindy McCord, Allied Member, ASID,
Registered Interior Designer in Tennessee
9489 Fox Hill Circle North
Germantown, TN 38139
901-752-3804
FAX 901-309-2229

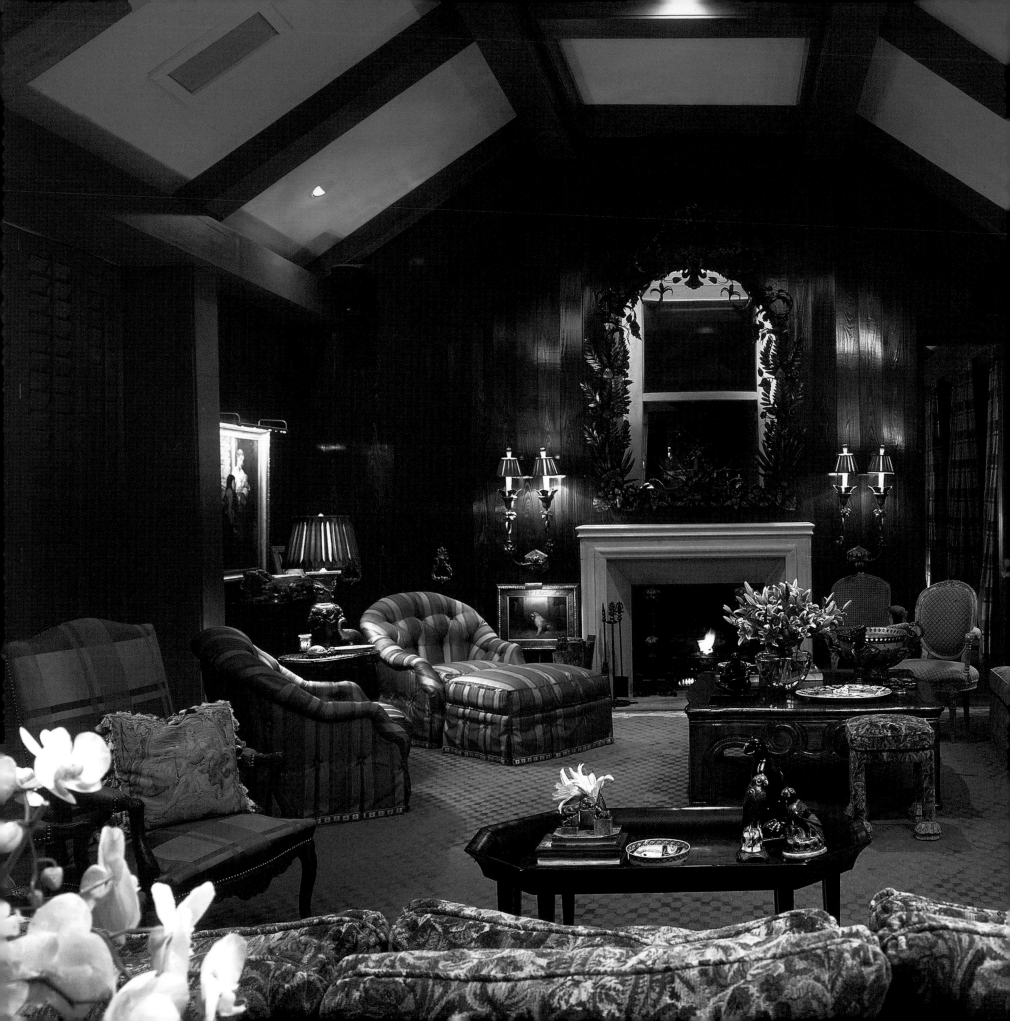

LANNIE NEAL

L. NEAL INTERIORS

Lannie Neal—veteran designer, Renaissance man and lover of French antiques— may say he's partially retired, yet he continues to create extraordinary interiors from Nashville to New York, Palm Beach, Paris and other far-flung points on the map. He fits his design work—often these days for the children of earlier clients, and with the help of his associate Sally Henderson—around his monthly trips to the Big Apple to hear the Metropolitan Opera and his regular jaunts to France. At the moment, Lannie's projects include a penthouse in New York City and homes in Boca Raton, Florida, and Mississippi. "I travel to eat, and I just happen to work in between," quips the designer, who has worked in the field for over 40 years.

After graduating with a fine arts degree from Peabody College at Vanderbilt, Lannie was headed to the prestigious Parsons School for Design in New York when his stint in the military interrupted this plan. Later, he was persuaded to use his talents at home and went to work at Nashville's Percy Cohen Furniture Showrooms. An influential trip to London to visit his sister and see Queen Elizabeth II's coronation in 1953, followed by a three-month jaunt throughout Europe, fueled Lannie's passion for extraordinary French antiques. The unforgettable trip also helped hone his eye for the unmistakably relaxed yet elegant European style he has

LEFT Large sofas and lounge chairs contrast with Louis XV and XVI chairs in this friendly room, which is anchored by a massive, carved cocktail table and distinguished with antique French lamps.

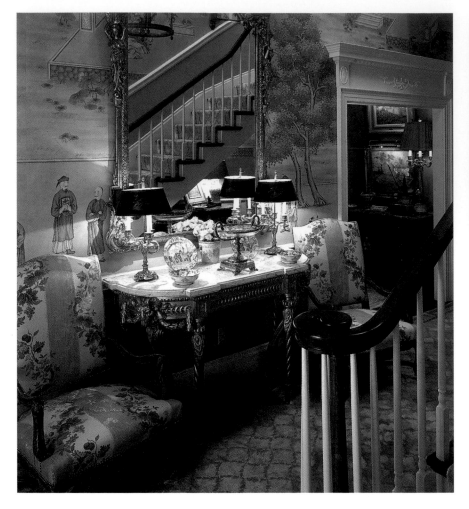

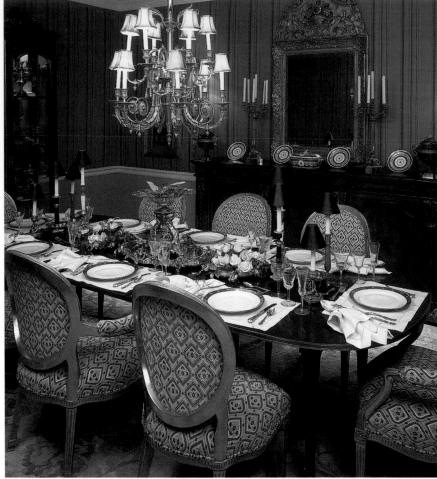

developed as his signature look, and it sealed his ambition to design. In 1972, he set out on his own, bought and renovated a building near Nashville's Centennial Park, and proceeded to train a multitude of Nashville interior designers who went on to make their own marks in the field. All the while, he was part antiques dealer, part interior designer, and always, focused on French furniture and accessories.

"If people don't want French they don't want me," says Lannie with a charming grin. He might use a casual French country style for a kitchen or a family room, but Louis XV and XVI are his favored duo. "It's all the classic style," he says, summing up his favored look, which includes fine French wood pieces, overstuffed seating, a copious amount of accessories, original art and sumptuous fabrics. "I'm a great believer in quality," he says, noting that he's especially fond of Louis XV furniture because of its heavier, carved qualities. "I love wonderful, overstuffed furniture with all wood pieces that are antiques."

While Nashville is home—Lannie grew up here, and he and his late wife Louise raised their two sons for the most part in Nashville—they also spent time living in Washington, D.C., in the 1970s, and enjoyed regular trips to a Paris apartment in the late 1980s and a home in Laguna Beach, California, during the 1990s. The opportunity to live in different places, experience different cultures and learn has always been paramount to Lannie, who supplemented his education and design experience with Sotheby's Decorative Arts Course in England, which gave him hands-on

TOP LEFT Hand-painted wallpaper by Gracy serves as a marvelous backdrop for the 19th-century French gilt console and mirror in an entry. The custom silk carpets throughout are by Hokanson and the 18th-century lantern is from Paris.

TOP LEFT A Louis Philippe curio graces an elegant dining room, which includes a 19th-century French chandelier and sconces. The 18th-century Italian mirror reflects a collection of porcelains from Jane Marsden in Atlanta.

FACING PAGE This comparatively narrow townhouse living room filled with art has room for 12 in period Louis XV and XVI seating. Karl Anderson's "Afternoon Tea" hangs over the gilt console, Philip de Laszlo's portrait hangs over the French limestone mantel, and a 17th-century Flemish screen graces the sofa wall.

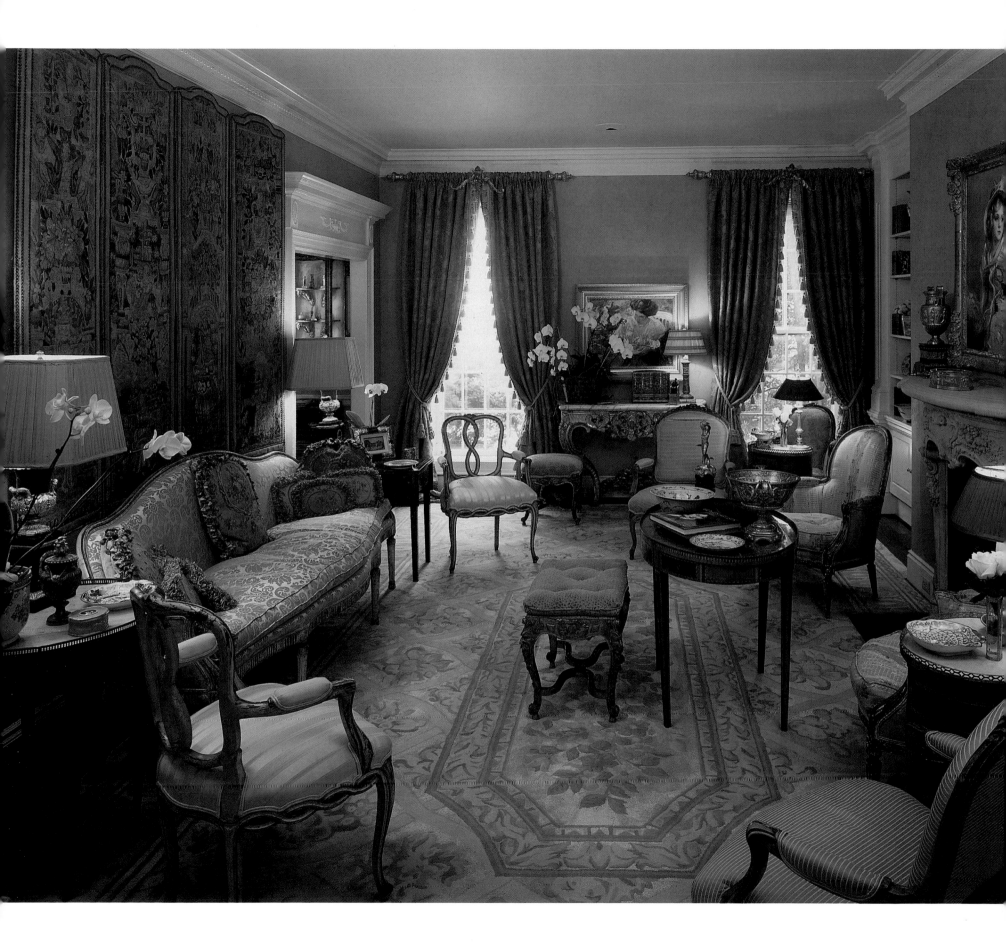

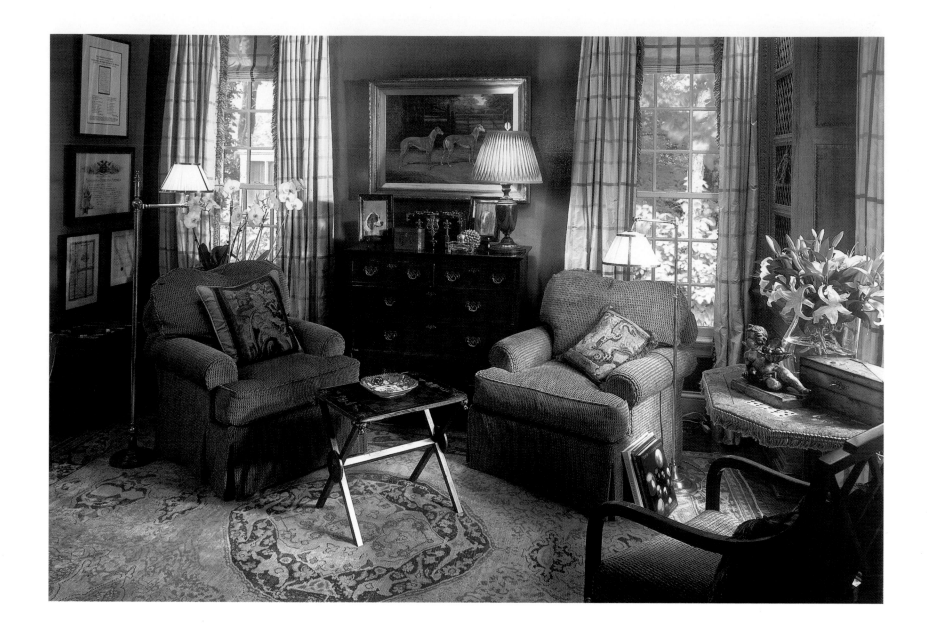

experience and connoisseurship training with a variety of continental porcelain, silver, furniture and accessories.

Lannie's work has garnered broad appreciation and has been published in prestigious magazines such as *Southern Accents* and *Southern Living*, but he considers his primary accomplishment to be his legion of friends around the world who have worked with him, learned from him and hired him over the years to create beautiful homes. "I've had one unbelievable life," he says.

ABOVE Luxurious comfort is the order of the day in this gentleman's reading room off a formal living room. The woodwork, moldings, and bookcases were carved by hand in Europe and the gilt was added locally.

FACING LEFT Carlton V fabric and Pierre Frey velvet drapery create a wonderfully private sleeping alcove in this master bedroom. The previous master bedroom now serves as a sitting room for the new sleeping area.

FACING RIGHT A mirrored commode and an Italian lavatory distinguish this dramatic space, which includes an 18th-century Italian mirror and a French chandelier and sconces. The fabric on the walls is from Brunschwig & Fils.

More about Lannie ...

WHAT IS THE HIGHEST COMPLIMENT YOU'VE RECEIVED PROFESSIONALLY?

One of the highest compliments Lannie receives from clients is when they tell him that a just-completed room looks "lived in," and the rooms continue to "live" comfortably for years.

DESCRIBE YOUR STYLE OR DESIGN PREFERENCES

Lannie loves a classic but comfortable, lived-in look with plenty of antiques, both furniture and accessories, and rooms filled with art, color and ambiance.

WHAT PERSONAL INDULGENCE DO YOU SPEND THE MOST MONEY ON?

Antique drawings—Italian and French from the 17th and 18th centuries, and carved antique church sculptures from Spain, Italy and France.

WHAT COLORS BEST DESCRIBE YOU AND WHY?

Reds, pinks, yellows. Cheerful colors because Lannie likes to be an "up" person.

WHAT ONE ELEMENT OF STYLE OR PHILOSOPHY HAVE YOU STUCK WITH FOR YEARS THAT STILL WORKS FOR YOU TODAY?

Quality. Lannie would rather have one good piece than a room filled with just ordinary things. He loves to mix new with wonderful, warm antiques, preferably from France.

NAME ONE THING MOST PEOPLE DON'T KNOW ABOUT YOU

In 1958, Lannie found himself drafted into the U.S. Army, and he ended up at Ft. Hood in Texas at the same time as Elvis Presley. "I chose not to go hear Elvis perform," recalls Lannie. "Instead I went to Dallas to hear Maria Callas sing!" Another interesting tale: Lannie once worked as a desk clerk at Nashville's famed Hermitage Hotel, and ended up being Gloria Swanson's dinner partner one night.

L. NEAL INTERIORS
Lannie Neal
Columbia, TN
615-356-6051
FAX 931-682-9175

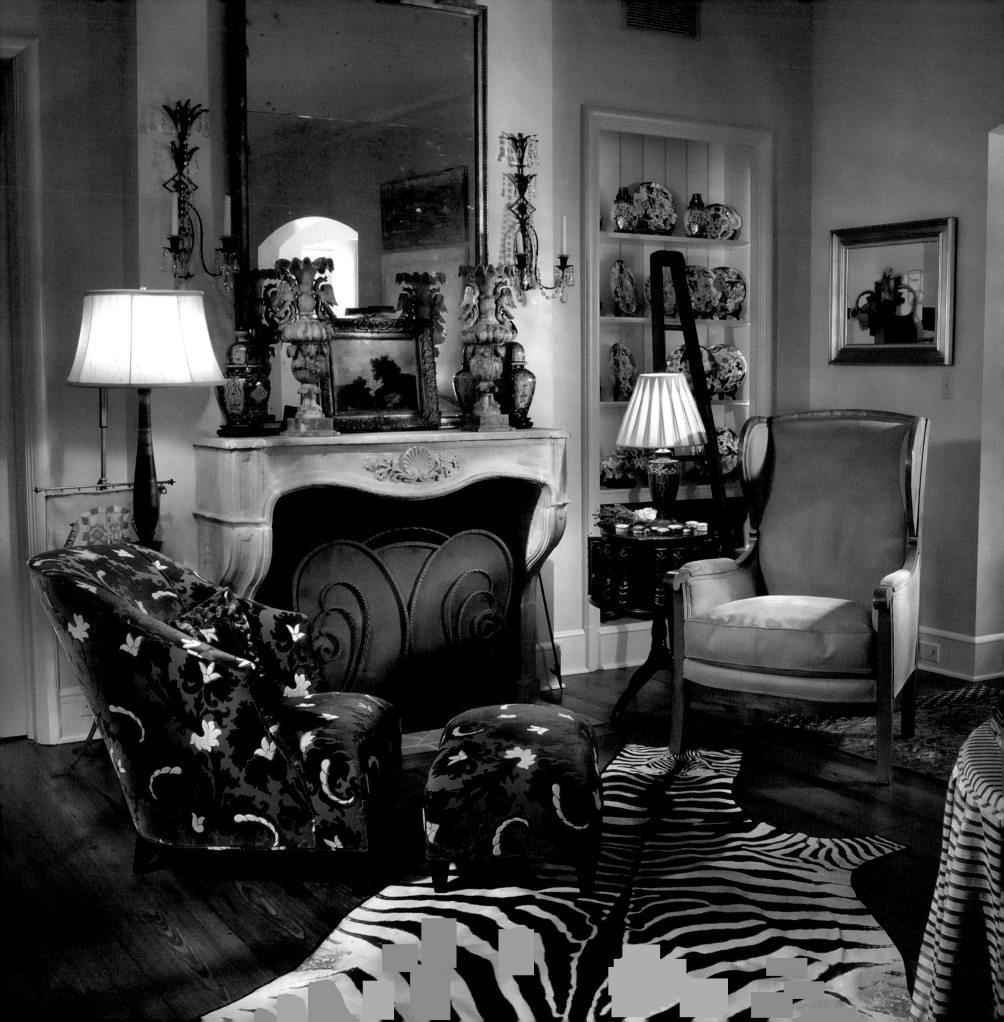

Memphis-based interior designer Biggs Powell began his namesake firm in 2002, and since then he has made a big splash in the design world, landing coverage in magazines such as *Southern Accents* and *Veranda*. In 2003, *House Beautiful* named him one of "America's Top Young Designers," and while he notes that his design work is classically inspired, he is quick to point out that he loves period rooms as well as classic modern design.

Besides his work with interiors, another aspect of Biggs' firm is his extensive inventory of antiques and decorative objects from the 19th to the late 20th centuries. His pieces are sold online on his web site as well as on the noted decorative arts design site www.1stdibs.com, and by appointment at his design studio. "I try to find things that are interesting based on texture, form and finish regardless of age or pedigree," he says.

Layering early 20th century pieces with more traditional French and English antiques is a forte. Using lighting as an example, Biggs is a proponent of juxtaposing contradictory elements in order to add an unexpected counterpoint to a room, whether it's a period crystal

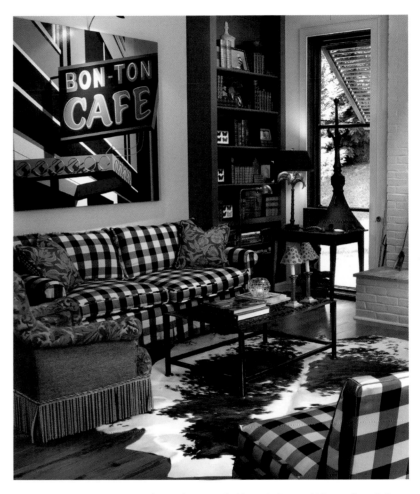

ABOVE Strong contrast in this study is provided by an Italian cowhide, a sofa and slipper chairs covered in a large-scale gingham, and "Bon Ton Café," an oil on canvas by Memphis artist Cindy Blair.

LEFT A zebra skin leads the way into this living room, which highlights a period French limestone mantel flanked by Donghia's shell chair and ottoman covered in "Brunelleschi" velvet.

chandelier to lend a surprise in a modern space or a pair of vintage Murano lamps to enliven a traditional room. "I stress the functionality of a space," says Biggs, who enjoys the careful use of color to create mood and flow. "I try to weigh the functionality of a space equally with the aesthetics," he says, noting that ideally, spaces are both visually interesting and physically comfortable.

While skilled with working with new construction, the character and solidity of older homes particularly appeals to Biggs, who has tackled numerous renovation projects for clients. Whether an older home or new construction, he focuses first on appropriate architectural details that achieve the correct scale and proportion before the "decoration." With good bones in place, he is able to create ideal interiors truly meant for living.

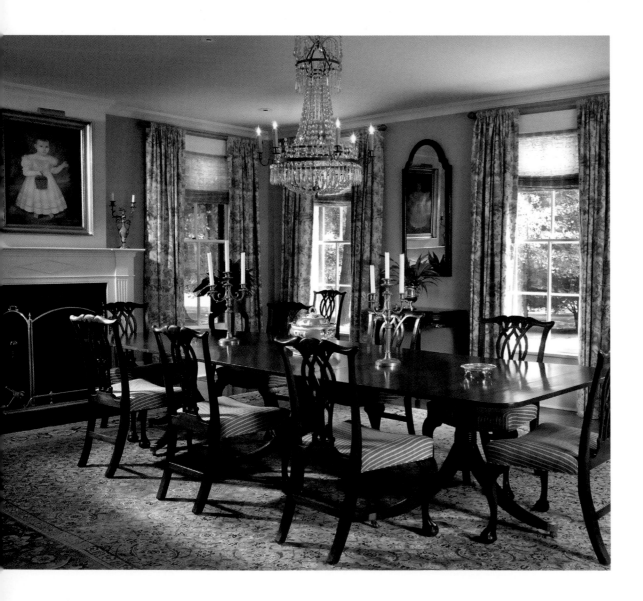

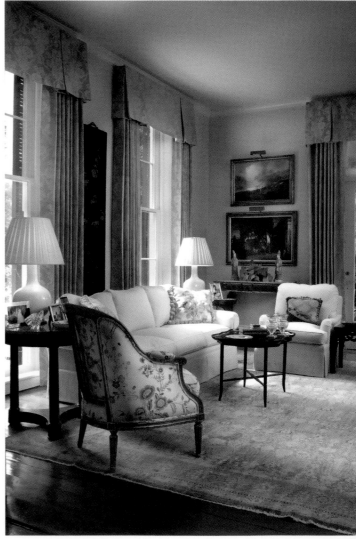

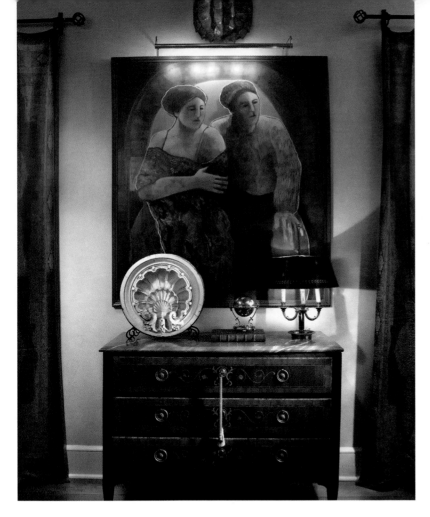

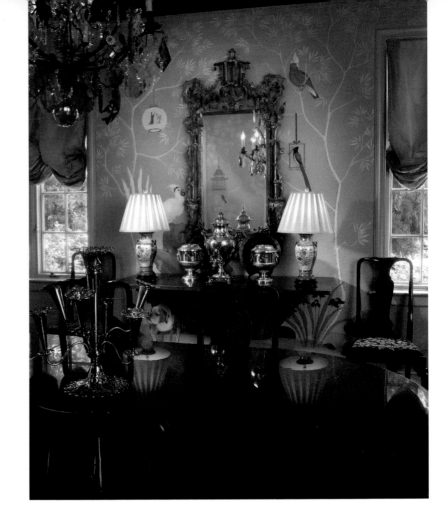

FAR LEFT A pale blue-green by Donald Kaufman sets the mood in this traditional dining room, which features a triple-pedestal dining table surrounded by period Chippendale dining chairs.

NEAR LEFT Silk Damas D'Orsay drapery and an antique Caucasian rug set off a light-filled living room with a neutral palette. ABOVE In a formal living room, an oil painting by Montgomery artist Barbara Gallagher sits above an inlaid commode with a marble top.

ABOVE In a formal living room an oil canvas by Montgomery artist Barbara Gallagher sits above an inlaid period marble top commode.

ABOVE RIGHT An antique gilt Chinese Chippendale mirror flanked by period walnut Queen Anne dining chairs centers a dining room hand painted by New York artist Robert Speed.

More about Biggs ...

WHAT PERSONAL INDULGENCE DO YOU SPEND THE MOST MONEY ON?

"Unfortunately, my home," says Biggs about his home in Memphis. "The projects never end." Of course, this helps him relate better to his clients in the midst of renovation projects.

WHAT ONE ELEMENT OF STYLE OR PHILOSOPHY HAVE YOU STUCK WITH FOR YEARS THAT STILL WORKS FOR YOU TODAY?

"Keep things simple—less is more. If you don't love something and don't need it, don't use it or don't buy it."

WHO HAS HAD THE BIGGEST INFLUENCE ON YOUR CAREER?

Biggs says that his parents have influenced his career, and that their support has been the underpinning of his success.

BIGGS POWELL INTERIOR DESIGN & ANTIQUES
Biggs Powell
1698 Monroe Avenue
Memphis, TN 38104
901-725-5225
FAX 901-725-5255
www.biggspowell.com

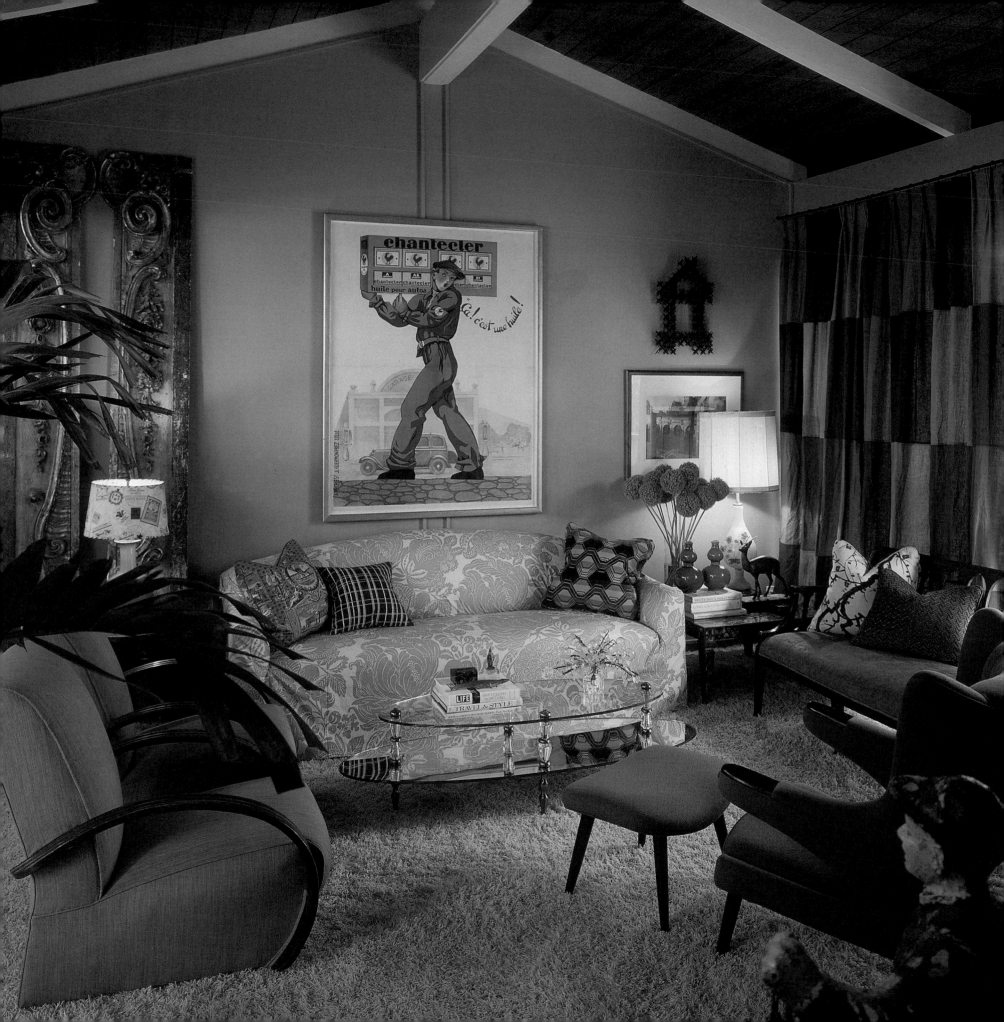

LEE PRUITT

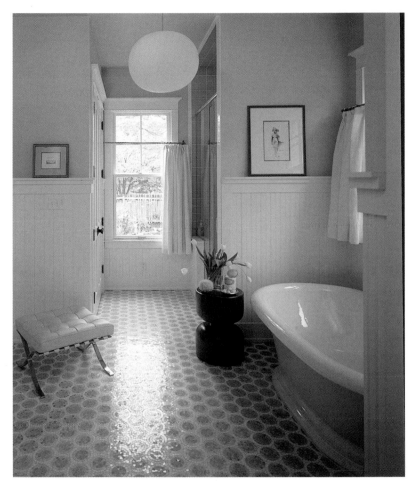

ABOVE A hand-cut mosaic floor, Knoll's "Barcelona" stool, and linen curtains distinguish this sophisticated bath. A teak tree trunk serves as a side table.

LEFT This mid-century modern house exudes bohemian chic thanks to a Danish Wegner chair, 1940's French mirrored coffee table, a rare 1920's French poster and hand-cut linen square curtains.

Arkansas-born, Memphis-based interior designer Lee Pruitt is happily busy and sometimes hard to pin down, but when he is, excellent design follows in his wake. "I like taking chances and mixing periods," says Lee, who works on a lot of new construction but loves a good remodeling project, too. "I love unique things that give tons of character to a room." In his heart of hearts, Lee would adore a highly personalized, chic and sophisticated bohemian interior, ripe with fabrics and amazing accessories. "It's comfortable, it's not formal and it's easy," he says about a rich bohemian look. "It's the eclectic mix of things and patterns...it's an English tuxedo-style sofa with a '50s chair." But regardless of the style he's working in at the moment, he's very people-focused. "I like finding design in the person's personality," he says about working with clients. "Some people are subtle and like their rooms subtle, while some people are aggressive and like their rooms to be bold."

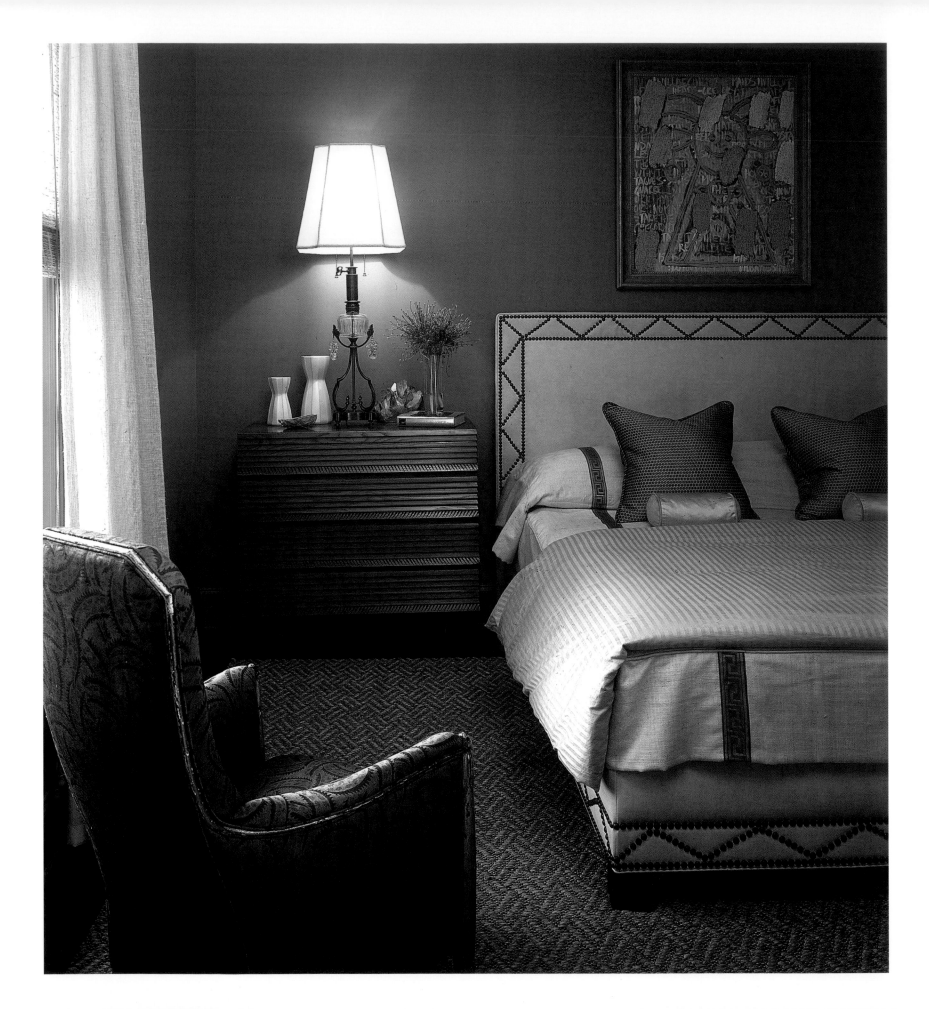

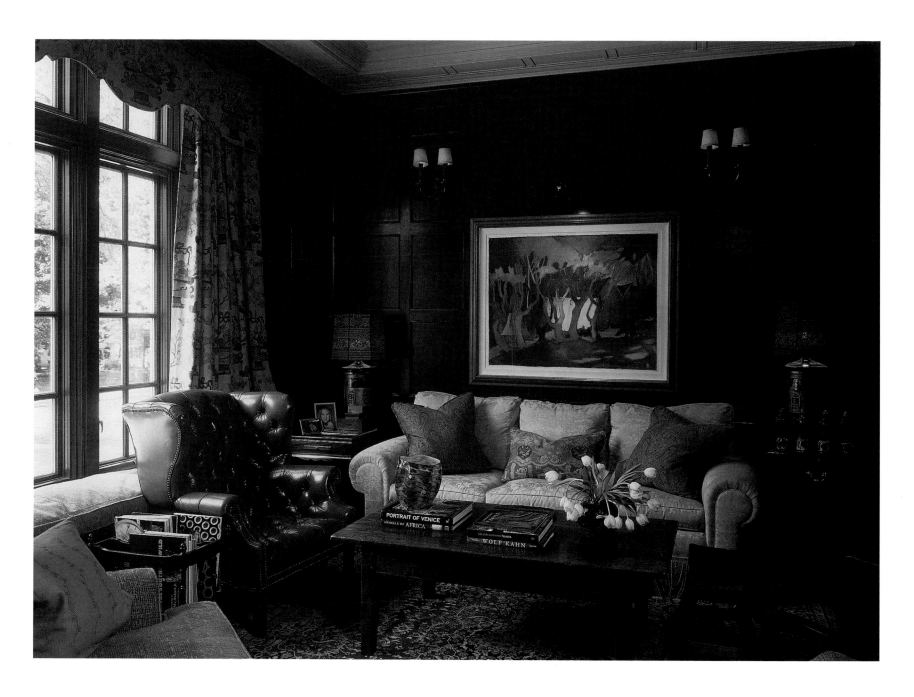

LEFT A Frank Lloyd Wright chest and period French Deco chair complement the custom leather bed with nailhead detailing in this bedroom.

ABOVE A pale sofa keeps this walnut-paneled room with vintage linen curtains from looking too expected. The lamps with original paisley shades are from the estate of Bette Davis, and the painting is by Frelda Hamm. A 19th-century Mahal rug injects color and warmth. The art glass on the table is from Chihuly.

"At heart, I'm a frustrated architect," says Lee, who initially chose that career before switching to design. "I realized I liked the interiors, color, texture and pattern more than I liked the engineering part," he says. That early architecture training has come in handy— Lee is an inveterate sketcher who has a gift for drawing details and working with builders to make sure nothing gets left out of a job. After earning a BFA in interior design from the University of Memphis and working for famed Memphis-based interior designer William R. Eubanks for nine years, Lee opened his own namesake firm in 1994. Today, he employs five people and works with four freelance designers, and completes projects

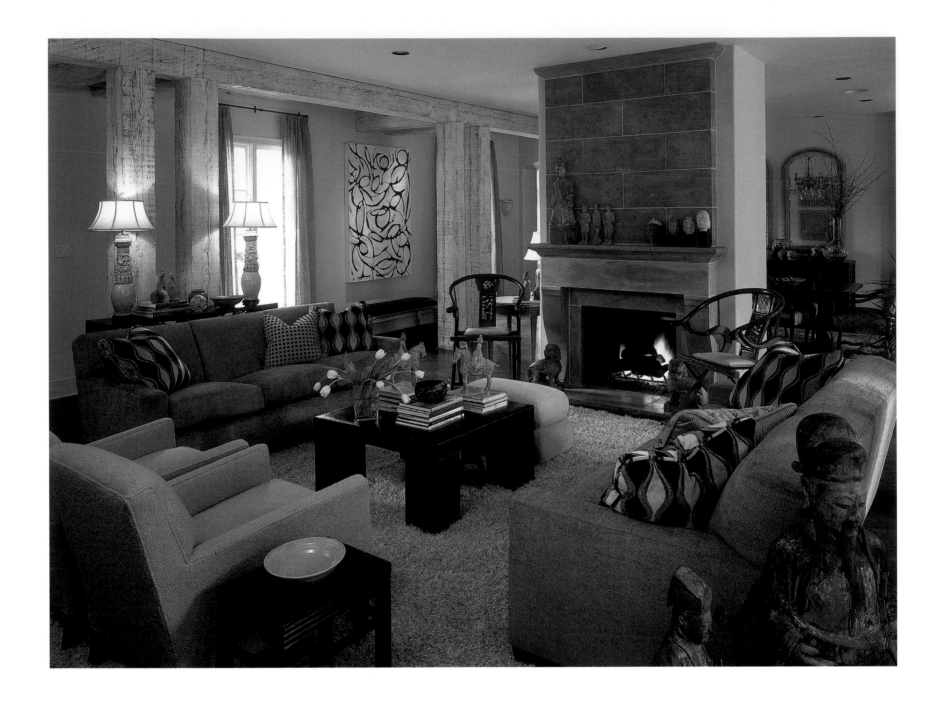

from Memphis to California, New York and Connecticut as well as across the Southeast. He even helped consult on a boutique hotel in the Cayman Islands.

For his Memphis-based retail shop, Lee likes to source items worldwide. Everywhere he travels he's on the hunt for fantastic finds, and they overflow into his 16,000-square-foot warehouse. "I'm unique—I'm not a big, go to market in Atlanta, person," says Lee, who has custom lamps made for the shop and focuses on custom furnishings. "I hate seeing the same thing over and over again." And that goes for design, of course, as well as individual objects.

ABOVE Lime-washed cedar beams and a French limestone mantel add substance to this living area, which features a collection of Chinese artifacts. Note the shag rug and the cocktail table, which is upholstered in faux alligator.

RIGHT Gas lanterns illuminate French-polished woodwork, old terra cotta flooring, and a 19th-century English oak bench in this Tudor-style home.

FAR RIGHT Back-to-back velvet sofas make the most of this cozy yet large room, which features an 18th-century Scottish limestone mantel and reclaimed beams and ceiling.

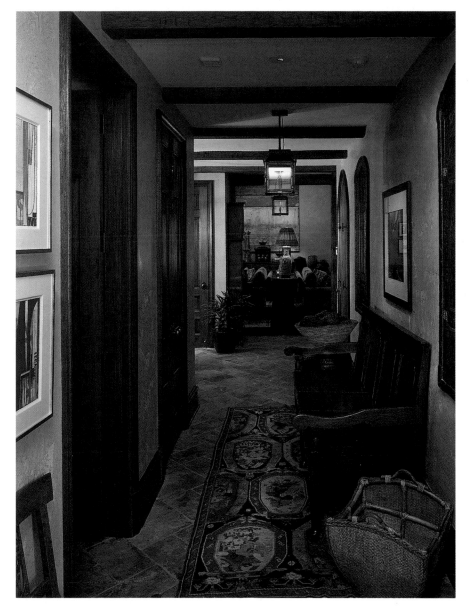

More about Lee ...

WHO INSPIRES YOU, DESIGN-WISE?

Design icons Coco Chanel, Billy Baldwin, Picasso, Billy Haines and Albert Hadley have all been influential to Lee. "What inspirations!" he says.

WHAT IS THE HIGHEST COMPLIMENT YOU'VE RECEIVED PROFESSIONALLY?

In addition to satisfying clients, Lee has been published in many national magazines, including *Southern Accents, Veranda, Better Homes and Gardens* and *Beautiful Homes,* among many local and regional publications.

WHAT IS THE BEST PART OF BEING AN INTERIOR DESIGNER?

"The creative process," says Lee. "I can walk into a room and see it finished in my head."

LEE PRUITT INTERIOR DESIGN
Lee Pruitt, Allied Member, ASID
2259 Central Avenue
Memphis, TN 38104
901-274-9184
FAX 901-274-9182
www.leepruitt.com

ROBIN RAINS

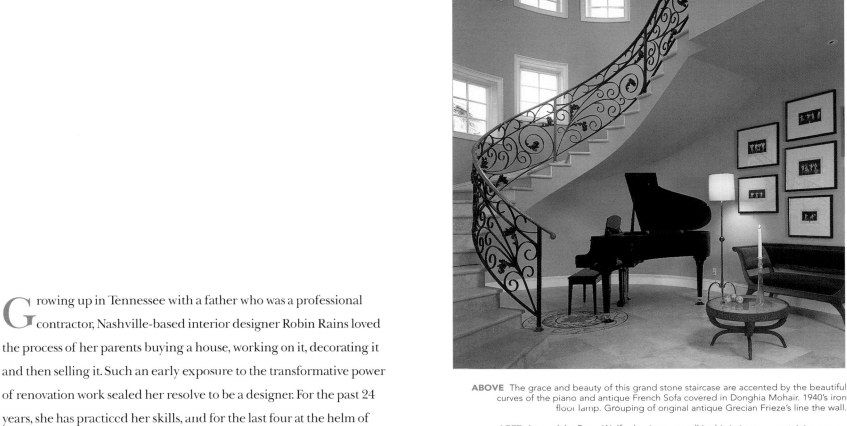

ABOVE The grace and beauty of this grand stone staircase are accented by the beautiful curves of the piano and antique French Sofa covered in Donghia Mohair. 1940's iron floor lamp. Grouping of original antique Grecian Frieze's line the wall.

LEFT Art work by Rusty Wolfe dominates a wall in this intimate entertaining space. Donghia fabric on Brueton sofa, antique biedermeier tables, chairs by Bill Sofield for Baker with wool fabric by Castel. Cocktail table by Ironware International. Benches made by local craftsman with fabric by Clarence House.

Growing up in Tennessee with a father who was a professional contractor, Nashville-based interior designer Robin Rains loved the process of her parents buying a house, working on it, decorating it and then selling it. Such an early exposure to the transformative power of renovation work sealed her resolve to be a designer. For the past 24 years, she has practiced her skills, and for the last four at the helm of her own firm, Robin Rains Interior Design. A consummate professional whose work spans luxurious urban residences, vast country houses and upscale beach properties, Robin feels that function and appropriateness are critical when it comes to designing spaces for her clients, regardless of their setting. "The furnishings in a house should be indigenous to that space," she says, noting that "it's not just the period, it's also the scale, the size of the rooms and the height of the ceiling."

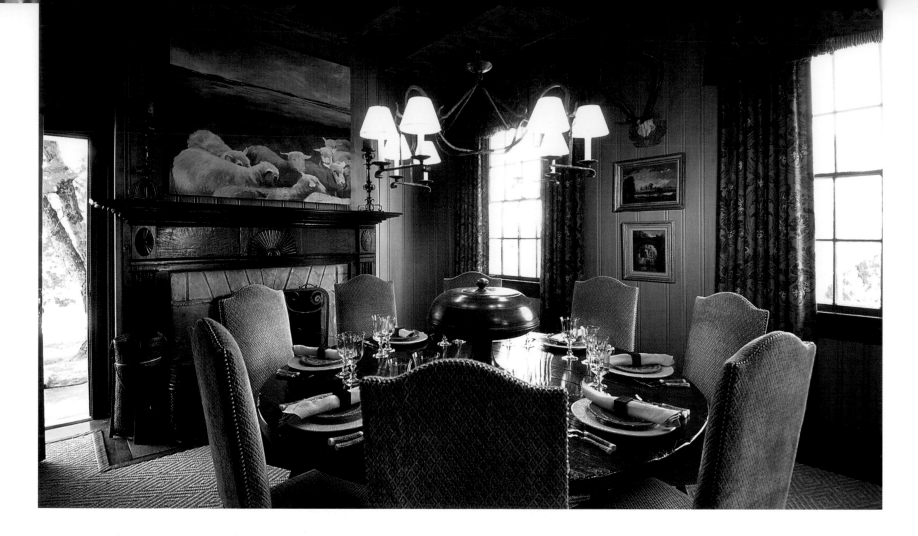

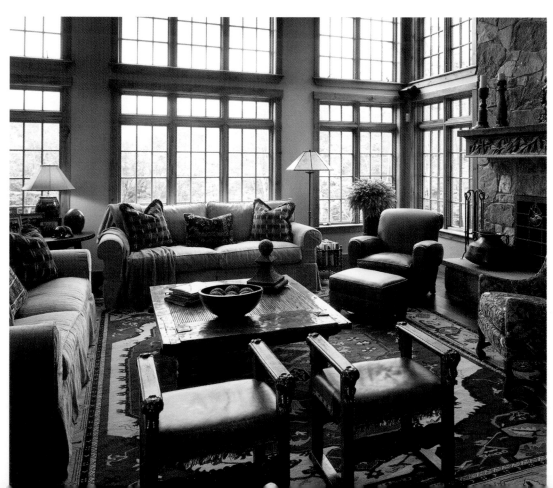

ABOVE Entertaining is frequent at this dining table during Fox Hunting Season in this Cornersville, Tennessee weekend home. Dining table was custom made in England, Antique French chairs with Old World Weavers fabric. Stark carpet. Drapery fabric by Schumacher.

LEFT A large bluestone fireplace anchors the living room in this mountain home while the mixture of rich patterns and colors warm the space. Pair of Italian footstools from the late 19th century sport original leather and trim. Heirloom wing chair holds a Westgate linen print. Antique Indonesia weaving table from Jalan-Jalen. Serapi oriental rug. Iron fire-screen by Herndon & Merry. Wooden mantle was hand-carved by local craftsman.

RIGHT This contemporary kitchen features an impressive range of textures: Maple cabinetry with frosted glass in geometric grid pattern, black granite and patterned stainless steel backsplash. The island is angles to encourage socializing! Bar stools by Mirak, custom Asian screen with rice paper designed by Robin Rains Interior Design and made by Premier Trade Group. Art by Carrie McGee at Cumberland Gallery.

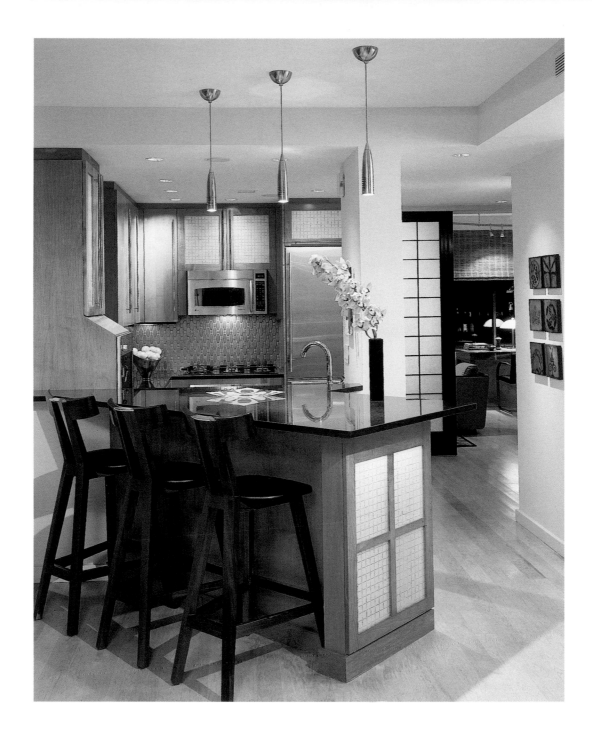

While clearly recognizing that nobody wants a design imposed on them, Robin's designs often feature a classic look with unexpected touches of modernism. The understated elegance that she is known for combines fine antiques with more modern pieces and often, custom furniture she has designed using exotic woods. To her, seeing what she creates come to life is one of the best parts of being a designer. "If you can dream, you can create what you dream," she says, pointing out the soft curve of a chair frame she had made out of rosewood, which appears as a stripe. "Using wood is a way to have the effect of color without its being perceived as color, and wood gives a vibrancy and warmth to the space. In a quiet room with quiet fabrics, the wood is what's accented."

To achieve a balanced contrast between old and new with her work, Robin loves using neutrals, especially oatmeal and gray tones, to provide a quiet backdrop for contemporary furniture spiced with timeless

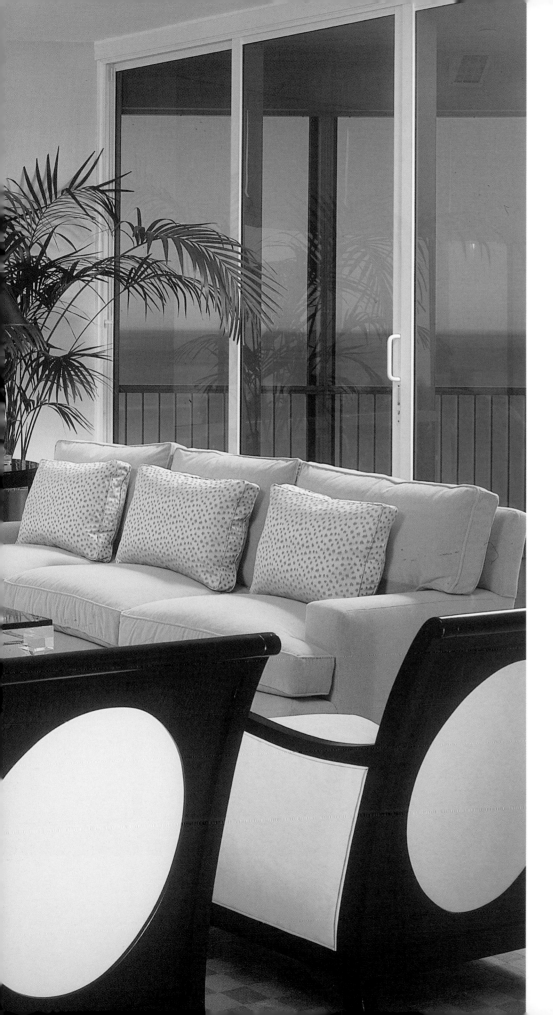

antiques. "I don't want my interiors to be so streamlined that they lack personality," she says, adding "nothing is more restful and beautiful than a room in a subtle range of shades of a single color." The challenge, and one that she meets beautifully with characteristic grace and calm, is keeping things soft and elegant, never boring, thanks to a range of textures from silk to linen, mohair, and velvet.

A self-proclaimed "people person," Robin enjoys the variety of working on projects as diverse as New York City apartments, a weekend house in Connecticut and a ski home in Vermont, as well as fine residences across Tennessee. Her newest venture is Old Hillsboro Antiques, a retail business in the picturesque Tennessee town of Leiper's Fork.

LEFT The living room in this Nashville family's beach home provides lots of space for entertaining and enjoying sunsets over the ocean. Sofas by Barbara Barry for Baker, gro point fabric by Zimmer & Rhode, pillow fabric by Jim Thompson, chairs by Milling Road, suede fabric by Kravet. Swaim chaise lounge, custom designed acrylic cocktail table by Creations. Hokanson carpet.

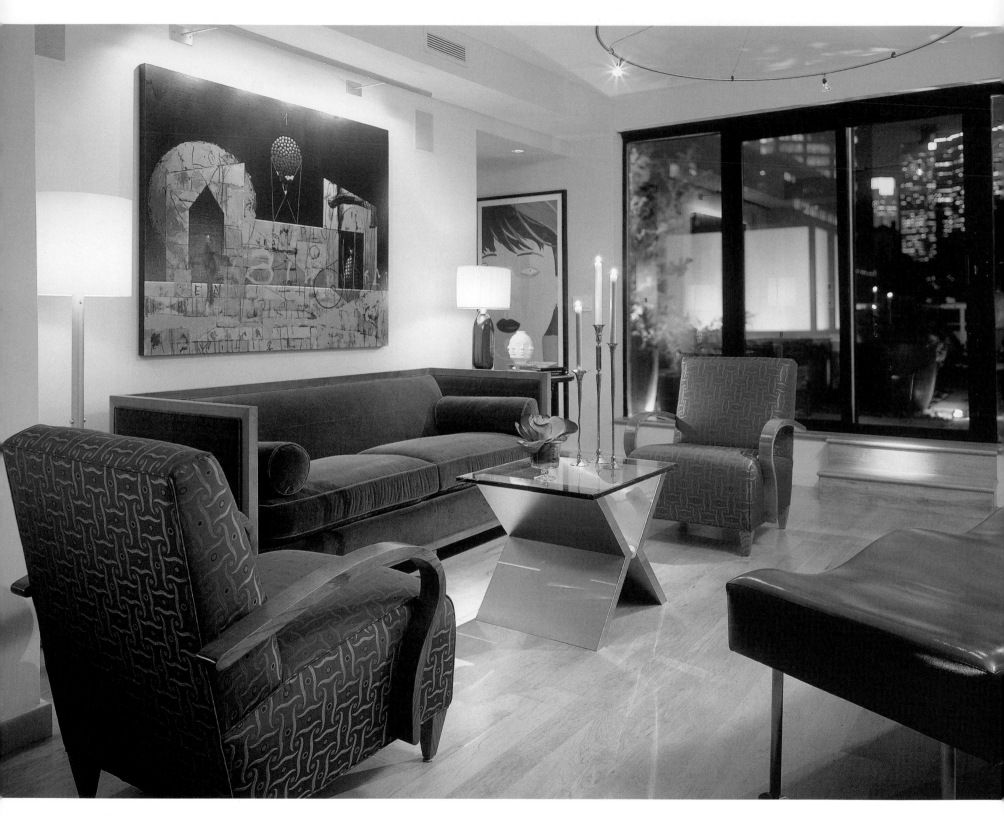

ABOVE This living room was designed with former assocaite Shelby McPherson. Shelby and I wanted to design this room using fewer pieces but incorporating strong lines and interesting shapes. Sofa is by Baker furniture with a gray mohair by Old World Weavers. Swaim chairs host a geometric silk by Donghia. Leather bench by Brueton. Metal cocktail table made by local artisan. Antique beidermeier table with frosted glass was used to soften the space.

Combining European antiques she selects personally and a variety of contemporary accessories, the shop is separate from her design studio but showcases pieces that appeal to her classic eye. Whether searching for the perfect piece or putting the finishing touches on an interior, Robin's work is a labor of love that is unique, never trendy. "The joy comes in knowing that your clients love it as much or more than you do," she says.

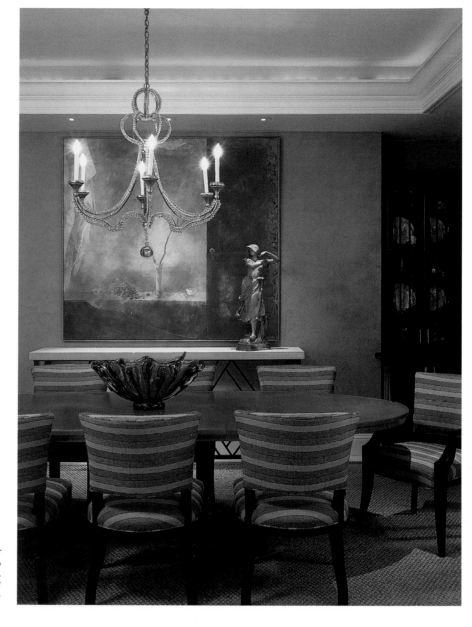

RIGHT
Comfortable chairs upholstered in a horizontal strip welcome guests to this dining room. Walls are Venetian plaster, dining table by McGuire, linen print drapery fabric from Ground Works. Art by Phillip Hershberger from Lisa Kurts Gallery, Sisal rug by Merida Meridian.

More about Robin ...

WHAT IS THE BEST PART OF BEING AN INTERIOR DESIGNER?
"Creating relaxed, intimate spaces that are so inviting that my clients never want to leave them," says Robin. "One of the best rewards is putting your 'all' into a job and seeing it turn out better than you ever dreamed that it would."

NAME SOMETHING THAT MOST PEOPLE DON'T KNOW ABOUT YOU
Robin's early work experience included a stint working at the local Farmer's Co-op and she also did makeup one year for the Miss Texas pageant.

WHO HAS HAD THE BIGGEST INFLUENCE ON YOUR CAREER?
"My parents," says Robin.

WHAT IS THE HIGHEST COMPLIMENT THAT YOU'VE RECEIVED PROFESSIONALLY?
"When clients tell me that I've helped take stress out of their lives, I know I've been successful."

YOU WOULDN'T KNOW IT, BUT MY FRIENDS WOULD TELL YOU I WAS...
"A perfectionist with loads of energy who loves to have fun!"

ROBIN RAINS INTERIOR DESIGN
Robin Rains, Allied Member, ASID; Registered Interior Designer in Tennessee
2047 Castleman Drive
Nashville, TN 37215
615-463-8885
FAX 615-463-3762
www.robinrains.com

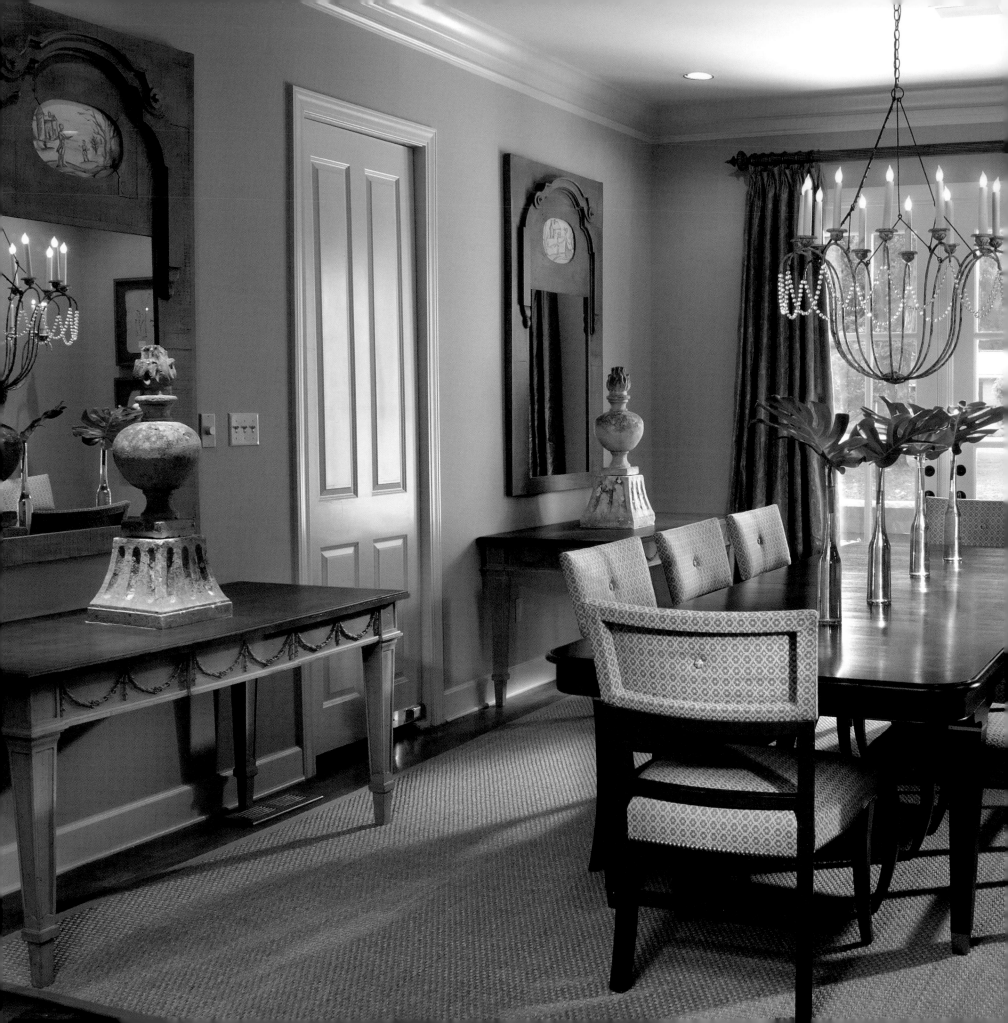

GRANT RAY & GREG BAUDOIN

RAY & BAUDOIN INTERIOR DESIGN

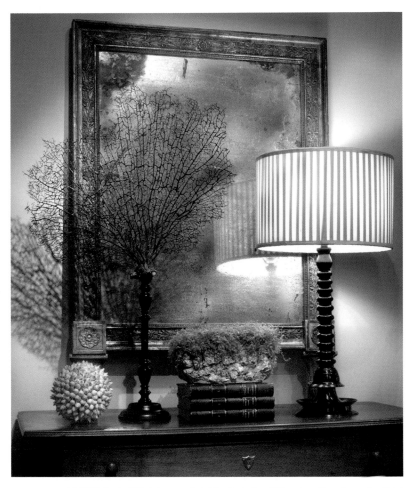

ABOVE Louis XVI style console tables featuring 19th century French garden finials mix with transitional style table and chairs to create a comfortable and elegant dining space. Trumeaux by Astier de Villate. Chandelier by Niermann-Weeks.

LEFT A 19th century Italian mirror rests on a French provincial commode with an interesting mix of decorative objects.

Memphis-based Grant Ray and Greg Baudoin of Ray & Baudoin formed their full-service interior design firm only three years ago, but between them they have a combined 20 years of experience in the field. Specializing in fine residences and vacation homes in the Midsouth and beyond, Grant and Greg work on everything from new construction and major renovations to "just redesigning a den," says Greg. While their work spans traditional European-inspired interiors to classic contemporary with a mid-century flair, it's not edgy, says Grant. It is, however, livable and comfortable and includes an unexpected dash of old mixed with new. "We may incorporate contemporary items or pieces in a traditional space but they will be classic pieces," says Greg.

Classic is indeed a buzzword for this design duo, who apply the word to period antiques as well as mid-20th century furnishings, which they both love because of the clean lines and updated look these pieces bring to any interior. "We like to incorporate them even though it might be in combination with an 18th century commode," says Grant, who points out that the draw toward mid-century classic contemporary pieces grows from the fact that they inject a freshness and

youthfulness into a room. The bedrock of Greg and Grant's design work, however, is stylish interiors that will stand the test of time without a trace of stodginess. Set against a traditional framework, antiques, sophisticated textiles and updated and even surprising elements create timeless rooms.

Three times each year, Grant and Greg travel to Europe to stock their retail showroom, which is on the ground level of their design studio and is filled with everything from antiques and important French pieces to mid-century finds and new accessories and lighting. "We're very diverse," quips Greg. "We appreciate 18th century things as much

as we appreciate contemporary design," adds Grant. Their careful shopping, primarily in France, constantly results in a very current mix of accessories and furniture that appeal to a broad market. Part of the joy of their design work is their hunt for the perfect piece, which often involves traveling. "You just never know what you're going to find," says Grant. And for consumers, that applies to their showroom, too.

BOTTOM LEFT A large upholstered mirror reflects a 19th century Italian chandelier hanging over a hand hewn table with a hammered bronze base. Drapery fabric by Malabar. Painting by Anne Siems.

BOTTOM RIGHT A painting by Memphis artist Kat Gore was the point of departure for this living room in soft neutrals and corals. Drapery fabric by Brunschwig & Fils. Coffee table by Julian Chichester of London.

FACING PAGE A serene bedroom overlooking the Mississippi river bluffs features a canopy bed dressed in Decorators Walk casement fabric. The custom walnut bench at the foot of the bed, designed by Greg Baudoin, is upholstered in Larsen "Metalworks."

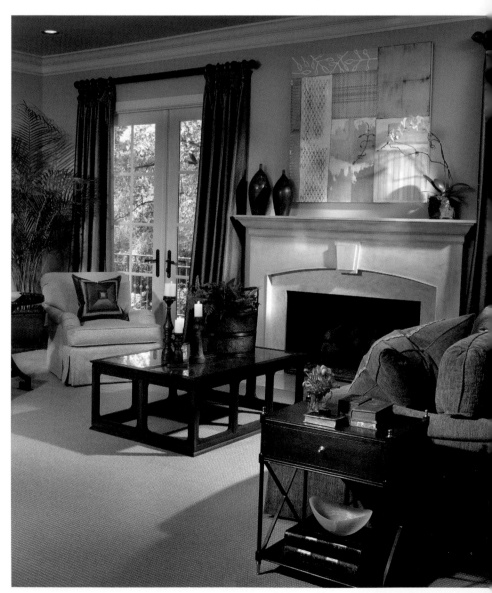

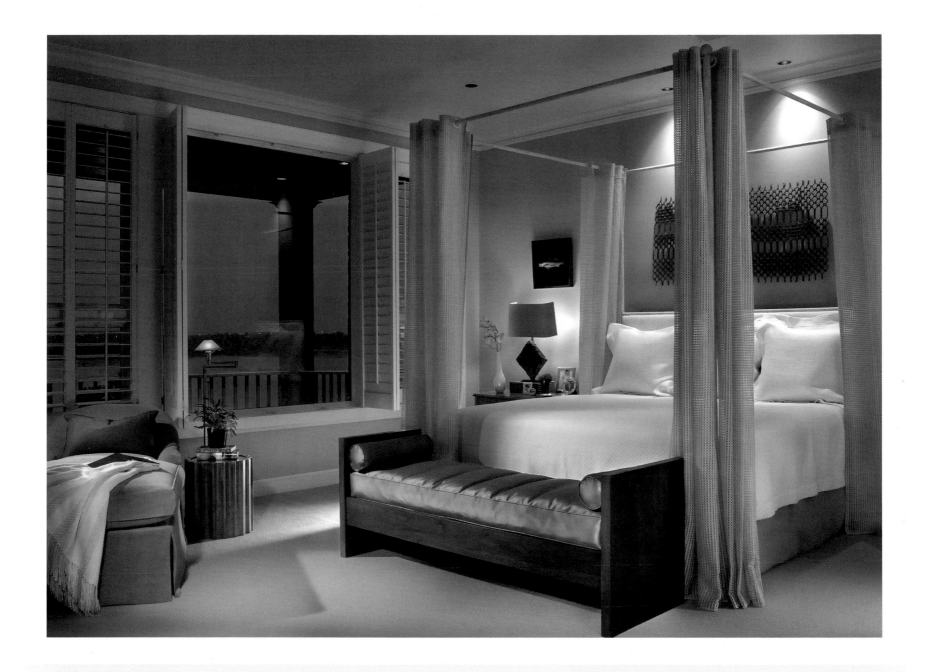

More about Grant and Greg ...

WHAT IS THE HIGHEST COMPLIMENT YOU'VE RECEIVED PROFESSION-
ALLY?

Being published in various design magazines has been a welcome accolade, but Grant
and Greg are especially thrilled anytime a satisfied client recommends them to a family
member or a friend.

WHAT IS THE BEST PART OF BEING INTERIOR DESIGNERS?

The fact that each project is uniquely challenging and allows the freedom of creative
expression, say Grant and Greg.

WHAT ONE ELEMENT OF STYLE OR PHILOSOPHY HAVE YOU STAYED
TRUE TO OVER THE YEARS?

Grant and Greg start with classic, traditional design elements as a framework and
then take into account the individual style and aesthetic of their clients.

RAY & BAUDOIN INTERIOR DESIGN
Grant Ray
Greg Baudoin
2206 Union Avenue
Memphis, TN 38104
901-791-0138
FAX 901-791-0148

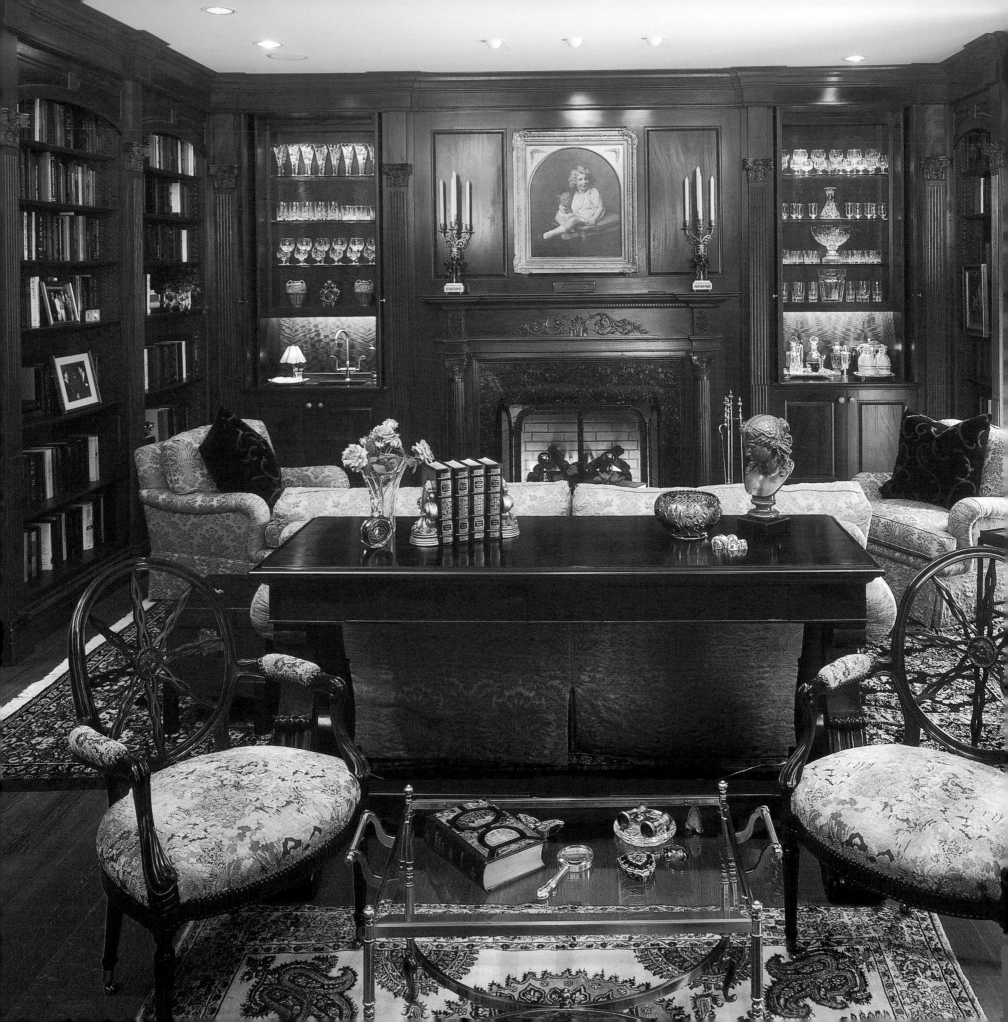

BARBARA G. RUSHTON
BRADFORD'S INTERIORS

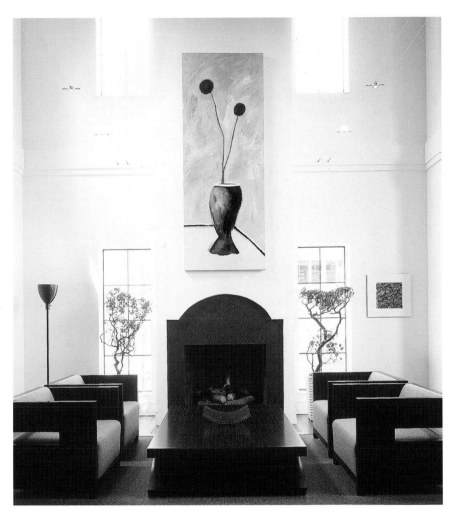

LEFT Warm and friendly, this small 'cocoon" library is a retreat within a 16,000-square-foot home built on beautiful farmland in the heart of Livingston, Tennessee.

ABOVE This sleek, urban entry/living room is located, surprisingly, on Nashville's traditional West End Avenue.

Barbara Rushton believes that interior design is an interpretive art—not simply an extension of a personal vision. "My focus is about enhancing the lifestyles of my various clients," she says. She also believes a good designer is a good listener, and one who learns her clients' interests, hopes, and even dreams. Once that groundwork has been laid, Barbara begins to use her skills to develop a plan truly unique to them. "Consequently, my work never seems to look the same. The best compliment I have received is when people have liked my work but had no idea of my involvement in the project."

The Tennessee based designer has spent the last 25 of her 32 year career with the well-known Nashville-based Bradford Furniture Company, where she is constantly renewing her skills through participating in some of the buying by attending markets nationwide and in Europe. "It's like a quick refresher course," she says. Barbara feels fortunate to have had two primary mentors in the Bradford's business, and early on,

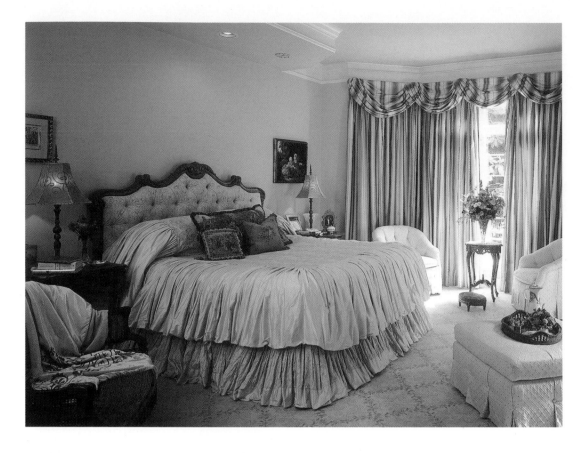

both were profoundly influential. "One showed me by example the importance of honesty, integrity, and professionalism, and the other taught me a deep appreciation for furniture craftsmanship and design." Less personally, Barbara continues to be inspired by noted designer Ralph Lauren. "He has always been able to transition from year to year and still have a fresh, sophisticated presence."

While inspired by others, Barbara is clearly an independent thinker. She likes her interiors to stress strong architectural character. "If it already exists, I work to enhance it. If it does not, I work to create it. I prefer unity in my backgrounds so that I can be a bit unpredictable in the arrangement of furnishings within." Her personal favorite style is contemporary, comfortable upholstery with antique case goods and, of course, art. "Art and more art gives a room soul," she says.

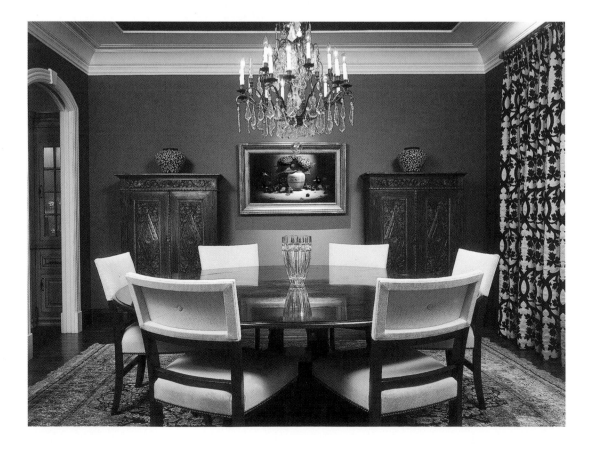

ABOVE An enchanting master bedroom suite nestled within a sophisticated Nashville home purveys a romantic escape for its industrious owners.

LEFT A large round table in an unconventionally designed dining room belonging to a young professional couple in the Belle Meade area of Nashville allows for intimate dining and conversation.

FACING PAGE This cabin on Center Hill Lake provides a relaxing respite for family and friends year-round.

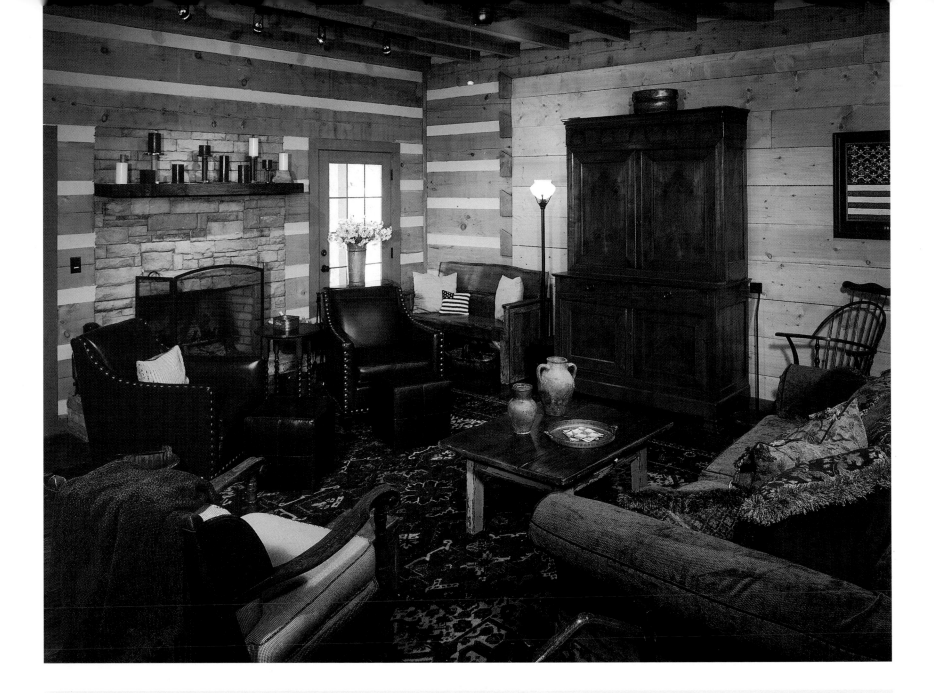

More about Barbara ...

WHAT ONE ELEMENT OF STYLE OR PHILOSOPHY HAVE YOU STAYED TRUE TO OVER THE YEARS AND THAT STILL WORKS FOR YOU TODAY?

"I have always preferred a classic look that can be applied to a log cabin as well as a high-rise condominium or a grand estate," says Barbara. Another tip: she loves using elegant, expensive fabric, even if it's on a single throw pillow.

WHAT IS THE BEST PART OF BEING AN INTERIOR DESIGNER?

Barbara loves the fact that her job has given her the opportunity to meet many different people over the years and to develop real friendships with many of her clients.

WHAT IS A SINGLE THING THAT YOU WOULD DO TO BRING A DULL HOUSE TO LIFE?

With a restricted budget, Barbara would definitely paint the walls. "If I had a more flexible budget, I would add art—as much as possible."

BRADFORD'S INTERIORS
Barbara G. Rushton, Allied Member, ASID
4100 Hillsboro Road
Nashville, TN 37215
615-297-3541
FAX 615-297-7281

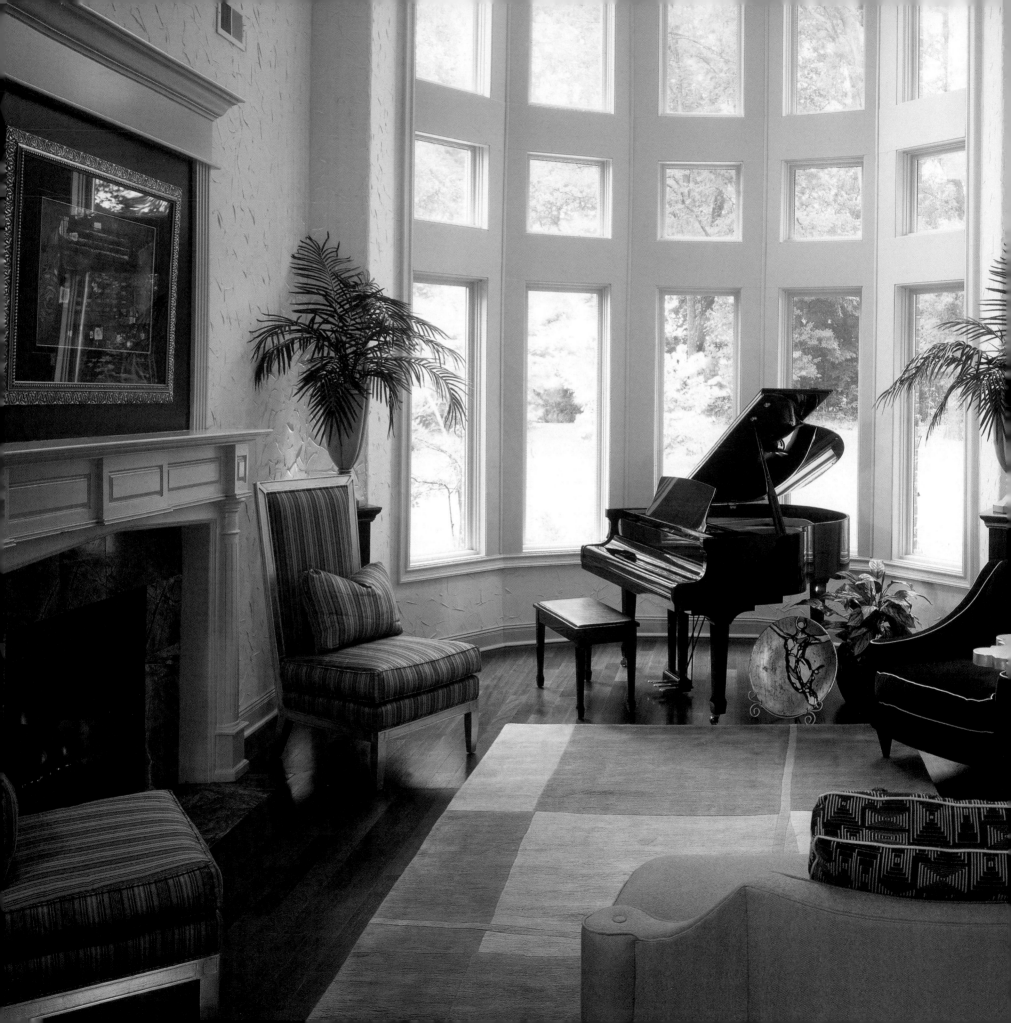

LESLIE SHANKMAN-COHN

ECLECTIC INTERIORS

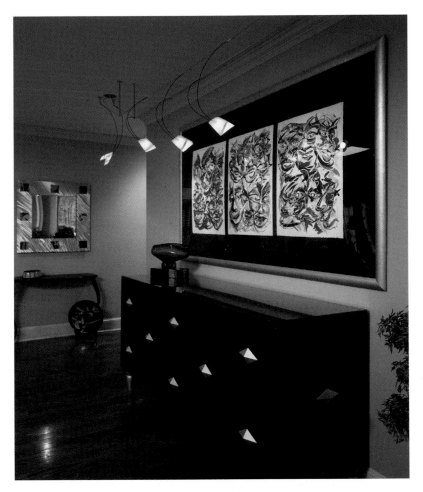

ABOVE Form follows function in this custom-designed sideboard, which was constructed with raised "silver" diamond appliqués and designed with touch-latch doors that provide ample storage for silver trays and fine china. Highlighted above is a triptych by the homeowner.

LEFT Light and nature flood into this elegant living room. Touches of terra cotta focus attention on the shades warm chocolate, robin's egg blue, and silver.

Talented interior designer, author and lecturer Leslie Shankman-Cohn, ASID, grew up in Memphis surrounded by the interior design field, with her father, a custom builder, and her mother, who was a designer. So it's only natural that Leslie would eventually found her own design firm, Eclectic Interiors, and become a leader in promoting the profession. She's also a leader when it comes to environmental issues and is a proponent of both sustainable design, which uses resources in a responsible way, and aging-in-style, which is her way of defining interiors that work for everyone, regardless of age or abilities. "It's simply good design," she says about the approach, which she tries to incorporate into all of her projects "because you never know where your life cycle is going to take you."

For Leslie, design is her life, not just her job. She keeps a pad of paper at her bedside in case creative thoughts strike in the night. The retail side of her company, Eclectic Interiors, includes an extensive array of furnishings and accessories, from the traditional to of-the-moment, and if she can't find the right piece for a client, she designs it and has it made. In keeping with her commitment to excellence, Leslie's custom furniture has garnered national design awards. "I view every project as an entity, and take an holistic approach," she says. "Everything matters!"

ECLECTIC INTERIORS
Leslie Shankman-Cohn, ASID
President, Tennessee Chapter, ASID
Registered Interior Designer in Tennessee
850 South White Station
Memphis, TN 38117
901-683-5598
FAX 901-683-4410
www.eclecticinteriors.com

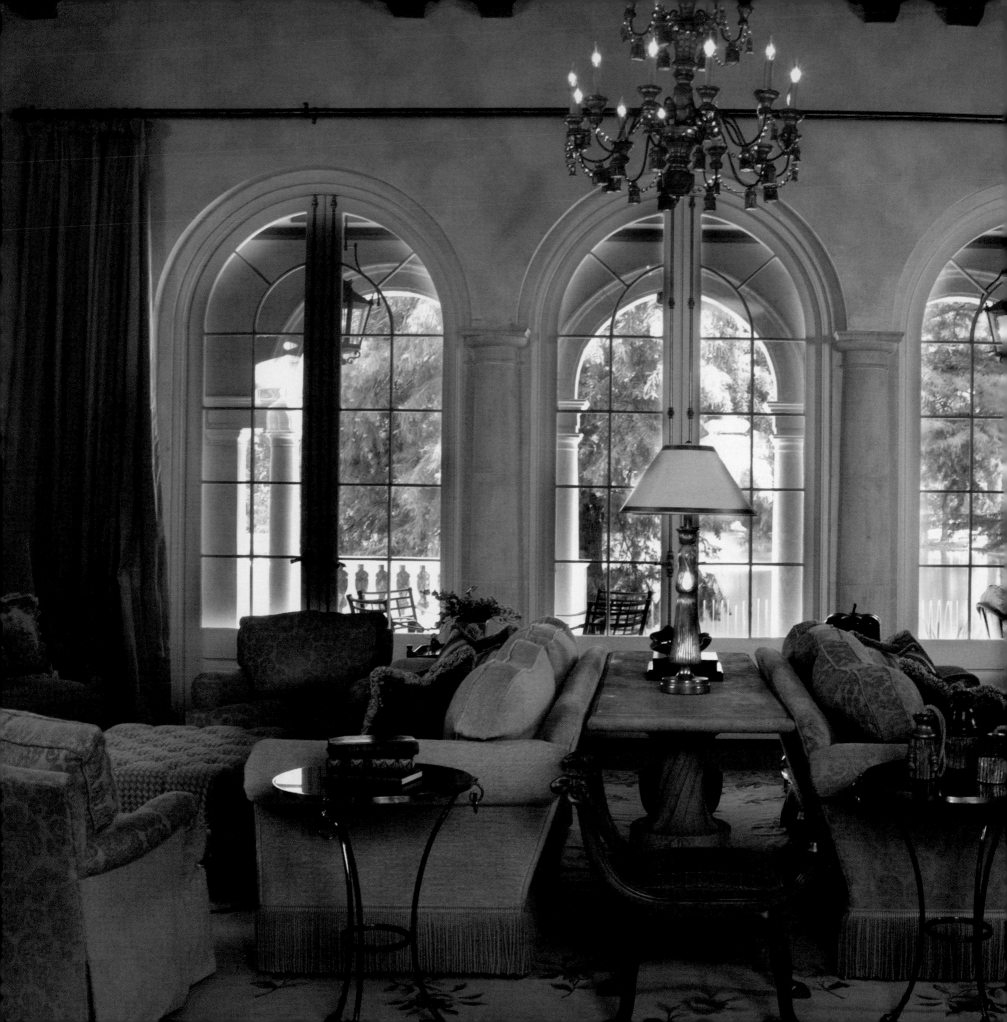

LYNDA MEAD SHEA

SHEA DESIGN & FRENCH COUNTRY IMPORTS

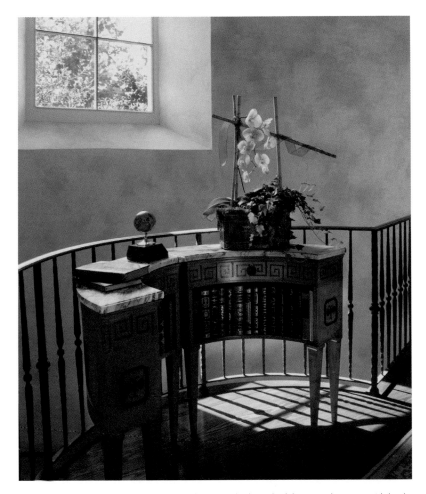

LEFT The large living room with French doors overlooking the lake is made cozier with back-to-back seating areas.

ABOVE A landing atop a curving staircase has a semicircular antique bookcase and a window cut through 14-inch thick walls.

It's hard to miss the eye-catching and authentic row of charming French-style town houses on Old Poplar Pike in the heart of east Memphis. Created by interior designer Lynda Mead Shea to shelter her design studio, Shea Design, the buildings are also home to Lynda's famed shop, French Country Imports. The 5,000-square-foot retail space is filled with antique and decorative accessories that she directly imports three times each year from France, and in September of 2005 she made her 50th buying trip to France. The elegant European aesthetic that exemplifies Shea Design is clearly apparent in the wonderful house shown on these pages.

The owner of the house featured here, which was designed by architect Ken Tate, was a longtime resident of Tennessee before he returned to his home state of Mississippi and embarked on a four-year building project. The experience involved multiple trips to France to purchase antique limestone floors, mantels, accessories and furniture. "It was so much fun shopping for just the right pieces because I knew the house would be a masterpiece and we wanted the interior to be equal in quality," says Lynda.

Focusing on fine residences throughout the Midsouth and a sprinkle of fun projects in Mississippi, Florida and Aspen, Colorado, Shea Design, which Lynda founded in 1982, leans toward uncluttered spaces, beautiful colors, quality fabrics, and antique furniture with character and beautiful patina. "We also put a lot of emphasis on clear communications with clients and very accurate estimates so there are no surprises," says Lynda, who trained at the prestigious Parsons School of Design in New York. "I like more spare interiors, fewer objects but perhaps larger scaled," she says about creating an ideal balance that combines function and beauty. "We all love contemporary art, so there's a big tendency to put wonderful modern art in projects as well as the 18th and 19th century paintings we find abroad. We also buy in Italy and Sweden so you might say our interiors have a European continental flavor rather than purely French."

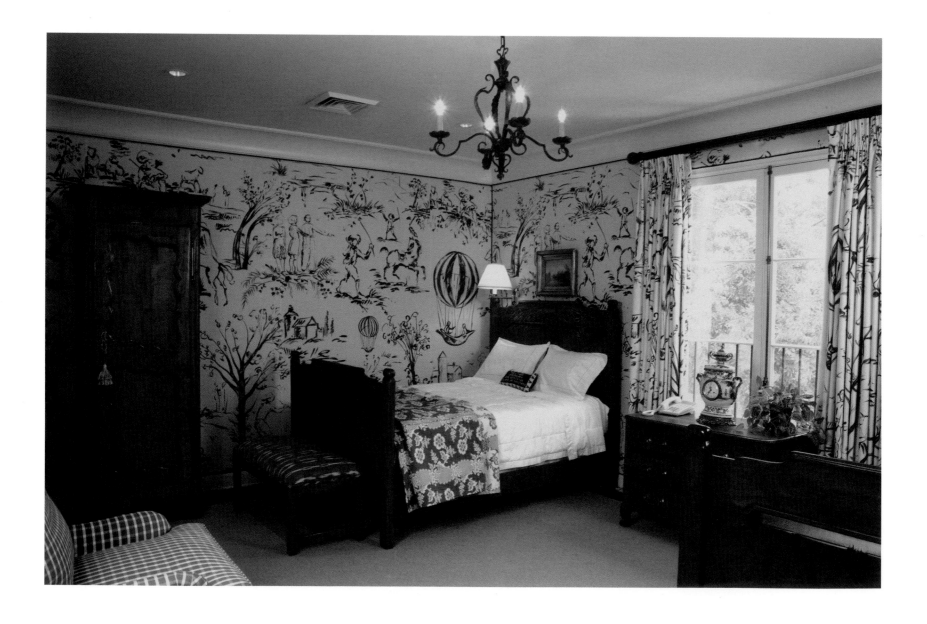

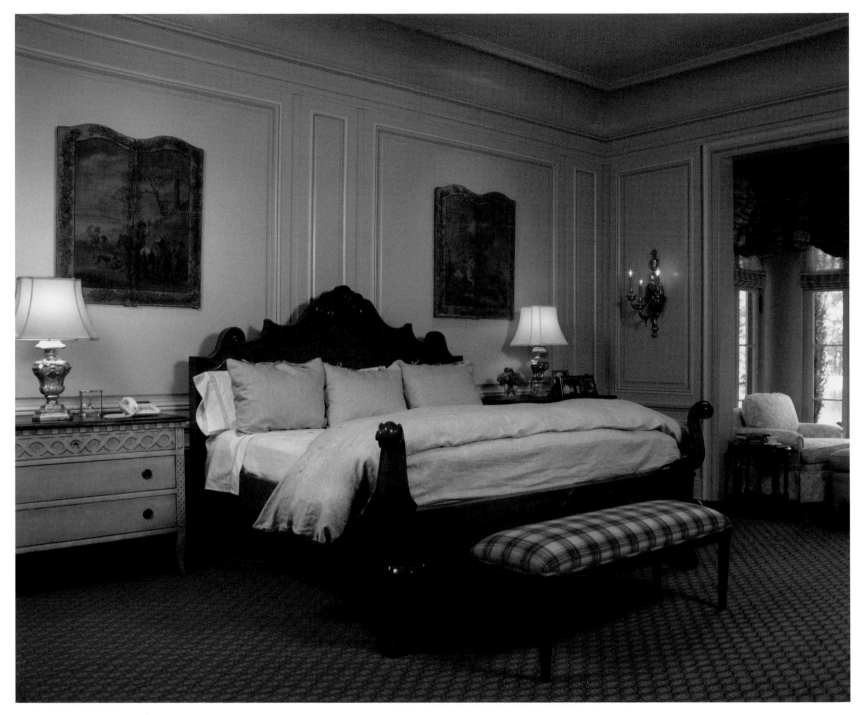

LEFT The walls of a guest bedroom are dressed in Pierre Frey's hugely scaled toile, which has no repeat from floor to ceiling.

ABOVE The dove-gray master bedroom features a Michael Taylor Italian bed, which is flanked by a pair of Patina "Firenze" chests. Antique silver lamps illuminate screens with charming landscapes.

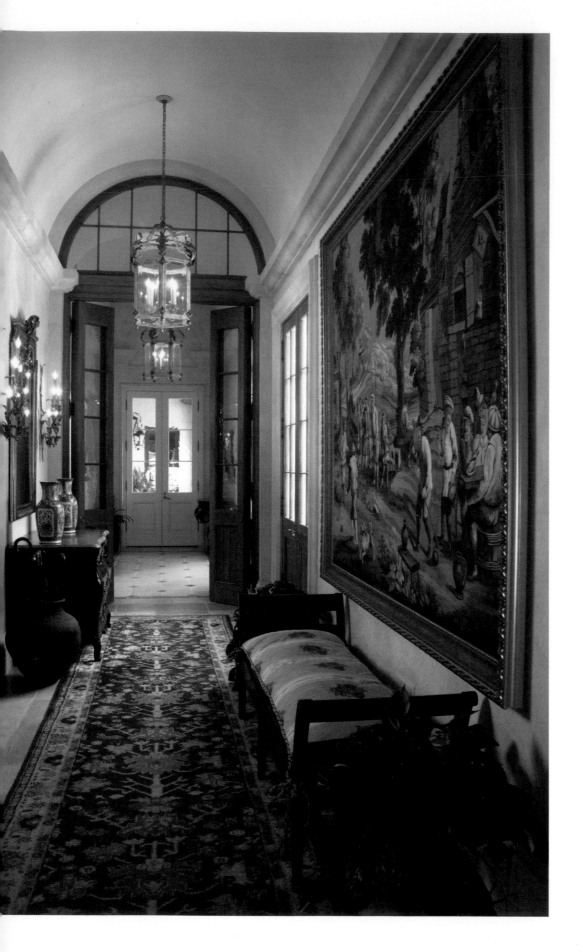

In 1984, two years after founding her design firm, Lynda established the retail side of her company, French Country Imports, when she realized there was a serious lack of resources for Americans interested in true French antiques and decorative items. She traveled to the south of France to see friends and as she put it, "the dollar was strong and the synergy was right," and she returned with a container full of pieces that quickly sold. Her early buying experience, fueled by many subsequent trips, instilled a passion for French design as a living, translatable set of principles that apply to many settings. Those principles include a preference for quality over quantity in all things, a respect for the domestic arts, and an absence of guilt about relaxing and enjoying life in a beautiful environment. "There is a serenity in that that is very appealing," says Lynda.

LEFT In the vaulted entrance gallery, three Niermann Weeks lanterns illuminate a 19th-century Aubusson cartoon.

RIGHT The architect designed the dining room's pine paneling, which was made in England. Two tables make for more intimate dining.

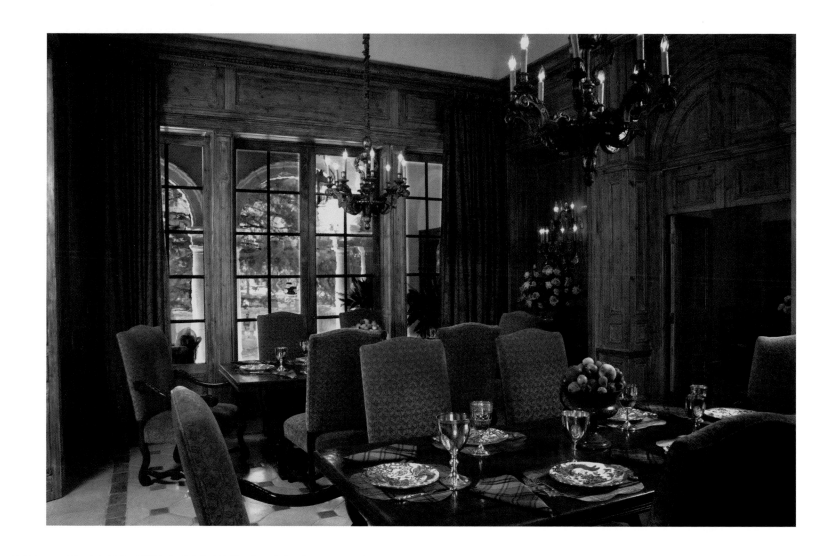

More about Lynda ...

WHAT IS THE HIGHEST COMPLIMENT
YOU'VE RECEIVED PROFESSIONALLY?

"I love it when a gifted architect tells me that he loves
my interiors," says Lynda. "The architects are the
severest critics but they are usually accurate."

WHO HAS HAD THE BIGGEST INFLUENCE
ON YOUR CAREER?

The wonderful homes Lynda has experienced in
France have made the biggest impact on her and her
work. "There is more focus on the quality of each item
and less focus on 'decorating' in France, and I find that
very appealing," she says. "Of course, it helps if you
have a 300-year-old house."

WHAT ONE ELEMENT OF STYLE STILL
WORKS FOR YOU TODAY?

"Less is more," says Lynda.

WHAT IS THE BEST PART OF BEING AN
INTERIOR DESIGNER?

"The creative aspect of it," says Lynda. "Designing a
room is akin to painting a picture. I love the search for
the right fabrics, wall coverings, rugs and accessories."
Traveling to France three times a year also gives her the
opportunity to search for exactly the right pieces for
her clients. "Creating a serene and comfortable
environment that reflects the tastes and personality of
a client is challenging and always engaging."

NAME SOMETHING THAT MOST PEOPLE
DON'T KNOW ABOUT YOU.

The former Lynda Lee Mead may sound or look
familiar...she was Miss America in 1960.

**SHEA DESIGN &
FRENCH COUNTRY IMPORTS**
Lynda Mead Shea, Allied Member, ASID
6225 Old Poplar Pike
Memphis, TN 38119
901-682-2000
FAX 901-682-8446
www.frenchcountry-imports.com

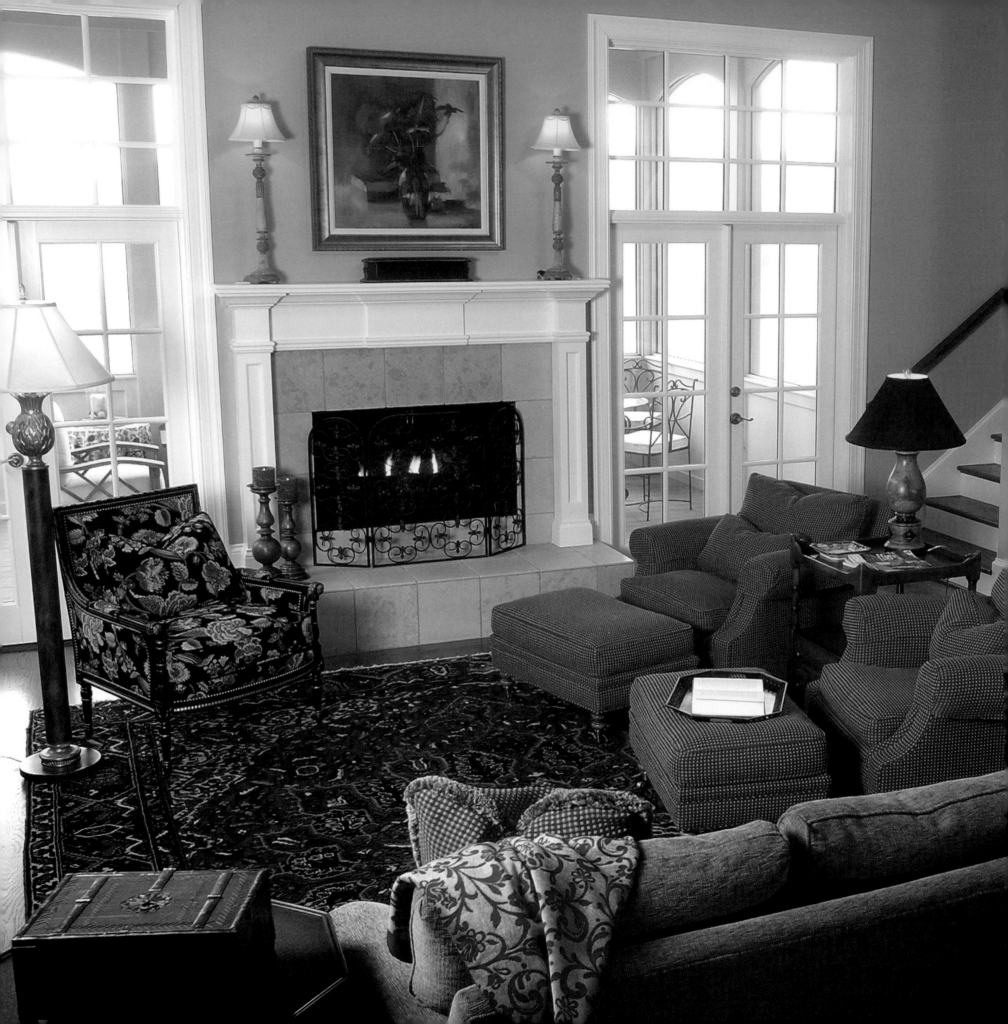

LESLIE NEWPHER TACHEK

LESLIE NEWPHER TACHEK INTERIOR DESIGNER L.L.C.

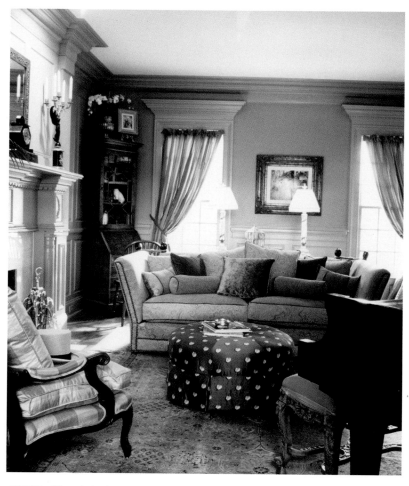

ABOVE Although this living room was completed years ago, the classic design still stands up to current trends. Notice the heavy traditional molding has been painted the same as the walls, a trend borrowed from the past that is seen more and more to create a larger more uniform feel in a room.

LEFT The heart of this casual living area is the semi-antique Persian Medallion Bakntiari rug. Its pattern is bold yet still works to pull in the other patterns in the room without fighting them.

Nashville-based interior designer Leslie Newpher Tachek loves classic, traditional design, has a photographic memory for fabric and color and a passion to match her skill.

"When the UPS man comes with my fabric orders it's like getting a Christmas present every day," says Leslie, who has been a professional designer for 13 years and has owned her own full-service firm for the last six.

"I just love fabrics, I love patterns, I love textures, and I love mixing them," says the designer, who grew up in West Nashville. "That is my favorite part of the whole design process."

Whether working on a large new home or on a remodeling project, Leslie enjoys the challenge of making a fresh space feel warm and comfortable. One of her key talents is using old rugs, original art and antiques mixed with new pieces to make rooms feel lived-in and luxurious. Not surprisingly, a client once remarked that a newly designed space looked like the family had lived there for generations.

It's a well-deserved compliment. With her knack for seamlessly blending comfort with top-of-the-line fabrics

and furniture, Leslie is an expert at making rooms reflect their owners while adding a finished, sophisticated quality.

"My clients have faith that I'll take their taste and their preferences and create a space that is absolutely perfect for their family," she says.

Working on custom homes has provided an exciting opportunity to design from the ground up, and Leslie enjoys the cohesiveness that comes with new construction. It's a challenge to make a new space look warm and friendly, but she delivers highly personal rooms that don't adhere to a singular "look."

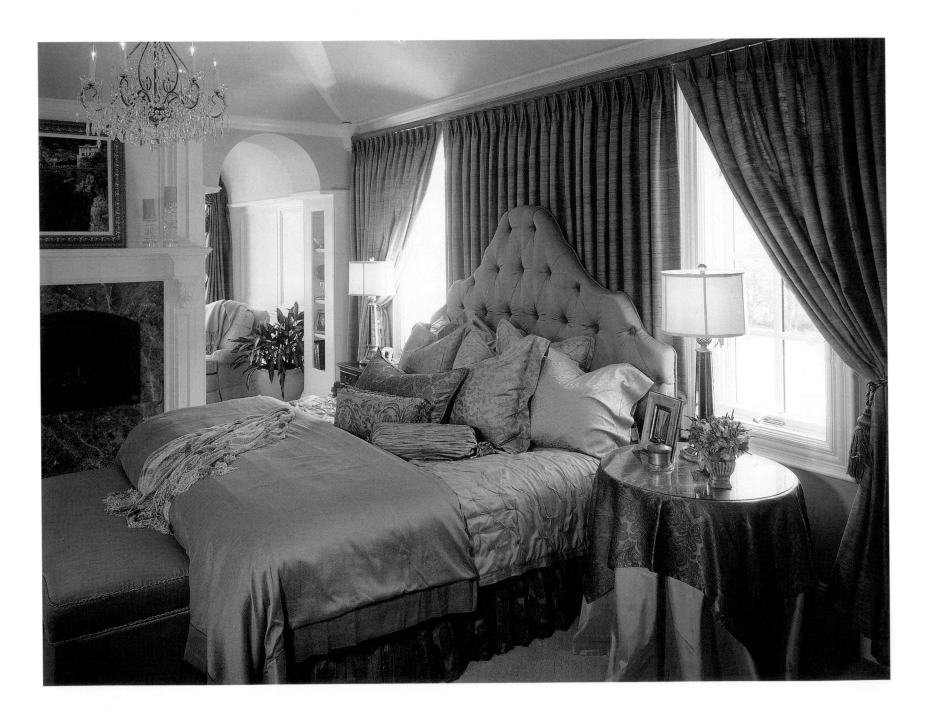

CONNIE BELL TAYLOR &
ANN LIVINGSTON HUIE

TAYLOR AND HUIE FINE INTERIORS AND APPOINTMENTS

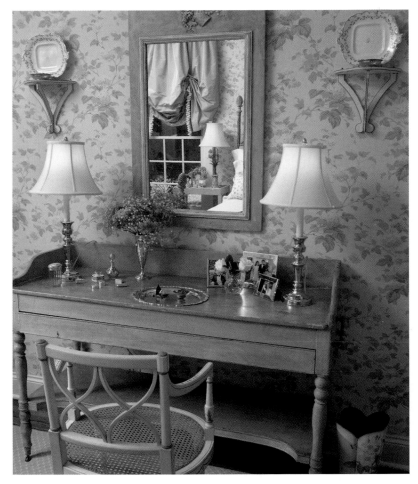

ABOVE A pretty dressing table graces a corner of this feminine bedroom.

LEFT Sophisticated country style is the hallmark of this cozy room, which features a series of bird prints, a comfortable fireside seat and a rich mix of fabrics.

While Taylor and Huie might appear at first glance as merely a marvelous shop filled with antique and new treasures, its expansive fabric library—one of the largest in East Tennessee—is a giveaway that there's a full-service design firm within its walls. Nestled around an early 20th century cottage in the historic Homberg area of Knoxville, the shop presents a cozy, friendly atmosphere that makes visitors want to linger, and linger they do, chatting with owners Ann Huie and Connie Taylor, who has been a designer for 18 years and in business with Ann for the last 16 years.

"We have so many of our customers repeat, so we feel that we know them very well," says Connie, who loves the challenge of making a new home look established and often works with several generations of the same family. Believing that interiors shouldn't stray too far from exteriors, Connie likes to keep appropriateness as a touchstone of her work, which spans traditional-style homes to the Arts & Crafts style and a sprinkle of contemporary interiors. With a portfolio that spans Florida, North Carolina and Washington, D.C., in addition to fine residences across Tennessee, Taylor and Huie focuses on exceptional service, working with their clients' treasures and helping their clients attain their own personal style.

TAYLOR & HUIE
FINE INTERIORS & APPOINTMENTS
Connie Bell Taylor, Allied Member, ASID
Ann Livingston Huie
4921 Homberg Drive
Knoxville, TN 37919
865-584-3031
FAX 865-584-6920

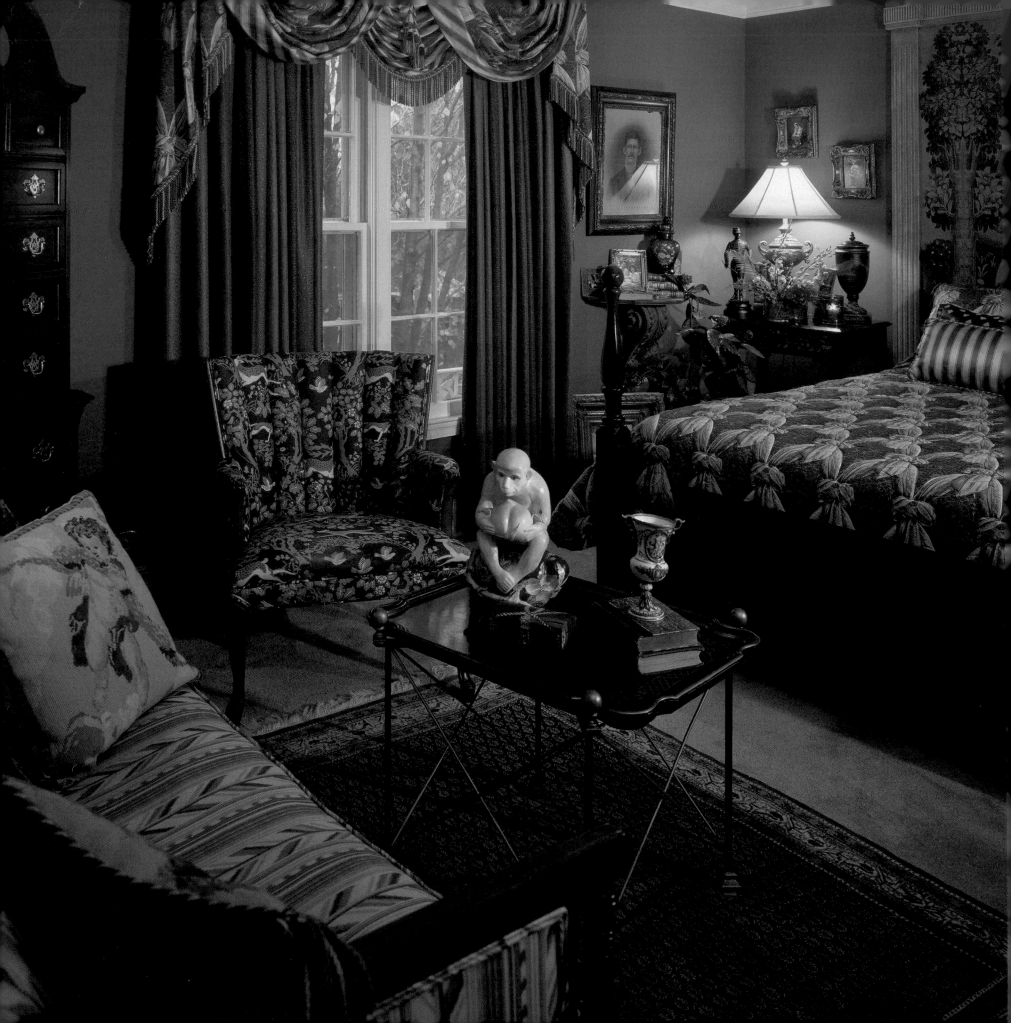

JOE TICE
JOE TICE INTERIORS

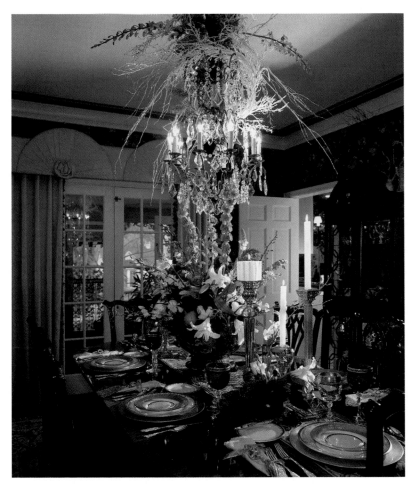

ABOVE Antique china and crystal lend a festive air to this holiday setting atop a dining room table from Baker.

FACING PAGE A delightful chinoiserie tray table anchors the sitting area of this inviting guest bedroom, which features formal draperies and bed coverings in fabric from Scalamandré.

Although he's been a professional interior designer for the last 20 years, Memphis—based, Missouri—bred Joe Tice earned his master's degree in vertebrate zoology and attended medical and dental school before he switched careers. Joe received a master's degree in design and jumped into a career that he continues to enjoy. Today, he cherishes his clients in locales from New York to California, his work running his own full-service firm, and the way his "God-given" talent can improve people's lives in both commercial and residential environments. Joe will be going international in 2006 while doing design work in China for a commercial client.

"I have been so happy being a designer, even on the worst of days," says Joe, an inveterate traveler whose work isn't easily defined, but is marked by a consistent use of many textures and patterns, and knowledge gleaned from years of studying art and architecture worldwide. "I love working from the ground up, working with the architect on the initial phases and designing furniture, cabinetry and lighting," he says, noting that he's just as challenged by a renovation project. "I'm known for making changes—changes that I think reflect the client and the intended use of the space. Change is good!"

JOE TICE INTERIORS
Joe Tice
4515 Poplar Avenue, Suite 131
Memphis, TN 38117
901-761-5900
FAX 901-761-0520

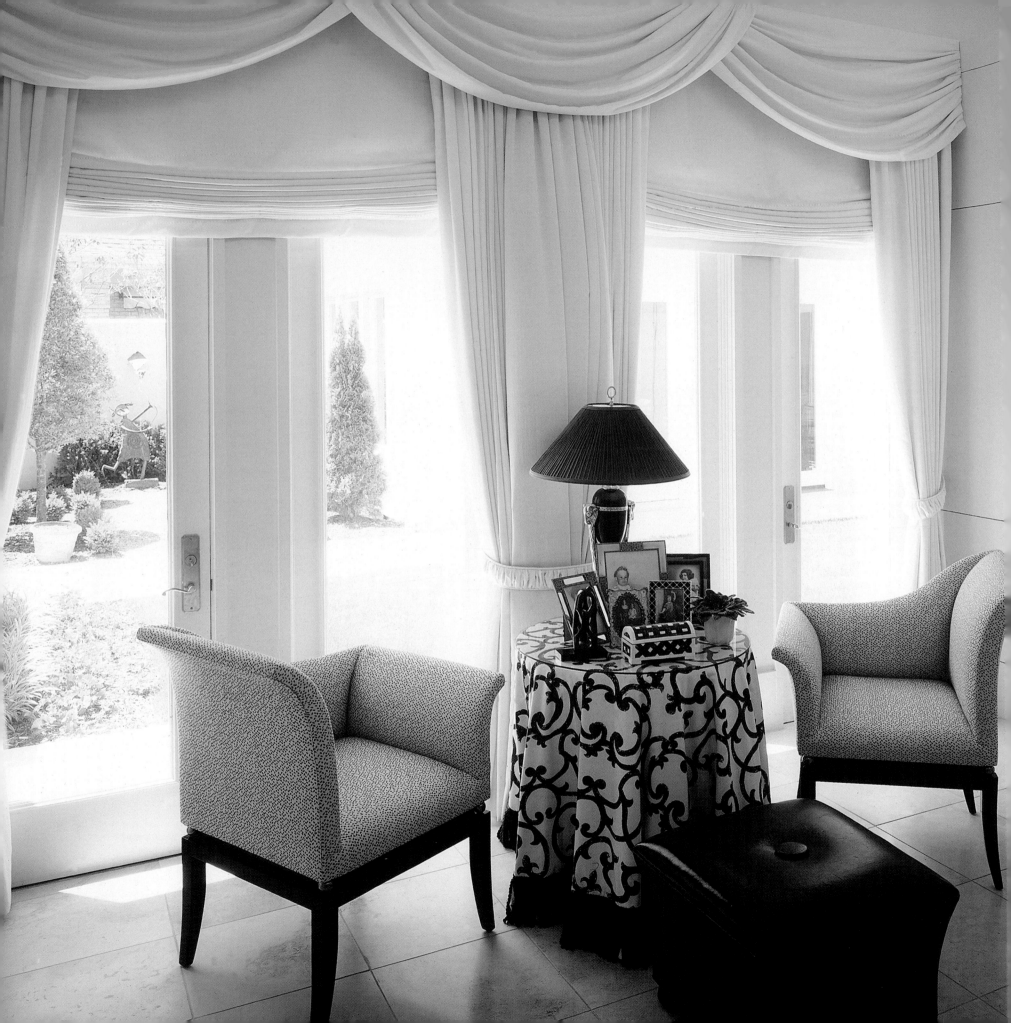

BARRY WILKER

B. WILKER & COMPANY INTERIOR DESIGN STUDIO

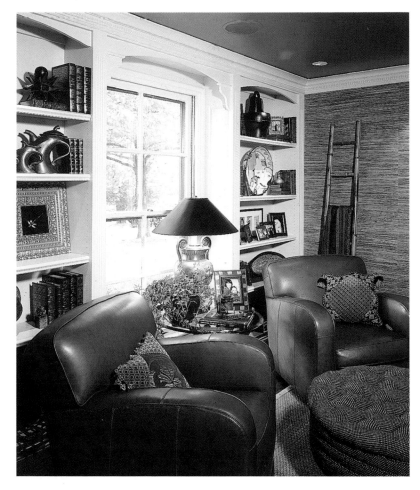

ABOVE In a cozy Nashville study, Art-Deco-style leather club chairs and grasscloth walls create a warm feeling, while shelves provide plenty of storage.

LEFT A sitting area in the master bedroom includes lacquered cabinetry that separates the room from the master bath, and a bank of doors that provide a garden view.

Upon entering B. Wilker & Company's smart shop and design studio, it is clear that this full-service interior design firm isn't married to one style. Sinuous, gourd-like lamps mix with lacquered trays, and antiques, accessories and art are sprinkled throughout the cozy space. While there are a lot of beautiful things, the feeling is overwhelmingly smooth.

"I love furniture and I love variety," says company president Barry Wilker, who has been in the design business for 29 years and now runs a small retail showroom alongside his design business. "I hate cluttered. I like things very clean."

Barry grew up in Nashville and after college, went to work at a bank before deciding banking wasn't for him. In a move that proved fateful, he started a job in 1976 doing displays for Bradford's, a venerable Nashville furniture company. During his tenure, he mastered the basics and demonstrated the talents that have become his forte. In Los Angeles, where he worked as a designer for 12 years, he flourished, honing his design and people skills. Armed with a strong residential and commercial portfolio of both traditional and contemporary designs

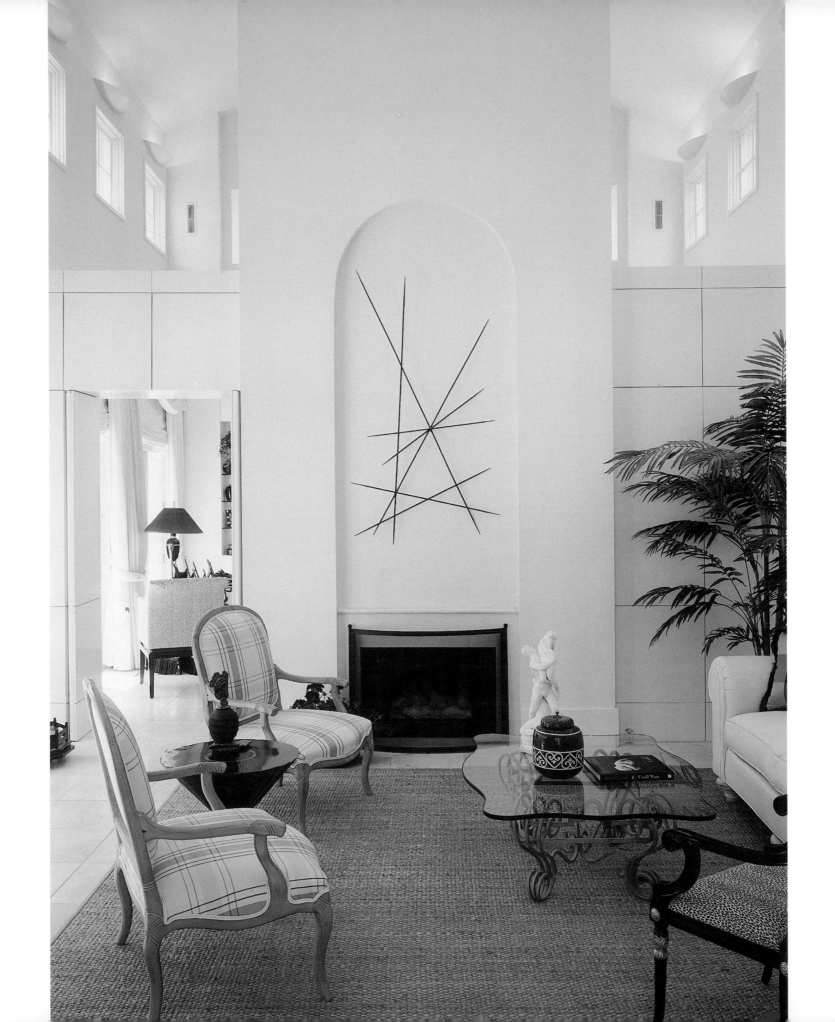

and a fresh perspective, Barry returned to Nashville where he eventually opened his eponymous organization in 2001.

Today, B. Wilker & Company includes Barry and four other professional designers: Marcia J. Knight, ASID; Connie Long, ASID; Connie Vernich, allied ASID and Lester Katz. While much of the company's work involves space planning and consulting on large new homes, the design team frequently tackles smaller

LEFT Wilker designed the iron sculpture above the fireplace in this dramatic, two-story living room in Nashville.

BELOW This Nashville family room includes a custom built-in media cabinet, limestone flooring and black lacquer pieces mixed with cream chenille fabrics.

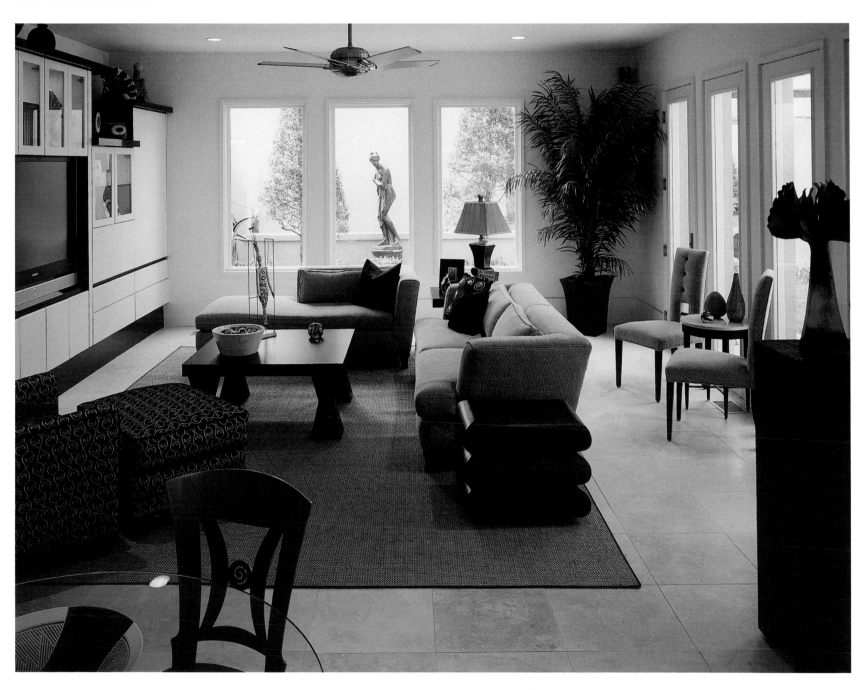

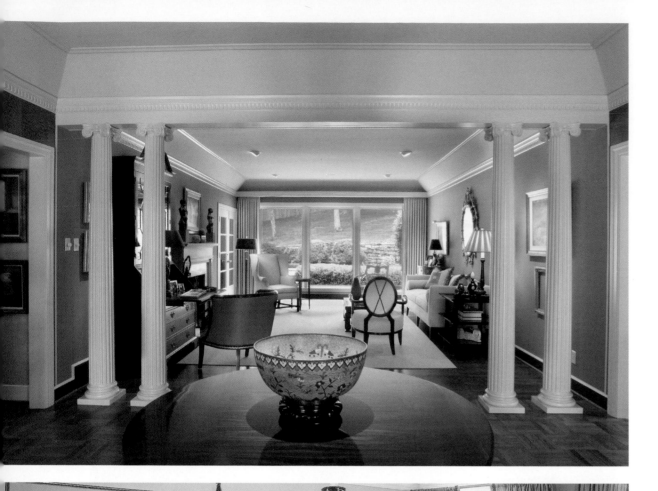

renovation and design projects in existing homes. Regardless of the size or scope of a project, Barry insists that the firm's core values of integrity, individuality and honesty apply.

Another thing he loves is interacting with passionate clients. "I want our clients to be thoroughly involved," he says. Collaboration is key to Barry's philosophy that design should be a pleasurable experience for everyone involved. "We are not forceful, high-pressure people, and I want to make sure we help our clients make the best decisions," he says, adding that whether a project is lean and contemporary or more traditional in nature, "I will not do anything to be short-sighted."

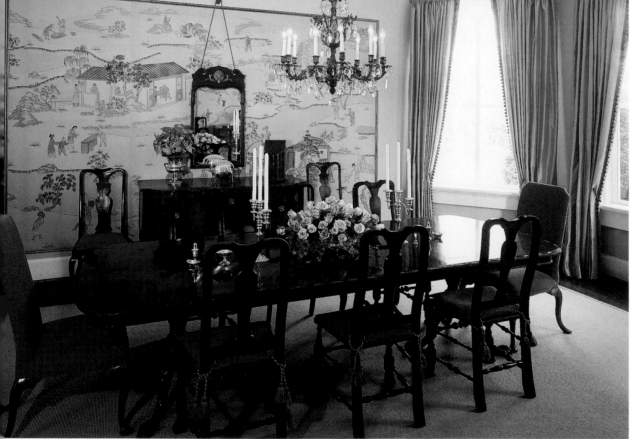

TOP LEFT Wilker pulled the orange from poolside flagstone for the walls of this neoclassical and contemporary living room to showcase the couple's art

LEFT Hand-painted silk panels were created to fit within a custom molding in this elegant, understated Nashville dining room, which was designed around the homeowners' antique English dining room furniture.

RIGHT For a client who desired a classic, old-world flavor, Wilker arranged the room around an Aubusson rug and mixed English and French pieces.

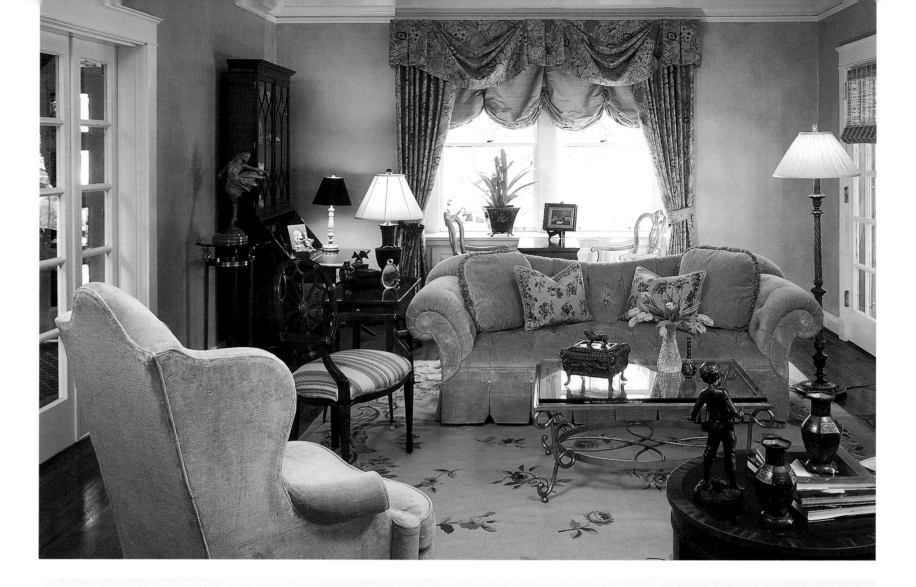

More about Barry ...

WHAT IS THE HIGHEST COMPLIMENT YOU'VE RECEIVED PROFESSIONALLY?

Clients have told Barry that he is the easiest designer they have ever dealt with, and that's a huge compliment to his professionalism. "A big part of my job is to simplify all of their decisions and smooth out the design process," he says.

WHAT SEPARATES YOU FROM YOUR COMPETITION?

Barry's style varies with his clients. By living and designing homes in southern California and Nashville, he learned to be adaptable and work with his clients' emotions and preferences to create their ideal environment. He loves mixing styles, beautiful fabrics and art to create a personal look.

DESCRIBE YOUR STYLE OR DESIGN PREFERENCES.

"My preferences are a clean look, no matter how traditional or contemporary," says Barry. "I don't like extremely flashy looks."

WHO HAS HAD THE BIGGEST INFLUENCE ON YOUR CAREER?

For Barry, working display at Nashville's Bradford Furniture Company, where he had his first design job in 1976, was a key turning point in his career.

YOU WOULDN'T KNOW IT, BUT MY FRIENDS WOULD TELL YOU I WAS...

"A comedian or a frustrated doctor at heart," says Barry.

B. WILKER & COMPANY INTERIOR DESIGN STUDIO
Barry Wilker, President, Allied Member ASID,
Registered Interior Designer in Tennessee
2210 Crestmoor Road
Nashville, TN 37215
615-460-1200
FAX 615-269-3444

THE PUBLISHING TEAM

Panache Partners LLC is in the business of creating spectacular publications for discerning readers. The company's hard cover division specializes in the development and production of upscale coffee-table books showcasing world-class travel, interior design, custom home building and architecture as well as a variety of other topics of interest. Supported by a strong senior management team, professional associate publishers, and a top-notch creative team of photographers, writers, and graphic designers, the company produces only the very best quality of these keepsake publications. Look for our complete portfolio of books at www.panache.com.

We are proud to introduce to you the Panache Partners team below that made this publication possible.

Brian G. Carabet

Brian is co-founder and owner of Panache Partners. With over 20 years of experience in the publishing industry, he has designed and produced more than 100 magazines and books. He is passionate about high quality design and applies his skill in leading the creative assets of the company. "A spectacular home is one built for entertaining friends and family because without either it's just a house...a boat in the backyard helps, too!"

John A. Shand

John is co-founder and owner of Panache Partners and applies his 25 years of sales and marketing experience in guiding the business development activities for the company. His passion toward the publishing business stems from the satisfaction derived from bringing ideas to reality. "My idea of a spectacular home includes an abundance of light, vibrant colors, state-of-the-art technology and beautiful views."

Julia Hoover

Julia is the Associate Publisher in Tennessee for Panache Partners. A native of Tennessee, she has spent over 10 years in the publishing industry. She lives in Nashville with her wonderful husband and three children. What makes a home spectacular to Julia is "the classic traditional style where family is the heart of the home and friends can enjoy good times and laughter."

Phil Reavis

Phil is the Group Publisher of the Southeast Region for Panache Partners. He has over a decade of experience in television and publishing. A native to the South, he has lived in Georgia for 14 years. "What makes a home spectacular is my wife and two children. They inspire me every day."

Bill LaFevor

Bill is the staff photographer for *Spectacular Homes of Tennessee*. He has been an accomplished and recognized architectural photgrapher for 27 years. One of his passions is anthropology, as he is working on a project documenting 16th century monastaries in southern Mexico, which are threatened by deterioration and earthquake activity. "My idea of a spectacular home is one that achieves originality by reflecting the personality of its owner."

Elizabeth Betts Hickman

Elizabeth, the book's editor, is an accomplished writer, field editor and photo stylist for a number of national design magazines, including Southern Accents. "My idea of a Spectacular home is one that's comfortable, full of love, has lots of bookshelves and a screened porch."

Additional Acknowledgements
Project Management—Carol Kendall, Donnie Jones
Traffic Coordination—Elizabeth Gionta and Chris Nims
Design—Anne Rohr, Emily Kattan, Michelle Cunningham-Scott

PHOTOGRAPHY CREDITS

Pages	Design Firm	Photographer
10-17	Adkisson Design	Sanford Myer
104-109	Allyson Interiors	Bill LaFevor
38-43	B.W. Collier, Inc.	J. Madison Culler
		Phillip Parker
		Andrea Zucker
18-19	Anderson Design Studio	Tom Gatlin
		Kristin Barlowe
160-165	B. Wilker & Company Interior Design	Bill LaFevor
28-31	Baylor Bone Interiors	Bill LeFavor
118-121	Biggs Powell Interior Design & Antiques	Rick Bostick
140-143	Bradford's Interiors	Bill LeFavor
110-111	Cindy McCord Interior Design	Chip Pankey
90-95	Davishire Interiors	Robt Ames Cook
		Michael Lewis
144-145	Eclectic Interiors	Bill LeFavor
50-55	Erwin, Follin & White	Bill LeFavor
72-75	Feltus\|Hawkins Design, LLC	Gabriel Benjur
		Tom Gaitlin
		Michael Lobiondo
48-49	Gwen Driscoll Design	Chip Pankey
76-81	Headley Menzies Interior Design	Bill LeFavor
82-85	Healy & Associates	Bill LeFavor
20-23	J.J. Ashley Fine Interiors	Bill LeFavor
158-159	Joe Tice Interiors	Allen Mims
		Sweeney South Photography
86-89	Jill Hertz Interior Design	Bill LeFavor
44-47	Kenneth Cummins Interior Design	Woodliff Photography
64-67	Landy Gardner Interiors	Mick Hales
112-117	Lanny Neal Interiors	Bill LeFavor
122-127	Lee Pruitt Interior Design	Bill LeFavor
152-155	Leslie Newpher Tachek Interior Design, LLC	Reed Brown
		Bill LeFavor
32-37	New Directions	Bill LeFavor
136-139	Ray & Baudoin Interior Design	Rick Bostick
128-135	Robin Rains Interior Design	Jerry Atnip
		Jennifer Deane Photography
		Tim Lee Photography
		Carolyn Bates
68-71	Sara Gillum Interiors	Bill LaFevor
		Peyton Hogue
		Sara Gillum
24-27	Shea-Noel Interiors	Chip Pankey
		Redroom courtesy of Midsouth Magazine
146-151	Shea Design & French Country Imports	Greg Campbell
156-157	Taylor Huie Fine Interiors & Appointments	Jean Philippe
96-103	The Iron Gate	Chris Little
56-63	William R. Eubanks Interior Design, Inc.	John Hall
		Allen Mims
		Thibault Jeanson Langdon Clay
		Ken Dittfield

Index of Designers

Jeffery Adkisson . 11

Kathy Anderson . 19

Jason Arnold . 91

Greg Baudoin . 137

Lisa Biggers . 21

Shandra Blackwell 25

Baylor Anne Bone 29

Kathryn Broadwater 33

Bradford Collier 39

Gail C. Cook . 29

Kenneth W. Cummins 45

Gwen Driscoll . 49

Joe Erwin . 51

Wiliam R. Eubanks 57

Mary Follin . 51

Landy Gardner 65

Sara Gillum . 69

Natalie Hart . 91

Kelly Harwood 21

Marjorie Feltus Hawkins 73

Keith Headley 77

Karen W. Healy 83

Jill E. Hertz . 87

Shirley Horowitz 91

Ann Livingston Huie 157

Rozanne Jackson 97

Allyson Justis 105

Cindy McCord 111

Lannie Neal . 113

Biggs Powell 119

Lee Pruitt . 123

Robin Rains . 129

Grant Ray . 137

Barbara G. Rushton 141

Leslie Shankman-Cohn 145

Lynda Mead Shea 147

Leslie Newpher Tachek 153

Connie Bell Taylor 157

Joe Tice . 159

David White . 51

Barry Wilker . 161